The Edge of the Millennium

**An International Critique
of Architecture, Urban Planning,
Product and Communication Design**

Edited by Susan Yelavich
Cooper-Hewitt, National Museum of Design
Smithsonian Institution, New York

Whitney Library of Design
an imprint of Watson-Guptill Publications
New York

Senior Editor: Roberto de Alba
Editor: Virginia Croft
Designer: Lorraine Wild, ReVerb/Los Angeles
Production Manager: Hector Campbell

First published in New York in 1993
by Whitney Library of Design
an Imprint of Watson-Guptill Publications,
a division of BPI Communications, Inc.,
1515 Broadway, New York, NY 10036

Library of Congress Cataloging-in-Publication Data

The Edge of the Millennium: an international critique of architecture,
 urban planning, product and communication design / edited by Susan
 Yelavich.
 p. cm.
 Includes bibliographical references and index.
 ISBN 0-8230-0254-3
 1. Communication in architectural design—Congresses.
 2. Communication in design—Congresses. 3. City planning—
 Forecasting—Congresses. I. Yelavich, Susan.
 NA2750. E34 1993
 745.4—dc20 93-28944
 CIP

Manufactured in the United States
First Printing 1993
1 2 3 4 5 6 7 8 / 00 99 98 97 96 95 94 93

THE EDGE OF THE MILLENNIUM

Contents

Foreword

The prospect of the new millennium raises and heightens expectations of change—change that will permeate every aspect of our lives. As Cooper-Hewitt, National Museum of Design approaches its centennial in 1997, almost in coincidence with the arrival of the year 2000, the Museum, too, finds itself immersed in its own millennial redefinition. Cooper-Hewitt is in the process of repositioning itself to serve as the National Museum of Design. Its mission has been redirected to explore the process and the consequences of design and its impact on our daily life. Our task is an urgent one, not to be delayed, for the consequences of our designed world will literally shape the lives of the citizens of the next millennium.

An important catalyst for the Museum's vision for the next century was the international conference "The Edge of the Millennium," which took place in New York in 1992. Significantly, this four-day, intensely speculative symposium was held at the Cooper Union for the Advancement of Science and Art—the venerable institution where the Museum's collections had their first home, where the value of design education has been safeguarded and prized since its founding by Peter Cooper in 1859. We are grateful to President John Jay Iselin for his support of the project in allowing these proceedings to take place in the Great Hall, on the same stage that has served as a platform for figures no less than Abraham Lincoln.

Through the generosity of Robert McNeil and the Barra Foundation, which funded the conference, and the Lisa Taylor Memorial Fund, what might have evaporated as "just so much talk" about the future of design has now been reborn as a book. *The Edge of the Millennium* allows the ideas to survive as a working resource in the tradition of the Museum's founders, Sarah, Amy, and Eleanor Hewitt.

The conference and the book were the idea of Susan Yelavich, Head of Education. Since its inception, Susan has nurtured the project with clarity of vision and tremendous dedication. She has worked to bring the many views of the millennium to life on the podium and on the printed page, and I am extremely grateful.

The essays that follow can be seen as a navigation map for the twenty-first century. Like the maps that were available to Columbus before his first transatlantic voyage, it will be an imperfect map. If succeeding generations find that we, too, have miscalculated, no doubt they will be fascinated by the prejudices and assumptions behind our millennial aspirations. It is our hope that they will not mistake the sincerity of the pursuit, but

understand it in the context of our moment in history. We are fully aware of the questions of survival at stake, not just in the practice of design, but in the practice of living as we now conduct it. For the millennium is no convenient hook for rhetoric—it is the critical impetus for change.

The year 2000 approaches with all of the mixed emotions that come with the idea of departure and arrival. It is our belief that the passage will be a little less rocky if those who are entrusted to shape the built landscape—the landscape of objects and signs—have the love of poetry, the memory of history, the perspective of philosophy, the understanding of function, and the pleasure of aesthetics. If these disciplines are exercised with the necessary compassion of empathy and sensitivity to the balance of nature, we will enter the millennium with a greater sense of security, confidence, and optimism.

Dianne H. Pilgrim
Director
Cooper Hewitt, National Museum of Design, Smithsonian Institution

Acknowledgments

By definition, this book—a collection of essays engendered by a symposium—is indebted to a great many individuals and institutions. I am especially grateful to Robert McNeil and the Barra Foundation in Philadelphia for their generous support of the conference "The Edge of the Millennium," organized by the Education Department of Cooper-Hewitt, National Museum of Design, Smithsonian Institution in January of 1992. For it is the ideas presented at this international gathering of architects, designers, critics, writers, philosophers, and historians that were the genesis for this book. The four-day event took place at the Cooper Union for the Advancement of Science and Art, for which we thank the Cooper Union's President, John Jay Iselin, and also Winston Wilkerson of the Cooper Union, whose audio and video tapes of the proceedings were invaluable in the transcription of various texts.

I am most particularly thankful for Cooper-Hewitt Director Dianne H. Pilgrim's constant encouragement and support for the project during a period of important growth for the Education Department and the Museum. With her endorsement, *The Edge of the Millennium* became a book and enjoyed generous support from the Lisa Taylor Fund, Cooper-Hewitt, National Museum of Design. As with all endeavors of this nature, *The Edge of the Millennium* is the work of a team of dedicated individuals. I am deeply grateful to the book's photo editor, Laurie McGavin Bachmann, who served as the eyes of the project. Her encyclopedic research and editorial discernment were invaluable to the development of the book. Special thanks are also in order to Christine Moctezuma for critical administrative support, to Leslie Gaspar for research, and to Elizabeth Meryman-Brunner, who served as photo consultant to the project, as well as to Maura Fadden Rosenthal, Peter Bachmann, and Maya Bachmann for their generous support. Collegial support also came from many different departments of the Museum, and I wish to thank Nancy Aakre, Head of Publications, Publications Department; Cindy Plaut, Publications Assistant; Brad Nugent, of Photographic Services; and Hilda Lee Wojack, Program Assistant, Education Department. I want to thank Roberto de Alba, my editor at The Whitney Library of Design, for his advocacy of the project from the start and his guidance in bringing it to fruition as a book. Lorraine Wild's clear perception of the issues at the "edge of the millennium" has resulted in a deeply sympathetic design, for which I am grateful. Above all, I am truly thankful for the careful editorial counsel and consummate patience of my husband, Michael Casey. I dedicate this book to Michael and to my son, Henry.

— S.Y.

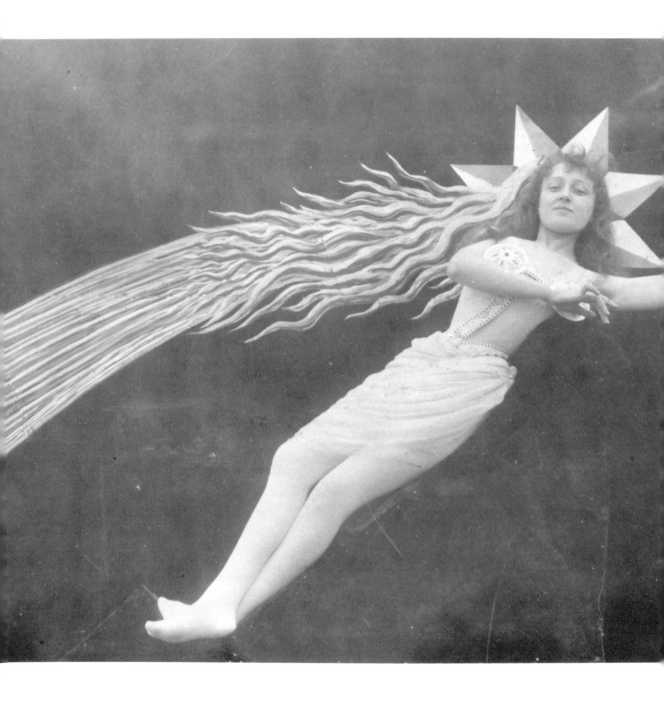

Georges Méliés, *The Eclipse, or the Courtship of the Sun and the Moon,* 1907. Photofest.

Setting the Stage
for the Third Millennium

An Apollo object, ripped loose from the asteroid belt, is heading toward us at ten miles per second. It's so big that when its leading edge hits, if it hits, its trailing edge will be up there where the aeroplanes fly.

A unique configuration of earth, moon and sun will cause hemispherical flooding. There will be sunquakes, and superbolt lightning.

A nearby supernova will presently drench the planet in cosmic rays, causing another Great Extinction.

Oh, and nuclear weapons, those dinosaurs...

And let's not forget the Second Coming, also awaited, in quiet confidence. Or not so quiet. On the street the poor rock and sway, like burying parties. All their eyes are ice.

"Call it off, Nicola," I said... "Forget it. Do something else. Live."
— Martin Amis, London Fields, 1989[1]

The year 2000. The specter of endings and the implicit promise of beginnings color the approach of the millennium. Predictions of political, social, moral, and biological apocalypse have become routine. A sense of closure and fast-forward surrounds us. Even as we describe it, the undertow carries us past reflection to the next century.

Millenarian forecasts of the end of history, the end of art, the end of all fixed meaning, are not, however, a conceit of our own time, nor any one time in particular. According to preeminent scholar Norman Cohn, the raw materials for the first revolutionary millenarian movements in the Middle Ages were ancient Jewish and later Christian prophecies.[2] Historically the Jews were the first to believe themselves to be the Chosen People of one God, and therefore elected for salvation. (As recently as 1993, the Jewish Lubavitcher sect hailed Brooklyn Rabbi Menachem Mendel Schneerson as their immanent Messiah.) Christian eschatology—the theological study of last things—is embedded in a literal notion of the Second Coming of Christ and a final state of perfection. (The year 1993 also saw cult leader David Koresh proclaim his own Judgment Day.) From these two belief systems has developed what might be called a generic millenarian framework—the endurance of extreme suffering and upheaval to be followed by a state of peace, joy, and serenity. A consoling and controlling strategy for the desperate and disenfranchised, this scenario has been recast and replayed countless times over history.

Nonetheless, millenarian movements do have a tendency to cluster around years with multiple zeros. The eleventh century produced the first of the infamous Crusades. Two years before the year 1500, the ascetic Savonarola was burned at the stake of a disintegrating Italian empire for his efforts to purify a corrupt populace and ready them for the next world.

Since then the notion of the century as a temporal frame for historic change has become a commonplace of modern thought.[3] Critical events such as the defeat of the Spanish Armada at the close of the sixteenth century, the American and French revolutions and the Reign of Terror leading up to the end of the eighteenth century, the advent of World War I at the turn of the nineteenth century, and the collapse of Communism at the waning of this century have coincided, if not with the calendrical double-aught, then certainly with the expectation that the *fin de siècle* is itself an impetus to revolution.

As to the relevance of millenarianism in our own ostensibly secular century and why designers and architects should consider it a reasonable point of departure for discussion,

there is little argument that the tectonic plates of social and natural order have been shifting and slipping fast. And designers, conditioned to plan, may be even more vulnerable to the current climate of insecurity, to the point of questioning their very survival. In millennial terms, they too face the prospect of radical transformation and rebirth as a consequence of disputed understandings of what constitutes the notion of place, of a looming technological juggernaut, and a seemingly relentless contemporary preoccupation with identity—be it cultural, national, social, racial, or gender-based. Little of the old order upon which design was built remains unaffected. Indeed, it would seem that the entire Western culture industry is challenged to defend, accommodate, or abandon the philosophical and pragmatic frameworks in which it presently operates.

Perhaps the most dramatic and sobering indices of global change are registered in the clinical statistics of demographers.

> By 2050, 8 billion people will populate the earth.... In thirty years, there will be 360 million inhabitants in China, 600 million more in India, and 100 million more in Nigeria, Bangladesh, and Pakistan. The population of Nigeria, which doubles every twenty-two years, will equal today's world population in 140 years. By 2050, the number of people of working age in the world will have tripled. More than half of the global population will then be urban, as compared to one third today.[4]

In the political theater, the disintegration of Yugoslavia begun in 1991 has become emblematic of the new tribalism that threatens statehood and the fabric of civilization in eastern Europe. The former Soviet republics maintain a fragile state of disunion, struggling with their own share of ethnic feuds; in India, Hindus threaten a Muslim minority with virtual extinction; and even the Velvet Revolution couldn't guarantee the union of Czech and Slovak peoples.

Nor is there a shortage of warnings about ecological endings. Indicative of their urgency is the dire admonition of Dr. Terry L. Erwin, an entymologist at the National Museum of Natural History, that "if the disruption of the ecosystem continues... within a few hundred years the planet will have little more than lineages of domestic weeds, flies, cockroaches and starlings."[5]

These pressures and countless other admonitions of impending global disaster, from AIDS to accelerated political terrorism, have helped to foment the late-twentieth-century condition of instability. This condition has found its own linguistic form of expression with the emergence of the critical modes of deconstruction and poststructuralism.

The postmodern proposition that all knowledge and value have no external reality but are socially conditioned has exerted a liberating influence on the norms of virtually every discipline and practice. But it has also generated tremendous insecurity, an uneasy sense of groundlessness. The resulting destabilization of language has been no less than Copernican in its decentering impact, ultimately rendering us less complacent about cultural hegemony.

The fact is that the dematerialization of products as a consequence of electronic digital technologies and the immateriality of chemical and biological processes all support the idea that our external reality is no longer entirely legible. Perhaps that is why we are more concerned with the fusion of internal and external realities. Increasingly there is a call for the recognition of the presentness of history and, by extension, for the presentness of the spiritual dimension of existence.

A closely protected optimism holds out that the current state of fragmentation will yield new visions—visions that reflect a more expansive, generous understanding of the world in the creation and generation of messages, objects, buildings, and cities. In the face of immense social, economic, and political upheaval, designers cannot resign themselves to being producers of mere merchandise, or they will be left designing the logotypes and the packaging for vapid products bearing the empty sign "Millennium."

In the face of discredited utopias and jaded dystopias, there is an irrefutable need for authentic engagement. Civilization depends upon it. So it is in a mood of apprehension and anticipation that we begin our ritualistic dance toward the edge of the millennium—moved by a vestigial faith in the redemptive possibilities of design and awed by the tasks that await.

— Susan Yelavich, editor

1 Martin Amis, *London Fields* (New York: Harmony Books, 1989), p. 118.

2 Norman Cohn, *The Pursuit of the Millennium* (New York: Oxford University Press, 1961), p. 19.

3 John Lukacs, "The End of the Twentieth Century," *Harpers,* January 1993, p. 40.

4 Jacques Attali, *Millennium* (New York: Random House, 1991), p. 76.

5 Quoted in William K. Stevens, "Species Lost: Crisis or False Alarm?" *The New York Times,* August 20, 1991, p. C-8.

The Apocalyptic Moment: Living in a Millenarian Culture

MICHAEL BARKUN

On September 26, 1991, four men and four women were sealed into a 3.15-acre complex of buildings in the Arizona desert near the aptly named town of Oracle. The structure, known as Biosphere 2, will have constituted their total environment for a two-year period, cut off from the rest of the world in all respects except for sunlight, electricity, electronic communications, and an airlock for use in emergencies.

The entry of the so-called Biospherians into their miniature world was a media event of considerable magnitude. *The New York Times* put the story on page one, under the headline "8 Seek Better World in a 2-year Ecology Project."[1] The idea of an ecologically purified future is a fitting reminder that this is no ordinary time—the "edge of the millennium." The years that remain before the year 2000 imply a special and intense attitude toward the future. As far as the Biosphere 2 project is concerned, it says more than it may intend about the nature of those attitudes.

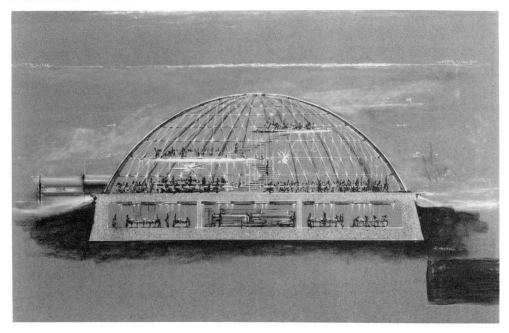

Russell Heston for Donald Deskey Associates, *Undersea Lounge: Scheme 3,* c. 1962.
Cooper-Hewitt, National Museum of Design, Smithsonian Institution.
Donald Deskey Collection, 1988-101-1502. Photo: Ken Pelka.

The approach of the year 2000 suggests to many that we are on the verge of sudden and dramatic transformations, changes appropriate to the beginning of the third millennium, the coming of which does indeed help stimulate expectations ranging from fears of world-destroying calamities to hopes of utopian perfection.

Yet appropriate as these emotions may seem to the "edge of the millennium," they are not limited to rare occasions such as this when we inaugurate a new thousand-year interval of calendrical time. Apocalyptic expectations—the belief that we face imminent world transformation—know no boundaries of history, geography, or culture. If we seem suddenly sensitized to new historic possibilities, so too were European peasants after the Black Death, English Puritans in the 1640s, and French revolutionaries in the 1790s—as well as the thousands of Native Americans who participated in the Ghost Dance in 1890 seeking the miraculous return of the buffalo, and the Melanesian islanders whose "cargo cults" have flared up in the South Pacific for the last century in search of the secrets of the Europeans' power. The present may therefore seem to be a special time, like no other in the past thousand years, but it is in fact not unique. What we have seen thus far, and what we may expect to see as the decade plays itself out, is a wave of millenarian expectations similar to those which have occurred many times in the past, in America and elsewhere.

The Branch Davidian standoff outside Waco, Texas, suggests both the power and the dangers of millenarian beliefs. On the one hand, it dramatizes the ability of millennialists to lay all other loyalties aside in the quest for transformation. At the same time, it demonstrates that such expectations can trigger confrontations with those who represent the established order. The Waco tragedy lay in the manner in which the Branch Davidians and the government fulfilled each other's expectations in a spiral of self-fulfilling prophecies: the Branch Davidians behaving as the authorities expected "cultists" to act; the authorities unthinkingly playing out the adversarial role cast for them in the Koreshans' millenarian script.

In fact, intimations of the apocalypse have seized the American consciousness every thirty to fifty years since the beginning of the republic, in a series of millenarian waves, when large numbers of people awaited some momentous shift in the social order. We are now in the midst of such a wave, the longest such flirtation with the idea of the millennium

16

in American history. It began with the upheavals of the late sixties and has continued for the last quarter century, encompassing new religious "cults," the resurgence of fundamentalism, and political sectarianism of the left and right. It is the fourth such wave in the last two centuries. The first peaked in the 1830s and 1840s during the tumultuous social changes associated with Andrew Jackson's presidency. A second, weaker wave crested a half century later, in the 1890s, in a nation coping with urban growth, industrialization, and mass immigration. The third wave came, not surprisingly, in the 1930s when Americans sought panaceas for economic and social crisis.

These earlier millenarian eras fed conspicuously on economic turmoil, from the Panic of 1837, through the downturn of the 1890s, to the Great Depression. The current millenarian wave, however, has thrived equally in the prosperity of the mid-eighties and in the contractions of the early nineties. One reason for its ability to sustain itself in good times as well as bad is the undercurrent of awareness and concern about the year 2000, the sense that this date must surely be associated with apocalyptic change.

At one level this is an irrational expectation, for the numbering of a year should have little to do with its character. Indeed, if any year had a claim to being considered an *annus mirabilis*, it should have been 1991, when the Soviet Union disintegrated. But, paradoxically, even that dramatic rupture and the subsequent political cataclysms will only heighten interest in the year 2000—on the theory that if such stunning changes can take place at the beginning of the decade, how much more remarkable will be those at the decade's close.

Our culture has made us prisoners of the decimal system, and with it the peculiar and deep-seated belief that years ending in zero have a special status as historic watersheds. Thus, whether the year 2000 has any intrinsic importance turns out to be irrelevant, for it becomes important when enough people *believe* that it signifies something. In that sense, the rhetoric generated by the year 2000 creates its own self-fulfilling prophecies.

That also explains why it is fruitless to argue, as some have, that the millennium will not really end until December 31, 2000.[2] Mathematics to the contrary, by common consent December 31, 1999, remains the accepted dividing line, for the issue is one of symbolism, not calculation.

What climate of expectation is this apocalyptic time likely to bring? Times of millenarian excitement are periods of both extravagant hopes and equally extravagant fears, when collective moods swing wildly between extremes. This is so because belief in the millennium is often, paradoxically, linked to expectations of disaster. Those who anticipate a totally transformed future often believe life will get worse before it gets better. Wrenching cataclysms must precede the emergence of a perfected social order. This linkage of disaster with the millennium is, in part, a measure of alienation from the existing society viewed as corrupt beyond any possibility of reform and therefore doomed to destruction. In part, it is a wish to begin with a clean slate from which all traces of old ways have been expunged; and, in part, it is a desire to locate markers on the road to the final consummation.[3] Disasters, by their magnitude and drama, function admirably as such signposts, so that they are simultaneously objects of dread and of giddy anticipation.

Millenarians have been preoccupied with images of disaster—with earthquakes (historically the great favorite), volcanic eruptions, plagues, storms, and famines. In a preindustrial age, when the ability to control nature was limited, the millenarian imagination associated the end of history with nature on the rampage, believing that natural disasters were a primary sign that the millennium was at hand. The predilection for such symbolism has waned over the last two centuries, but it is safe to say that if and when California experiences "the big one," some will conclude that the end is near.

In the traditional view, acts of God would warn humanity that the latter days were coming, and that the forces of nature would destroy existing human institutions. But this approach was radically challenged by the rise of science and technology. In the first place, science largely demystified natural calamities, so that it was more difficult to see the hand of God in them. In the second place, greater knowledge of, and control over, natural forces made most such disasters predictable or preventable. In short, it became harder to assign them a central role at the end of history.

At the same time, the scientific and technological progress that diminished the significance of natural disasters also had the capacity to improve the condition of human life. It was tempting to think of this new manipulative power as sufficient to produce the perfected plateau of existence that would constitute the millennium. In fact, by the nineteenth century, even some religionists had ceased to believe that human history would end

LEFT: G. Brad Lewis, *Evening Splendor*. Hawaii National Park, 1991.

RIGHT: *Dawn of a New Day*, record album. The Queens Museum of Art, Queens, New York.

Photo: Alan Law.

through divinely induced cataclysms. Instead, it seemed plausible to both believers and nonbelievers alike that the very forces that had unmasked and subdued nature would eventually produce a perfected human society. As a result, belief in a millenarian future could now take secular as well as religious forms. Hunger, disease, backbreaking labor, and every other human ill would sooner or later fall before the forces of scientific prediction and technological control. One problem after another would be solved, and society itself would become a rational, harmonious organism designed to produce the elusive goal of human fulfillment.

This vision, suggested by such early-nineteenth-century social reformers as Robert Owen and Charles Fourier, took increasingly tangible forms. The utopian communities created by the followers of Owen, Fourier, and people like them aimed to create millenniums-in-miniature—consciously invented societies that would simultaneously grant their members a fulfillment that normal life could not, and would teach the larger order how to restructure itself.[4] Owen's most famous community, New Harmony, Indiana, grew out of his purchase of the buildings of an earlier communal experiment established by the Rappites, a German pietist sect. While New Harmony lasted less than a year as a utopian community, its buildings remain, both those Owen purchased from the Rappites and those erected later. Today they stand adjacent to two monuments of modern design, Richard Meier's Atheneum, and Philip Johnson's Roofless Church.

But the most vivid expression of this technological millennialism took the form of the world's fairs that exemplified this new optimism and confidence, from the Crystal Palace in London in 1851, to New York in 1939.[5] Their ever more futuristic visions laid out a coming age of peace and plenty made real by a messianic engineering prowess. No fair since the end of the Second World War has kindled quite the same excitement as those during the more innocent and confident age that preceded it.

For, once again, perceptions of technology have changed. Once seen as a positive, inexorable force capable of producing the millennium—what world's fair showmen liked to call "the world of tomorrow"—technology has largely lost its image as a redemptive force. In a more cynical or perhaps merely more chastened age, longing for the millennium

remains, but fewer believe that technology will produce it. If anything, technology is increasingly expected to produce the very disasters that will eventually destroy the old order. Whereas history was once expected to end with earthquakes, it has now become fashionable to picture the end as technology run amok.

I need do no more than suggest a few of the scenarios of manmade disaster that have now become common currency: environmental pollution and runaway economic growth that will make human life on earth insupportable; population growth that will outstrip food production in a Malthusian spiral; or a world financial collapse. Whatever the actual probability of any of these forecasts, their plausibility increases with every Three Mile Island, Bhopal, or Exxon *Valdez* incident, or, for that matter, with an intractable recession.

Despite the dramatic change in the character of U.S.–Soviet relations, nuclear weapons remain a major symbolic focus of technological fears. They have long had a prominent place in the apocalyptic futures projected by such secular writers as Robert Heilbroner and Jonathan Schell. What is less well known is the prominent role they continue to play in the millenarian scenarios of Christian fundamentalists. Few works by advocates of nuclear disarmament contain so chilling a description of nuclear war as that found in *The Late Great Planet Earth*, the leading paperback nonfiction bestseller of the 1970s by fundamentalist author Hal Lindsey.[6] The major difference between fundamentalists and their secular counterparts, where nuclear war is concerned, is the religionists' conviction that if nuclear war occurs, it will be an unpreventable act in fulfillment of God's will.

These expectations of disaster exist in a reciprocal and symbiotic relationship with the idea of the year 2000. On the one hand, predicted disasters in close proximity to the year 2000 seem to buttress the belief that the date does indeed signal cataclysmic change. On the other hand, the closeness of the year 2000 leads us to expect ferocious upheavals, sensitizes us to look for clues to their onset, and therefore validates prophecies of imminent calamity.

Although millenarians have provided ample graphic descriptions of preliminary upheavals, they have typically been vague about the details of the perfected society they anticipate. To the extent that this millennial future *can* be described, its outlines reflect a hostility toward technology and the features of modernity associated with technology:

economic growth, consumer society, and urban life. However much religious and secular millenarians may differ, they share a distaste for the commitments to rising productivity and large-scale social organization that have dominated the West since the Industrial Revolution. The world they yearn for is a romanticized preindustrial world of intimacy, spirituality, and rootedness in nature, a return to an Eden or an Arcadia, a mythic rather than a historic past.

This millennialism of nostalgia makes the city a special target, a symbol of evil and decay for both religious and secular apocalyptic visions. To fundamentalists, it is a place of vice and crime, where sexual immorality and mindless violence flourish as they did in the biblical "cities of the plain." To them, the AIDS epidemic is God's judgment on a sinful world, a view shared, incidentally, by some extreme environmentalists who preach a secular gospel of small, dispersed populations, where viruses and microbes would enjoy the same "rights" as other life forms.[7] But in fact, most nonreligious apocalyptic visions concentrate on other aspects of modern urban life. They view the city as both a profligate wastrel, expending scarce energy resources with no eye to the future, and as an equally prolific polluter befouling the ecosphere. Thus, whether the judgment is rendered in religious or secular terms, the city epitomizes all that millenarians wish to see expunged. In this they draw, however unknowingly, on an old and powerful American distaste for urban life, a tradition that goes back to Jefferson and to which generations of American millenarians have contributed. Near the end of the nineteenth century, the social reformer Henry George saw the cities of his day as:

> These vast aggregations of humanity, where he who seeks isolation may find it more truly than in the desert; where wealth and poverty touch and jostle; where one revels and another starves within a few feet of one another.... Let jar or shock dislocate the complex and delicate organization, let the policeman's club be thrown down or wrested from him, and the fountains of the great deep are opened, and quicker than ever before chaos comes again. Strong as it may seem, our civilization is evolving destructive forces. Not desert and forest, but city slums and country roadsides are nursing the barbarians who may be to the new what Hun and Vandal were to the old.[8]

The desire for rootedness in nature seems to mandate abandonment of the city's artificially constructed environment. Like the seventeenth-century English millenarian Gerrard Winstanley, some contemporary fundamentalists see the millennium as the lifting of "Adam's curse" off the physical world.[9] One fundamentalist writer promises that "the desolate lands... will become like the garden of Eden," while another predicts that "this tired and abused planet" will be "born again."[10] Pat Robertson predicts that in the millennial age, the saved will be empowered to spiritually control geologic faults and prevent earthquakes.[11]

To those of a more secular bent, in a world on the verge of ecological collapse, the stimulation and gratification of material appetites is both imprudent and immoral. Hence

21

the quest for spiritual enlightenment, personal fulfillment, and aesthetic satisfactions as new ideals that require separation from a contaminating present.

Where earlier millenarian visions promised plenitude, this one offers asceticism. It may be found in both religious and secular forms: in Alexander Solzhenitsyn's 1978 Harvard commencement address, "World Split Apart"; in Ernest Callenbach's influential environmentalist novel, *Ecotopia*; in the writings of religious millenarian survivalists who seek sanctuaries in the countryside so that they can ride out the tribulation; and in the rhetoric of the New Age.[12]

How deeply are these values of antitechnologism, antimaterialism, and harmony with nature likely to affect American society? It must be said at the outset that relatively few will take these beliefs to their logical conclusions—that is, either withdrawing from the larger society into small, self-sufficient communities, or trying to accomplish the total transformation of existing institutions. Both approaches involve high risks and demand the radical renunciation of traditional ways of life. For these reasons they will attract only the most committed.

Nonetheless, an examination of earlier millenarian periods shows that the idea of imminent transformation can deeply influence many who are unable or unwilling to completely accept the implications of an apocalyptic world view. Thus, in 1844, when the followers of William Miller awaited the Second Coming throughout the Northeast, there may have been, as Miller himself estimated, no more than 50,000 committed adherents willing to act on the assumption that normal ways of life were about to be extinguished forever. But letters, newspaper accounts, and memoirs make clear that virtually every informed person was aware of the movement, including many skeptics who still held open the possibility that Miller's predictions might be correct. Sensational press accounts told of Millerites standing on rooftops in white "ascension robes" awaiting translation to heaven, and of Millerites going mad when the great event failed to take place—folklore as colorful as it was unfounded.[13]

Today ideas on the "fringe" of respectability migrate even more rapidly into channels accessible to the general public: through the media with its insatiable appetite for the new

William Blake, *The First Book of Urizen,* Plate 11, 1794. The Pierpont Morgan Library, New York, PML 63139.

and bizarre; through the technology of desktop publishing, which allows small coteries to reach wide audiences; and through conferences, workshops, and retreats, which allow individuals to sample unconventional ways of life without abandoning traditional jobs, families, and lifestyles, suggesting new variations on American pluralism, based neither on religion nor ethnicity, but upon different attitudes toward change and the future.

The "apocalyptic moment," then, turns out to be an extended period, spreading over the roughly two-generation span from the mid-1960s to the year 2000. It is composed of seemingly incompatible elements—political radicalism of the left and right, environmental militancy, fundamentalist religion, sober scholarly analyses of future trends, and New Age lifestyles. The issues that divide such groups are sometimes profound, and quite understandably they often see little or nothing in common with one another. Yet they are joined by beliefs that transcend their differences—a suspicion that technology will produce more harm than good, leading perhaps to the kinds of world-shattering disasters once identified with natural calamities; an identification of the city with sins and problems so massive that remedial action is pointless; a longing for a simpler and purer life close to nature; a renunciation of acquisition and consumption in favor of intangible values, whether in the form of piety, enlightenment, or harmonious interpersonal relationships; and an attraction for small social units where face-to-face contact and relationships of intimacy prevail.

It need hardly be said that just as one person's heaven can be another's hell, so this is not a millennium to everyone's taste. Indeed, many might see it as a regression to a social order dominated by conformity and a new tribalism. But millennialism has always been a matter of taste, beckoning some while repelling others.

This spare and dematerialized vision might seem to have little to do with the glittering domes and skylights of Biosphere 2, especially since the project has eaten up a reputed $150 million of Edward Bass's oil money, much of it to develop sophisticated technologies that will allow Biosphere's environment to operate independently. Nonetheless, there is in reality no better exemplar of the current apocalyptic mentality.

In recent statements to the media, the project has been justified in fairly mundane terms, as a particularly audacious route to the technologies that may enhance the environment as well as prove commercially marketable. In fact, the project's publications in the early and mid-1980s, when it attracted much less attention, were decidedly apocalyptic. One goal was to perfect techniques that would allow the construction of underground refuges where small communities could survive nuclear war—the same goal as may be found in a hundred survivalist manuals about how to construct a fallout shelter and store canned goods, but on an altogether more sophisticated level. Alternatively, the project was to be a step in a mystic process of space exploration and colonization, which would, in the words of Biosphere's leading figure, John Allen, help realize "Man's destiny," instead of submitting to the "fate, which we daily endure… to be lost in time, separated in space, entropic in energy and information, limited in matter, deficient in data, uncertain in perspection [*sic*], and certain only of continuing folly."[14]

As has now been widely reported, the views of John Allen, the project's guiding spirit, were already well formed in 1969, when he and the group he then led established a commune called Synergia Ranch near Santa Fe, New Mexico. When the distinguished historian Laurence Veysey visited the ranch for five weeks in 1971, he found Allen articulating the millenarian vision that would eventually take form twenty years later in Biosphere 2. It was the same vision I have been characterizing as both typical and symptomatic of the present period.

Convinced as a result of the upheavals of the late sixties that America would be destroyed in an ecological calamity, Allen and his followers believed they constituted the elite that would escape the disaster in order to create a new planetary civilization as the next stage in human evolution. Building upon such diverse sources as Buckminster Fuller and the Russian mystic Gurdjieff, Allen envisioned this new civilization as a world without cities, in which small, self-contained rural communities would allow individuals to reach hitherto unavailable levels of enlightenment.[15]

The content is unremarkable and now is the common currency of much New Age millennialism. This version, however, stands apart because it has had access to the financial resources necessary to realize it in a dramatic manner. And it is sufficiently in tune with the semiconscious attitudes of large numbers of Americans, so that it has generally been met with curiosity and respect rather than disinterest and ridicule.

Biosphere 2 may appear to be the antithesis of the apocalyptic visions described here, for it seems to represent the exaltation of technology, not its renunciation. Yet in a larger sense it is of a piece with antitechnological millennialism, for it harnesses high technology to create a world in which technology will no longer be necessary and small, self-sufficient groups with modest material expectations will live in harmony with the natural environment. Thus, Biosphere 2 is the perfect metaphor for the contemporary millenarian quest.

How that quest will end, whether in disillusionment or fulfillment, lies beyond our capacity to foresee. But its antiurban bias and its distrust of modernity are real enough. In subtle and indirect ways it will help shape this decade, and whether or not yearnings for an Arcadian paradise are satisfied, we will all be involuntary passengers on the journey.

24

1 *The New York Times,* September 27, 1991. There have been numerous allegations that, since the closing of Biosphere 2, its closure has been compromised by unpublicized additions of supplies, outside air, and air-cleaning machinery. *The New York Times,* January 26, 1992.

2 Hillel Schwartz, *Century's End: A Cultural History of the* Fin de Siècle *From the 990s Through the 1990s* (New York: Doubleday, 1990), p. 27.

3 I have examined the relationship between disaster and millenarian movements at greater length in *Disaster and the Millennium* (New Haven, Conn.: Yale University Press, 1974; Syracuse, N.Y.: Syracuse University Press, reprinted 1986).

4 This point is made forcefully by Arthur Bestor in his essay "Patent Office Models of Society," reprinted in Bestor, *Backwoods Utopias: The Sectarian Origins and the Owenite Phase of Communitarian Socialism in America: 1663–1829,* 2d ed. (Philadelphia: University of Pennsylvania Press, 1970). I discuss the relationship between millennialism and utopian communities in *Crucible of the Millennium: The Burned-Over District of New York in the 1840's* (Syracuse, N.Y.: Syracuse University Press, 1986).

5 Paul Greenhalgh, *Ephemeral Vistas: The Expositions Universelles, Great Expositions and World's Fairs, 1851–1939* (Manchester, England: Manchester University Press, 1988).

6 Hal Lindsey, with C. C. Carlson, *The Late Great Planet Earth* (New York: Bantam Books, reprinted 1973). Sales figures for Lindsey's book were reported in *The New York Times Book Review,* April 6, 1980, p. 27.

7 Miss Ann Thropy (pseud.), "Population and AIDS," *Earth First!* 7 (May 1, 1987), p. 32. I am indebted to Martha Lee for bringing this citation to my attention.

8 Henry George, *Social Problems* (1883), in *The Complete Works of Henry George* (Garden City, N.Y.: Doubleday, 1911), p. 6.

9 For Winstanley's view of Adam's curse, see Christopher Hill, *The World Turned Upside Down: Radical Ideas During the English Revolution* (New York: Viking, 1972), p. 236.

10 The first comment is Jim McKeever's; the second, George Otis's. Similar views have been expressed by John F. Walvoord. All appear in Jim McKeever, *Christians Will Go Through the Tribulation And how to prepare for it* (Medford, Ore.: Omega Publications, 1978), pp. 300–307.

11 Pat Robertson, with Bob Slosser, *The Secret Kingdom,* expanded ed. (Nashville: Thomas Nelson, 1987), pp. 247–248.

12 Alexander Solzhenitsyn's Harvard Address appears in *Solzhenitsyn at Harvard,* ed. Ronald Berman (Washington, D.C.: Ethics and Public Policy Center, 1980). Ernest Callenbach, *Ecotopia: The Notebooks and Reports of William Weston* (New York: Bantam Books, 1977).

13 Barkun, *Crucible of the Millennium,* pp. 31–46.

14 John Allen and Mark Nelson, *Space Biospheres* (Oracle, Ariz.: Synergetic Press, 1986), p. 86.

15 Laurence Veysey, *The Communal Experience: Anarchist and Mystical Counter-Cultures in America* (New York: Harper and Row, 1973), pp. 279–406. Veysey's lengthy description of Synergia Ranch masks the identities of participants and refers to John Allen as Ezra. However, Veysey has subsequently been quoted as confirming that Allen and Ezra are one and the same and that the Synergia Ranch group is the core from which the Biosphere project developed (*The New York Times,* May 27, 1986). A highly critical account of Biosphere based on Veysey's earlier research appears in Marc Cooper, "Bursting the Biosphere Bubble," *The Village Voice,* April 2, 1991.

25

LEFT: Donald Lipski, *Waterlilies #47,* 1990. Galerie Lelong, New York.

The End

KARRIE JACOBS AND TIBOR KALMAN

"The End" was commissioned for Cooper-Hewitt, National Museum of Design's 1992 conference
"The Edge of the Millennium."

This year it's 1992.
But not for everyone.
For the Muslims it's 1412.
For the Jews it's 5752.
For David Duke it's 1952.
For Shirley MacLaine it's hard to say.
For Philippe Starck it's 1937.
For Robert A. M. Stern it's whatever year the client wants it to be.
For Prince it will always be 1999.
Any excuse for a party.

We're going to have to be very arbitrary. After all, this is a very arbitrary event. The idea that we are approaching the millennium is based on one calendar, one system of counting the days since the beginning of time.

Time is endless, but because every so often we come to the end of something—a week or a year or a decade or, less frequently, a millennium—we're allowed a sense of closure. We say, "Thank God it's Friday." We sing "Auld Lang Syne."

In fact, there is no closure.

However, speaking culturally... and personally, we are willing to play along.

We're caught up in the millennial spirit. We enjoy closure. Come the turn of the millennium you'll find us glued to the TV watching *A Thousand Years of Bloopers, Blunders and Practical Jokes* hosted by Ross Perot and Mikhail Gorbachev.

The millennium, like the decade, is a completely capricious way of grouping years. It makes a nice packaging concept for conferences, television specials, "best of" lists, and, of course, books.

In the old days, eight or nine hundred years ago, when they held a conference in anticipation of the millennium, it usually consisted of a bunch of religious zealots with scourges—nail-studded whips—standing in a town square flagellating themselves. Even today, conferences are characterized by a certain amount of self-flagellation.

And the millenarian cults of the past, the people who believed that the world would end after a thousand years time, weren't looking at the calendar. Not this calendar, anyway. They had their own cycles and prophecies that told them: "Now it's time to go wild. Now it's time to crusade. Now the end is near."

They found the idea that the world was coming to an end... reassuring. Life in the Middle Ages didn't provide much comfort for most people. Life was tough. There were terrible famines. The plague kept coming back, killing nearly half the people in Europe in the fourteenth century. If the world would just hurry up and end, everyone—at least the true believers—could go on to the next world, where things would be much, much nicer.

The end of the world, then, from the point of view of the medieval serf, meant progress.

The cultists of the Middle Ages—with their desire to wipe away the world they knew, the old world, and go on to something

27

LEFT: *New Year's Eve with Guy Lombardo*, 1972. Photofest.

ABOVE: *The Crusades*, 1935. Photofest.

clean, pure, and beautiful—were the modernists of their day. They were led by visionaries like Peter the Hermit or Betrand of Ray, much as we were led by visionaries like Gropius or Corbusier.

Today, as in the old days, good millenarians are always ready for the "big one." Whether through wholesale slaughter or wholesale purchases of canned goods, millenarians are preparing for the apocalypse. This is a tradition.

And in a funny way we are traditionalists. So we have one message: the end is near.

The end of what? The end of civilization? The end of an era? The end of trickle-down economics? The end of the baseball season?

The end of this essay?

Along with architects, product designers, graphic designers, and all sorts of academics and critics, we've been asked to make connections between design and the arrival of the year which, in living memory, has been synonymous with the idea of the future.

The year 2000 is coming. The future is not very far away at all.

28

But how does this relate to design?

Designers are no slouches. They know their marketable concepts. The design profession is already doing its part to make the millennium a memorable event—like the Bicentennial or the 100th birthday of the Statue of Liberty or the Persian Gulf War—complete with a logo, T-shirts, and souvenirs.

But that's not what the millennium is about. Not traditionally. The millennium, whenever it takes place, is a time for cataclysm. The millennium is a time for something big, something momentous, something scary.

So we want something momentous to happen in design too. Something that won't change the future of design, but will change the future. Period.

But before we look forward to the future, we need to look at the past. Who do we think of when we think of the history of design? Raymond Loewy? Walter Dorwin Teague? Ray and Charles Eames? Le Corbusier? El Lissitsky? Joe Colombo?

Among designers, these people are considered gods. But most people have no idea who they are.

So have designers really changed anything, besides design? And if not, who really changed the world?

There are some obvious answers: Christopher Columbus, Adolf Hitler, Johnny Carson.... And then there are answers that serve to expand the meaning of the word *designer*.

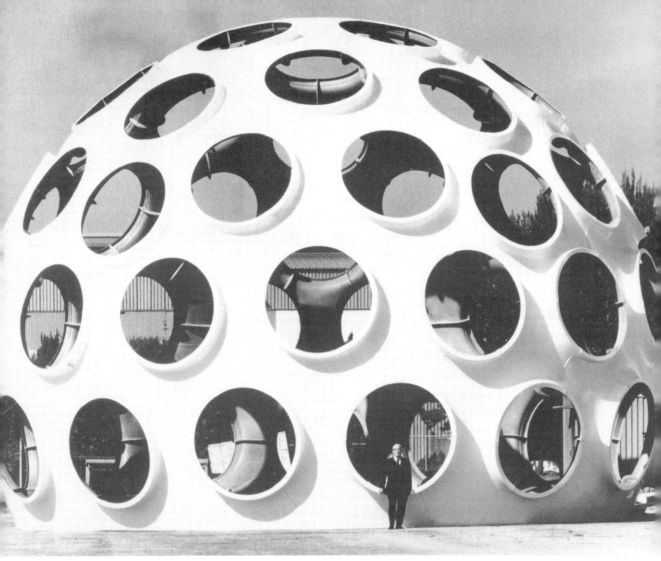

For example, there's Villard de Honnecourt, the thirteenth-century architect and engineer. He designed cathedrals, bridges, a water-powered saw. He may not have been the best medieval architect, but he left behind a sketchbook full of drawings of his ideas and inventions—like the earliest representation of clockwork—that were studied for hundreds of years after his death.

But if design is about changing things, really changing things, we might consider Denis Diderot, who, as one of the leading thinkers of the Enlightenment, wrote plays and criticism of government, religion, and art. Diderot believed that knowledge was the best weapon against theocracy and monarchy. His life's work was designing a monumental encyclopedia in which he hoped to compile all the world's knowledge.

And there was Diderot's contemporary, Benjamin Franklin, who was a printer, which would make him a graphic designer, wouldn't it? And an inventor who designed things,

R. Buckminster Fuller in front of 50-foot-diameter *Fly's Eye Dome,* 1979
(from Monohex U.S. Patent #3,197,927). Copyright 1983 Estate of Buckminster Fuller.
Buckminster Fuller Institute, Los Angeles.

like a more efficient wood-burning stove. He was also a statesman, helping Jefferson design the Declaration of Independence and, as an ambassador, designing a settlement with the British.

And then there's Mary Shelley, the designer of Frankenstein and creator of the idea of science fiction. If we credit William Gibson, author of *Neuromancer*, with the invention of cyberspace, we have to credit Shelley with the invention of William Gibson. Also, we shouldn't leave out Buckminster Fuller. He made things: the geodesic dome, the dymaxion car, the 4-D house. When you read him you realize that he wasn't just a designer, but also a philosopher and a mad scientist. And mad scientists are much more powerful and important than the sort of designers who are popular in design management circles.

None of the people we have just discussed fit neatly into the narrow vocation we now call design.

It used to be that there were inventors and philosophers and political leaders and artisans and artists. Sometimes all of these professions were embodied in one person. And these people had a profound influence on the quality of the world. They were significant. They were not the sort of people you read about only in trade publications. And if we think of design as innovation that significantly changes the world, then these people were designers.

But that's not how design is defined.

It's defined as something much narrower.

31

Sometime after the Industrial Revolution added steam to the making of things and before the machine age became a style, a new profession emerged, one that promised to blend the intuitive qualities of the artist with the pragmatism of the engineer. This new field was called the applied arts or commercial arts. It was the profession of making faster and better.

The new profession was design.

Designers believed that the perfect balance of art and industry could make things that would give people better lives.

Many designers still believe that.

But the balance doesn't exist anymore. And it probably didn't really exist then either.

Design was okay, though, because it gave people who were artistically inclined a respectable vocation.

Design, for a minute or two, seemed like the perfect balance of commerce and culture. The ultimate multidisciplinary profession. But something changed. And it wasn't design. It was the world.

32

LEFT: *Notre Dame Cathedral*, Paris. Photofest.

RIGHT: Mies van der Rohe, *Seagram Building, New York*, 1958. Copyright 1991 Ezra Stoller/Esto.

It was the end of the world.

The Second World War was the end of one world and the beginning of another. It shook things up but good.

So in the late twentieth century, all of society's hard and fast rules dissolved. Which, by and large, was a good thing. The traditions and social structures that kept African Americans out of schools and lunch counters, Jews out of country clubs, and women out of the workplace began to collapse.

Still, packed inside all the cultural baggage we tossed out was some good stuff. Woven through that rigid old fabric were the threads that held our culture together: our common assumptions, our shared goals, the secular religion in which we, theoretically, believed.

It's almost impossible to list the things that we shouldn't have tossed away because we'll wind up sounding like Ron and Nancy. Somehow all the wrong people have appropriated words like *values*, *integrity*, and *decency*.

At any rate, after the big shakeup after WWII, the only common denominators we had left were corporations. And advertising. And products.

Things became the only things that we, as a culture, share.

Products have a new role. Instead of being things that we buy to perform a task, they are things that we buy to define who we are. And designers, who give products the characteristics that set them apart from other products, have become, purely by default, the priests and philosophers of our corporate culture.

We're not saying that designers are deep. We're saying that our culture is shallow.

If we look at the last thousand years of design history, we notice that at a certain point real innovations give way to commercial affectations.

33

Michael Graves, *Walt Disney World Swan Hotel,* detail, 1990. Michael Graves Architect.
Photo: Steven Brooke.

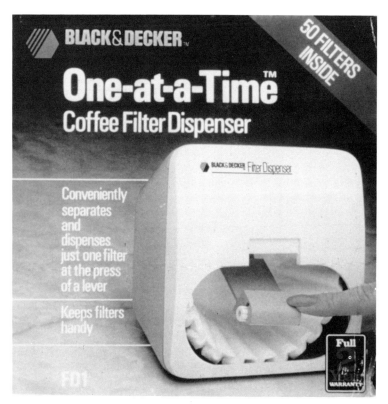

Designers say they're professional problem solvers. Here are some problems:

1. In 1991, 6,019 people were wounded or killed by gunfire in New York;
 530 were children.
2. The number of U.S. welfare recipients increased more in 1990 and 1991
 than in the previous 16 years combined.
3. One of every 53 New Yorkers is infected with the HIV virus.
4. Each day some 137 species become extinct mostly because of rain forest destruction.
5. Coffee filters are often a hassle to pull apart.

Which one of these looks like a design-sized problem?

Well, here's the solution: the One-at-a-Time Coffee Filter Dispenser from Black &
Decker.

1. Just depress lever with the adhesive roller until it touches the top filter. Quickly
 release lever.
2. The roller lifts the top filter and pushes it forward.
3. Simply pull the filter out!

34

One-at-a-Time Coffee Filter Dispenser, Black & Decker. Photo: Tom Mylroie.

Operating Knob

ONE SLICE

AC Power Cord

Crumb Tray

Shade control knob

One-at-a-Time exists because Black & Decker held consumer focus groups on the subject of coffee making. It seems that people kept complaining about the difficulty of separating coffee filters. The company thought, "Maybe there's a chance that a product that solved that problem would be of benefit to the consumer."

We look at this sad object, this example of industry for industry's sake, and assign it a meaning. Even if it serves no real purpose, we can give it symbolic value. We can take this object and turn it into a symbol for the decline of civilization.

We hereby declare the One-at-a-Time Coffee Filter Dispenser emblematic of everything that is wrong with society in general and the profession of design in particular.

Design has become the profession of solving very small problems. Larger problems are left unsolved because everybody is too busy designing.

Design affects the things we come into contact with every minute of our lives. And often those things contribute to our ideological framework.

For some people, the objects in their lives—their car, their clothes, their television, the cash machine, the office copy machine, the Coke machine—provide their entire ideological framework, and the designers of these things do, in fact, supply a sort of philosophy or religion for these people.

Take the most mundane, everyday object: a toaster. When most of us think of the word *toaster*, we picture a stainless steel box with a surface so shiny we can see our reflection while we're waiting for the toast to pop. But if you look at the toasters they're selling at Macy's these days, you'll notice that a lot of them are white. White plastic.

Given our assumption that designers are philosophers by default, it would be appropriate if some industrial designer at DeLonghi or Toastmaster had said, "I want to design a

35

Toaster Parts Identification Diagram.
Cooper-Hewitt, National Museum of Design, Smithsonian Institution.

toaster that will change what people see first thing in the morning. I'll make it white to symbolize technological purity."

It would be sweet if designers actually thought about toasters as Lisa Krohn and Michael McCoy do in their essay about product semantics: "This toaster celebrates the everyday act of making toast. Its axial symmetry suggests ceremony, while the bread-shaped toasting chambers, their aluminum fins evoking waves of heat, encapsulate the process of toastmaking."

But the philosophical outlook of design is a bit more pragmatic.

The only reason toasters are now white and, as it says on the box, "cool to the touch," is that they give people a reason to buy a brand-new state-of-the-art toaster.

Corporations may understand the value of design even better than designers. They know that it's cheaper to change the design of something than to change what that something actually is.

Now more and more of our culture is designed. Just like toasters, and with about as much cynicism.

ELECTRONICS—A NEW SCIENCE FOR A NEW WORLD

Design has become the significant creative act of our day. Music isn't composed, it's designed. Movies aren't scripted, they are designed. Books aren't written, they are designed. Political views aren't formulated over a lifetime of experience, they are designed.

The concern is style, not content.

The ongoing struggle to assign meaning to design starts to become funny. Like, hey, what does that electric can opener signify? What does that coffee maker really mean? What is the belief system of that food processor?

But in a way it's not a joke. Because all these appliances are part of a belief system that says that progress—increased efficiency, increased convenience, and higher technology— is the greatest good.

In the twentieth century, at the tail end of the second millennium A.D., we believe—we still believe—in progress, that a steady stream of technological improvements will take us to the next world where everything is better. Progress is our crusade, and in our crusade— our sacred mission to wipe out the infidels—we are every bit as fanatical, ruthless, and tragically misdirected as our medieval predecessors.

Let's just say, for the sake of argument, that there was no such thing as design. What would that mean?

There would be no books like this one. No more magazines with pictures of objects that no one uses and buildings that will never be built.

It sounds terrible. We would all wither away and die. It would be... the end of the world.

What if the kind of design we have today, the vocation, never existed? What if all the high-minded style czars—Frank Gehry and Philippe Starck—as well as the corporate serfs (responsible for coffee filter dispensers) vanished all at once? What if Raymond Loewy and Marcel Breuer had gone, respectively, into dry cleaning and orthodontics?

Maybe it wouldn't be the end of the world.

Maybe it would just be a different world.

If this were a different book, we might be talking about scientists and the millennium, or lawyers and the millennium. Both are professions that, like design, have grown up to be servants of business. And we might advocate the same fate for those professions as we're advocating for design.

LEFT: Herbert Bayer, *General Electric Brochure,* cover, 1942.
Herbert Bayer Collection and Archive, Denver Art Museum.

What we're talking about is balance.

Think of society as a magazine. In a magazine there's advertising and there's editorial. In a good magazine there's a balance between the two. But society today is like the October issue of *Vogue*. The advertising far outweighs the editorial content.

We want to restore the balance between the real culture (and politics and civilization and health care and housing) and the corporate culture. We think that designers, who could have—at some point long ago—thrown their weight on the real culture side of the scale, have instead made the corporate culture side very heavy. Because what designers have done is devoted all their creative power to making the corporate culture seem more beautiful, more seductive, and more real than the real culture.

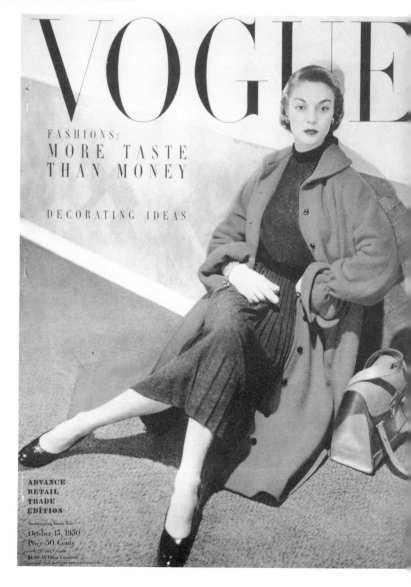

And we find ourselves in a position where the real culture can't survive without the financial support and imprimatur of a Mobil or a Philip Morris.

Worse, as the federal government's commitment to public education has dwindled, corporations have begun to take up the slack. More and more, companies like Whittle, who are willing to provide financially strapped school systems with much-needed equipment, are also setting the tone of the curriculum. Corporate culture is being taught in the schools to the children. Call it designer education.

We understand that design is a symptom rather than a root cause of many of the problems we've described. But we believe that one way to rebalance the culture, to make it so that the real culture has a competitive edge, is to eliminate design. Not the activity of design, but the profession. The one that provides creative services to business.

We have a modest proposal.

Why don't we get rid of graphic design
and industrial design
and architecture
and interior design
and even interface design?

Design Trends International Inc
214 W 39..302-4603
Design Trends International Inc
239 W 39..302-0487
Design 24 70 W 36.....................947-7988
DESIGN 2000 INC 110 Greene. 334-6211
Design Works International
230 W 39..719-2222
Design Works Kitchen Center
150 E 58..838-2812
Design Zone 1407 Bway...................704-4280
Design 4 80 4 Av.......................254-9200

LEFT: *Vogue* cover, October 1950. Courtesy of *Vogue*. Copyright 1950 (renewed 1978) Condé Nast Publications, Inc. Photo: Horst.

ABOVE: *Design 2000,* Manhattan telephone book. Photo: Tom Mylroie.

For a long time we have been arguing that design is a significant force by nature of its ubiquity. It's everywhere. So it must be important. It influences all our lives all the time. And so we've argued for design to be socially responsible. And smart. In the hope that the design of everyday things would begin to have an intellectual and social role that transcends its purely commercial purpose.

But now we are approaching the problem differently.

We're conceding the obvious. That design is just design.

Design is taking up space. And brains. And talent. And money. And if it weren't there, maybe there would be something else.

If there weren't so much style, maybe there would be time for more content.

So, in the apocalyptic spirit of the millennium, we are calling for the end of design.

40

Roy Lichtenstein, *Bauhaus Stairway,* 1988. Copyright Roy Lichtenstein.
Courtesy of the artist.

We are not, by the way, calling for the end of visual culture or a ban on bright colors.

Pictures often convey messages, and words—ad copy, for instance—can be completely devoid of meaning.

We're not calling for a dictatorship of the proletariat. Nor are we saying that everything should be one-size-fits-all.

We're not even saying that ornament is a crime.

What we're calling for is the end of a design profession that has, as its sole purpose, the propagation of style devoid of content, form devoid of function, and commerce devoid of culture.

We have noticed that much of the money, effort, and thought expended in the name of design, to make things look better, ends up making things look worse.

We have noticed that most design doesn't concern itself with function. That function is taken care of by someone else—an engineer, a technician, an inventor. And when design does try to make things work better, it often makes them work worse.

And we're worried about the future. One of the things that designers create is other designers.

It used to be that people, trained as engineers, architects, artists, and the occasional English major, wound up as designers. But now there are design schools that teach nothing but design. Very professionally, but without the social vision associated with early design institutions such as the Bauhaus. And so there are legions of young people coming out of these schools knowing an awful lot about style but nothing about content. And they are preparing to shape the future.

We wish they were going to school to learn something else. Greek philosophy. African history. Theoretical physics. English literature. Art. Anything.

Anything but design.

We think it would be more practical.

Because designers would know something about what things are, rather than what things appear to be.

The end is near. But we're optimists. We hope it's just the end of design.

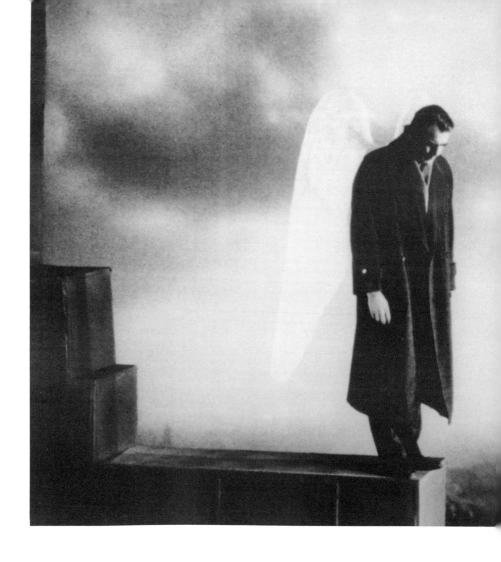

42

Still from *Wings of Desire,* a film by Wim Wenders, 1987. Road Movies, Berlin.

City: Spirit and Form

Millions of eyes look up at windows, bridges, capers, and they might be scanning a blank page. Many are the cities like Phyllis, which elude the gaze of all, except the man who catches them by surprise.[1]

To consider the city in the fullness of its spirit and form is to negotiate the terrain between millennial reincarnation and reconstruction. The pathology of our damaged cities requires this passage lest we find ourselves scanning "blank pages" where there once were places.

Rather than the surrender of the idea of the city, it is the persistence of communities within communities that is the leitmotif of the essays tendered here. Collectively they unmask the buildings, the plans, the programs, and illuminate the city as a physical and metaphysical entity, lived in and infused by the spirit of its inhabitants.

While it is common currency that discussions hinged on notions of duality—corporeal and noncorporeal, home and homeless—are based on a false premise of separation of spheres, it is also true that we spend much of our time contending with the legacy of that thinking. In *The Conscience of the Eye,* Richard Sennett says of the disjunction between the inner and outer world that "nothing is more cursed in our culture than the continuing power of this separation," for it perpetuates a puritanical disdain for form.[2] In an intriguing analysis of how the "city in the park" became the "city in the parking lot,"[3] he contends that the notion of a

deferred spiritual fulfillment is responsible for the bland appearance of our cities today.

In fact, it could be argued that in Judeo-Christian culture two primary archetypes have shaped the notion of dwelling: Eden, the pastoral, undefended landscape of the Garden of Paradise; and the New Jerusalem, the secured, jeweled city of God. At the edge of the millennium we still vacillate in our attachment to those two unattainable states—the forever-banished Garden and the promised, jeweled City of Heaven.

Americans have always been acutely conflicted about the city as a viable dwelling place, despite the fact that our population has become increasingly urban. But the value placed on open space—the Edenic model—is by no means an American prerogative. Perhaps the most cited modern attempt to reconcile the realms of the pastoral and the paved is Le Corbusier's 1925 Plan Voisin, which proposed to erase the old city of Paris and replace it with a grid of towers surrounded by parks. At the end of the same century, the tension between trees and towers has left the rhetorical realm and become a question of planetary survival.

Whether one blames the sterility of modern cities on a Protestant ethic of space or the religion of modernism, one suspects that many of our urban forms are simply of no value or consequence because they are not built with anyone in particular in mind. Traditionally, religious buildings suffered from no such confusion and were iconographically encoded with richly detailed surfaces and sophisticated plans. As architectural programs were created to accommodate new technologies and social practices—two popular examples being the train station and the library—the energies formerly reserved for religious structures were transferred to these new building types, as had already happened with banks and theaters and would continue to happen through to the early skyscraper. However, the skyscraper quickly became the commercial developer's notion of Paradise: interchangeable boxes, to be rented for any purpose, stripped of any meaning. And where these monoliths displaced residential quarters, they eradicated the salient characteristic of authentic cities—the fact that people live in them, not just work in them.

Is community the first condition for an authentic city? If it is, what programs can acknowledge the most profound understandings of community? I would offer two specific cities with vastly different communal qualities—New York and Berlin. Both are inarguably authentic cites, both pathologically damaged. The city of Berlin elicits a deeply felt response to its scars. There is a sense—at least at this juncture,

before the erasures of imminent development—of shared sorrow, shared history, and shared shame.

In New York, on the other hand, the erosion is of a different genesis. Instead of the instant annihilation of bombs, there has been the incremental decay of neglect. Instead of punishing the visible heart of the city, its ravages eat at the peripheries, which are universally referred to, with no small irony, as "bombed out." And because we are a racist, polyglot society, we do not share the sorrow, the history, or the shame. New York continually buries its dead, thinking they are truly gone. The recent, accidental exhumation of the Negro Burial Grounds in Lower Manhattan painfully illustrates the impossibility of this practice of denial. For as the historian G. M. Trevelyan observed:

> *The poetry of history lies in the quasi-miraculous fact that once on this earth, on this familiar spot of ground walked other men and women as actual as we are today, thinking our own thoughts, swayed by their own passions but now all gone, vanishing after another, gone as utterly as we ourselves shall be gone like ghosts at cockrow.*[4]

The fact remains that we have few witnesses to document the soul of the city, to show us its angels. But, of course, they are with us. Be they only the fallen angels of our "mean streets."

The architect Daniel Liebskind talks of rooting architecture in social ethos. New York's social ethos was founded, and continues to be, in flux. And now Berlin is facing the acute conflict of accommodation of northern and southern cultures that will dominate the next century. With the mass exodus of the rural impoverished seeking solace in cities across the globe, we need to accommodate and facilitate new social contracts within our cities if they are to survive in the next century.

Among the many altered social contracts that have direct bearing on the architectural landscape is the contract between men and women, between women and society. Feminists lay stress on the need for an architecture that places a premium on social connections and attachments in opposition to a tradition of separatism, stoicism, and heroicism. Through a new understanding of the feminine as multivalent, layered, and dispersed, might we elude patriarchal habits of classification, the ghettoizing habit of dualities? Not for the purpose of creating facile correlations of feminism in form, but for changing the thought that engenders that form.

Because we are still in the process of reconfiguring cultures, particularly Western

culture, "we can no longer practice the dogmatism of a single truth and we are not yet capable of conquering the skepticism into which we have stepped," as Paul Ricoeur wrote in 1961.[5] We are, in essence, in the aftermath of a millenniastic crisis in the collapse of modernism, so it is all the more urgent to have visionaries who will begin to rebuild a new, more elastic framework for practice, with the capacity for memory without co-optation.

Then we can tease out the invisible cities within our real cities. Cities like *Olinda*, the city that grew in concentric circles with new quarters around it "like a loosened belt."[6] Or *Moriana*, "a city of alabaster gates, coral columns, and glass villas in which one has only to walk in a semi-circle to see its hidden face of rusty sheet metal, soot, and piles of tins—a city with no thickness, like a sheet of paper."[7] Or *Zobeida*, based on the trail of a woman running at night, built by a succession of men who dreamed of pursuing her and created a city of traps.[8]

Of course, *Olinda, Moriana,* and *Zobeida* are all the same city. In Italo Calvino's meditation, they are Marco Polo's Venice. And while it is true that all cities are built on the same human foibles, it is no less true that the way we give vent to our lust, grief, mourning, and joy is built into each culture differently. Hence, each of the four cities we have here chosen to examine—London, Tokyo, Mexico City, Los Angeles—warrants our scrutiny to the extent that they retain and deny regional and cultural differences within the larger electronic city of sameness that links them. Each has its own stories, its own lessons to offer, as we construct new myths for the millennium.

One such narrative is suggested in Wim Wenders's *Wings of Desire*, a cinematic portrait of a visible/invisible Berlin, where spirit and form elide. It can be no accident that his guardian angels find themselves in Hans Scharoun's famous library. Scharoun "viewed the single building as he did the city... shaped from a multitude of human actions."[9] So, too, does Wenders as he pans from apartment interior to apartment interior, exposing the simultaneous lives of Berlin's citizens, always encased and given movement by the architecture of the city. Like Bruno Ganz, who sheds his wings for human love, we must find new ways to be full participants, not just onlookers in the framing of the city—and our inducement, in the end, must also be love.

— S.Y.

1 Italo Calvino, *Invisible Cities* (New York: Harcourt Brace Jovanovich, 1972), p. 91.

2 Richard Sennett, *The Conscience of the Eye* (New York: Alfred A. Knopf, 1991), p. 42.

3 Colin Rowe and Fred Koetter, *Collage City* (Cambridge: MIT Press, 1978), p. 65.

4 G. M. Trevelyan, quoted in "Clio Has a Problem," by Simon Shama, *The New York Times,* September 8, 1991.

5 Paul Ricoeur, "Universal Civilization and National Cultures," in *History and Truth,* trans. Charles A. Kelbley (Evanston, Ill.: Northwestern University Press, 1965).

6 Calvino, p. 129.

7 Ibid., p. 105.

8 Ibid., p. 45.

9 Alan Balfour, *Berlin: Politics of Order 1737–1989* (New York: Rizzoli International Publications, 1990), p. 217.

RIGHT: Sir Thomas More, frontispiece, *Utopia,* 4th edition (Basel: Johan Froben, 1518). The Pierpont Morgan Library, New York, PML 19444.

Waiting for Utopia

ROSEMARIE HAAG BLETTER

The widespread fear of an apocalyptic end of the world that was widely held in European culture before the year 1000 may seem amusingly archaic today. However, at the close of the twentieth century there is a general pessimism, perhaps of parallel dimension, that pervades social and cultural debate. Today we have a creeping, incremental pessimism that is not centered on the year 2000. We might call it the absence of hope about the future. Lack of hope is like dying a slow death and in the end may be much worse than fear of the apocalypse.

While I cannot speculate on the year 2000, it is clear that millenarianism, futurism, and utopianism are all closely linked to the landscape of twentieth-century modernism. By following their trajectories through the 1990s, a pattern may emerge to suggest what we might expect next.

"No Place"

Ernst Bloch, the Marxist philosopher who dealt extensively with the role of utopia, begin-

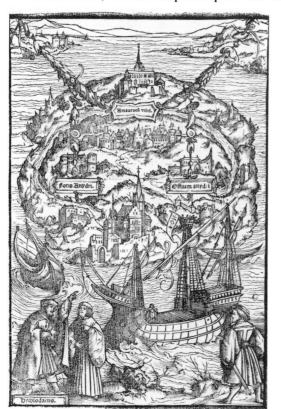

ning with his 1918 *Der Geist der Utopie* (*The Spirit of Utopia*), saw the function of utopia as a critique of what is present. Utopia seen in this sense can be inspirational and oppositional. Other utopias depict the attainment of a presumably perfect state of society. However, the absence of real-life conflict can make such perfection exceedingly boring. In fact, the self-contained nature of many utopias, which often seem atrophied in their ideal state, without any further possibility of change, renders them rigid, even totalitarian. The inherent contradictions in utopian longing are evident in the varying interpretations of Marx's critical view of the idea of social utopias. Bloch asserts that late Marxists

misread that view in their rejection of the usefulness of utopian thinking entirely, and goes on to say:

> *The turn against utopia that has been conditioned by the times has certainly had terrible effects. Many of the terrible effects [came about because]... Marx cast much too little of a picture... in literature, in art, in all possible matters of this kind. Only the name Balzac appears; otherwise there is mainly empty space.*[1]

Bloch believed that utopian illumination occupied an important place in our social contract with the future. But the literal meaning of utopia, "no place," has been so reified that today utopia (no place) usually has no place in a constructive discourse.

All Roads Led to Utopia

Most modernist urbanism in the early twentieth century was not *always* infused with a utopian critique of current conditions, but certainly with an optimistic belief in progress and a technocentric futurism. The emphasis on transportation, especially the car, led to the most explicitly graphic form: linear development along a transportation network. Although there were towns that had developed along commercial routes (and in the nineteenth century attempts were made to have planned developments along railroad lines), in the twentieth century the linearity of the automobile route played a more dominant role

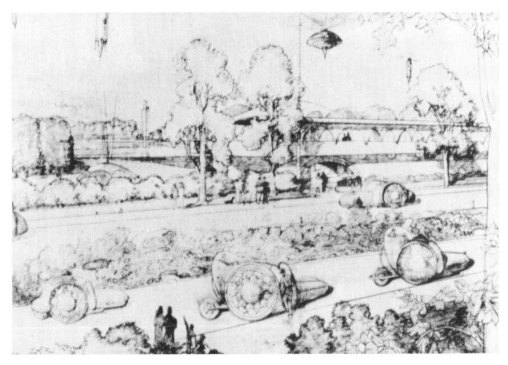

48

ABOVE: Frank Lloyd Wright, *Broadacre City Landscape,* c. 1950, published in Robert Fishman, *Urban Utopias in the Twentieth Century* (Cambridge: MIT Press, 1982), p. 114. Photo: Ken Pelka.

RIGHT: *License Plate,* 1939 New York World's Fair. Photofest.

in determining spatial form in many urban schemes. When roadway and houses were fused into a single linear system, urban public space disappeared entirely, as in Corbusier's proposal for Rio. The Soviet schemes of the twenties, which had probably inspired Corbusier, included urban nodes at intervals, and were referred to by their proponents as *deurbanist*. The extreme deference to transportation was most clearly expressed in the American Edgar Chambless Roadtown of 1910. It was a futuristic fantasy but, in its total absence of civic places, only an intensified version of today's commuter suburb.

Frank Lloyd Wright's proposals for Broadacre City, begun in the thirties and added to in the fifties, were in part inspired by a Jeffersonian America. The Broadacre plans embodied a modest utopian vision with a small settlement that still allowed for proximity to the countryside for all residents and a small town mix of agriculture and industry. The integration of architecture with nature in Wright's schemes is well known, if stressed too exclusively. Wright was at the same time enthusiastic about the developing car culture: Broadacre City clings to the spine of a superhighway, along which it would expand as a linear band. In fact, Joel Garreau in his *Edge City* of 1991, which enshrines the unplanned suburban agglomerations around shopping malls and office parks as the new frontier where the American middle class prefers to live, completely bypassing the old urban centers, writes that Wright's Broadacre "anticipated with stunning accuracy many of the features of Edge City."[2]

"Town of Tomorrow"

In addition to Wright's Broadacre, Garreau could also have invoked the populist, commercial futurism on display inside the General Motors Pavilion at the 1939 New York World's Fair. The Futurama exhibition was conceived by the industrial designer Norman Bel Geddes and was the most popular exhibit of the fair. Moving chairs gave visitors an aerial view of this city of the future set in 1960. Although Bel Geddes began with an urban vision that was more indebted to Hugh Ferriss's and Harvey Wiley Corbett's proposals of the twenties than to those of Corbusier, it was a GM exhibit and therefore promoted the car more than any sort of urbanism. Superhighways crossed a pristine countryside in the idealized Bel Geddes version of a separate city and countryside while, in fact, a national highway system was being put in place that would provide the spine for unplanned commercial strips. On leaving the GM Pavilion, visitors walked through a full-scale

49

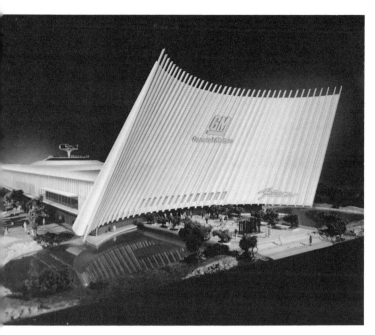

intersection of the city of 1960 in which vehicular and pedestrian traffic were separated, giving them a good, unobstructed view of GM cars. It is significant that the full-scale model was a traffic intersection, a space dominated by the car. Even the pedestrian areas were merely traffic paths, not civic spaces.

The car culture so evident in the 1939 World's Fair was referenced more indirectly in the fair's residential models, the Town of Tomorrow, which was actually much more conservative than the commercial pavilions. It was meant to suggest a New England town. The Motor Home of Tomorrow was defined by its prominent garage doors—the main entry to the house was reduced to a minor incident. (The car had also determined the classification of the residential sectors in Wright's Broadacre as areas of "two-car houses and three-car houses.")

Driving Away from the City

The 1964 New York World's Fair, like the one in 1939, was not an official world's fair but primarily a free-enterprise zone with a smattering of national pavilions to give some justification to its title "World's Fair." The 1964 fair, like the one in 1939, had a General Motors Pavilion designed by the firm of Albert Kahn. He was the architect of several Ford and Chrysler car assembly plants and in the thirties had designed tractor plants for the Soviet Union. The 1964 version of GM's Futurama exhibit was totally conceived by car designers. It was sawed into sections and shipped to New York by a fleet of fifty trailers. The scenic backdrops were painted by artists from MGM, and the music that accompanied the taped explication and emanated from speakers in the moving chairs was written

50

LEFT: *Hotel Beneath The Sea,* 1964 New York World's Fair Futurama, General Motors styling staff. General Motors Corporation.

RIGHT: *Three-Wheeled Runabout,* 1964 New York World's Fair Futurama. General Motors Corporation.

by a jingle writer. The design was pedestrian, metaphorically speaking, compared to Bel Geddes's slicker presentation in 1939. There were taller buildings and bigger highways, but the urban concept of the future had stood still. But then, GM was not terribly interested in cities anymore. The press release stated: "The city, which long strove for growth, is imperiled by its own excesses. The suburbs are emerging as the centers of communal living." What the cities' excesses *were* was not made clear. A notable difference in the 1964 Futurama was that the design allowed for more cars on existing motorways—an "autoline" that would automatically control cars to increase highway capacity by reducing the space between vehicles. These cars were, moreover, equipped with television sets, stereos, game tables, and refrigerators. They were cruising dens, motor homes in an "autoline."[3]

One of the themes of the fair was concern with an ever-growing population and a shrinking globe. (The time capsule contained birth control devices.) In this spirit, the 1964 Futurama showed a global penetration of technology to the most inhospitable regions. Electronic and computerized farming would use desalinated sea water to reclaim deserts. An underwater hotel featured sportsmen traveling in aquascooters. Antarctica was to be opened to settlers by means of an all-weather harbor covered by a plastic dome with atomic-powered submarine trains beneath the ice shelf. The jungle was to be conquered by replacing the "aimlessly wandering river" with big highways. This new motorway was to be cleared by a tree clipper with laser machines, followed by chemical sprays. Then came the giant Roadbuilder, a machine five stories high and three football fields long, "capable of producing from within itself one mile of a four-lane, elevated superhighway every hour." In fact, this Roadbuilder was conceived as a mobile factory using mass-production techniques to create instant superhighways. The jungle habitat also included self-propelled houses. Everything from factory to house had been transformed into moving units. Throughout the shopping areas of the Futurama, GM exhibited three-wheeled

Runabouts that contained a built-in, removable shopping cart, as the brochure said, to cope with and satisfy women's special function as "poor drivers" but "avid shoppers."

The only element of the GM Futurama that came true was the depiction of containerization: the efficient shipment of goods inside standard-size containers that can be loaded on ships and attached to railroad flatbeds or trucks. While the Futurama showed open high-rise warehouses for the orderly storage of containers, today they are simply stacked out-of-doors in large open lots. And it is this need for huge parking lots for containers that has devalued New York's once thriving waterfront, now replaced by the less constricted (i.e., less urban) harbors of the Jersey waterfront.

"Pragmatic Futurism"

Though the wonders of atomic energy were alluded to in several of the 1964 fair exhibits, a *fear of the future* began to manifest itself in other ways at the fair—specifically, the fear of a nuclear holocaust. One of the residential buildings on display was the grandly named Underground World Home designed by Billy J. Cox and Don L. Kittrell. *Progressive Architecture*, in its review, noted that the Underground World Home was meant as protection against radiation fallout and more benign pollution such as pollen.

The underground house was the idea of Texas builder Jay Swayze. Swayze was a former military instructor in chemical warfare turned contractor of luxury houses. When the Cuban Missile Crisis occurred in 1962, the Plainview, Texas, City Council commissioned a fallout shelter to specifications set by the Department of Civil Defense. Swayze began long-range planning for underground, defensive residential construction. He claimed that in a survey conducted by him to learn how much value is placed on windows, he found that the "average family prepares for work or school in the morning without glancing outside... and in the evening simply reverses this process." Actual views are

often uninspiring or show "dusty skies." Furthermore, he noted, "we sleep a third of our lives." Swayze concluded that windows may be needed for psychological reasons and decided that an artist could do "a thousand times better." The underground house had painted views. He wrote that, although most people love nature, they do not want to take care of it. Light in his simulated out-of-doors was "completely controlled from rheostats... choices are sunlight, light simulating a rainy day, moonlight, or no light at all." Though much more defensive than the Futurama, the Underground World Home was not alien to

LEFT: *The Atomic Cafe,* 1950. Photofest.

RIGHT: Archigram, *Plug-in City,* 1964, published in Colin Rowe and Fred Koetter, *Collage City* (Cambridge: MIT Press, 1978), p. 40.

the car culture of the GM Pavilion. Now the only aspect of the residential building that remained visible aboveground was the two-car garage; every other aspect of habitation had dropped out of sight.

The aspiring utopias of the twenties seemed to be completely displaced by this kind of technocentric and pragmatic futurism as well as by the academicization and commercialization of early-twentieth-century modernism after World War II. The abstract formulations of urban life fostered by the CIAM (Congress Internationaux d'Architecture Moderne) helped to calcify English New Towns or larger urban models like Corbusier's Chandigarh and Lúcio Costa's and Oscar Niemeyer's Brasília, both done in the fifties, into places that were dysfunctional as cities. However, in 1956 CIAM Ten had begun to ask critical questions about urbanism (later known and published as *Team X*, 1968), and Corbusier had become ambivalent about the technocentric, rational urbanism of the thirties as he had come increasingly under the influence of an anthropocentric surrealism and postwar existentialism, most clearly evident in his later works.

"From Car Culture... to the Counter Culture"

During the sixties there was a brief renewal of visionary, technological utopias. Many of these were the products of an activist, engaged counterculture, a counterculture that, at least in America, defined itself in opposition to the prevailing mass and car culture. Some mimicked the speed of transportation but applied it to larger social units than the family; others tried to escape it, albeit not successfully.

Archigram, a group of young English architects, came up with the most technologically intense proposals for a Walking City and plug-in cities. As these cities repositioned themselves, terms like *place* and *hometown* became meaningless. The social structure of the Walking City was not addressed, i.e., who decides which way "the city" should walk?

Paolo Soleri's proposals for prototype settlements of 5,000 people were called arcologies, a combination of the words *architecture* and *ecology*. On the surface they seem to be critical of an overly technological futurism. Each arcology is a 25-story-high communal structure intended to replace single-family houses. Presumably by concentrating habitation into such beehives, land and its exploitation could be better protected. After the energy crisis of the seventies, Soleri also became concerned with energy conservation.[4] He then made the mistake of wanting to see his vision carried out. He acquired 860 acres in the

high desert north of Phoenix and called this community, to be built on 13 acres, Arcosanti. Because he has relied on voluntary help and contribution, work has been slow. When I saw it in 1983, most of the buildings were still incomplete and construction equipment had been allowed to scar the desert, a landscape that Wright not surprisingly understood better at nearby Taliesin West.

What is not clear is how energy and water can be brought efficiently to the high desert. Behind Soleri's insistence on an ecological approach is really a technological utopia. During my visit he was in China investigating rice growing, not a good choice for the desert. He also raised money through arts and music festivals. In 1978, 10,000 people came and parked their cars in the desert he claimed to protect. He complained that the dome of the main hall had gotten damaged because tourists walked on it. One of the few completed structures in 1983 was a kidney-shaped swimming pool built into the side of the hill. Communal utopia here has degenerated into a sad reminder of possibilities not addressed.

A utopian vision of the future, together with the technological inventiveness of charismatic thinkers such as Buckminster Fuller (see, for example, his *Dome over Manhattan* proposal shown in the "Visionary Architecture" exhibition at the Museum of Modern Art in 1960), influenced the counterculture of the 1960s directly, but with paradoxical results. Drop City, a commune near Boulder built in 1966, was loosely inspired by Fuller's geodesic domes, but is covered with old car parts, the detritus of the official car culture. Drop City won the Buckminster Fuller Cymaxion Award. The experiment of twenty people living as a commune in domes was described by Peter Rabbit in *Drop City* (1971) as a group of "total revolutionaries; we are free men living equally with free creatures in a free universe. The story of Drop City will never end. It's the story of man on the road to be free." What freedom meant was not explained, but the group spent a great deal of time driving around in cars going to stores to buy food and to junkyards to buy automobile parts for their domes.

The crossover from the car culture to the counterculture did not always take communal form. Reyner Banham's 1965 *Environment-Bubble* was a proposal for soft housing that could be inflated around a mobile service core—a small vacation trailer and tent combination.[5] By the 1970s such house-and-car arrangements became more individualistic and nostalgic. The car was still in the picture, but utopias and futurism began to disappear with postmodernism.

54

California Truck-house, c. 1970. Photo: Rosemarie Haag Bletter.

Regressive Futurism

By the sixties some American architects began to look to the commercial context for models of public space, and some egregious examples were elevated as archetypes of popular taste. In "You Have to Pay for the Public Life" in *Perspecta* (1965), Charles Moore wrote about Disneyland's organizational techniques and especially about its invention of a unified Victorian Main Street. The easygoing populism of Moore would not be shared by Colin Rowe and Fred Koetter in their essay "Collage City," first published in 1965 and, in a somewhat different form, as a book in 1978.

A fuller critique of Disneyland as utopic degeneration appeared in Louis Marin's *Utopics: The Semiological Play of Textual Spaces* (published in English, 1984) and in *Variations on a Theme Park*, edited by Michael Sorkin (1992). Sorkin's essay "See You in Disneyland" is a vivid analysis of a dystopic fantasyland with pedestrian malls surrounded by transportation systems and car parks. Of course, Sorkin is right, but it has become much too fashionable to hate Disneyland—it is used as a stand-in for commodity culture and simulation. Orthodox Marxists, who think the utopian is always bad, call it utopia or dystopia. However, the intentional creation of fake spaces is not a unique aspect of commodity capitalism. All architecture and built form is by its nature artificial—it is made by us, not produced by nature. The Gothic cathedral was meant to produce the semblance of a spiritual space. I see Disneyland only as a small blip in our modern leisure industry.

Recently *Sixty Minutes* on CBS reported that in many countries tourism is the major industry and that many historic monuments are suffering from too many visitors. One could say, then, that all the Disneylands and Disney Worlds perform a useful function if they deflect tourists from those monuments we perceive as historic. A future generation, however, may want to landmark Disneyland, particularly if it ceases to be a successful commercial enterprise.

In *Complexity and Contradiction* (1966), Robert Venturi wrote, "Is not Main Street almost alright? Indeed is not the commercial strip of Route 66 almost alright?" In

55

EuroDisney Logo Silhouette Graphic, 1990, Deborah Sussman, Paul Prejza,
Robert Cordell, and Dan Evans. Sussman/Prejza & Company, Inc., Los Angeles.

Learning From Las Vegas (1972), he went further and singled out the Vegas strip as a model for the creation of public spaces. Choosing this gambling center and mecca of sleaze and corruption as his prototypical Main Street did not endear him to anyone. He followed Tom Wolfe's 1965 essay on Las Vegas, in which Wolfe described with morbid fascination giant signs that celebrate one-story casinos, but Venturi viewed them literally as the space-making devices appropriate in settings defined by the car culture. Later he also turned his attention to the design of civic and cultural signs in his 1973 *City Edges* project for Philadelphia and to the study of older, ordinary Main Streets and developer houses in an exhibition called *Signs of Life* in 1976. His own designs for buildings, especially those along commercial strips, then began to incorporate these lessons, as in his *Basco* project in Bristol, Pennsylvania, in 1979. Whatever one thinks of his strategy, he is one of the few architects who deals with the presence of the car head on.

One of the many critiques of Venturi's accommodation to the most commercial forms of building was in Rowe and Koetter's *Collage City. Collage City* singled out the reliance on perceptualism—how one *sees* the large signs from the moving car in the case of Venturi—and also criticized Venturi's apparent refusal to transform the ordinary object of daily experience. Rowe and Koetter do not call Disney World and Las Vegas utopias, but see them as pragmatic material fragments that would require novel juxtapositions and alterations to make them meaningful as architecture. They propose Cubist collage and bricolage as good models for transforming the ordinary into something new. However, one could argue that occasionally Venturi does just that, and that using Cubist collage as a model for American urbanism may not solve the problems of a car culture.

Surprisingly, *Collage City* also criticizes *modern* utopian conceptions, but not utopias in general. Rowe and Koetter believe that the older Renaissance model of utopia as

56

Caesar's Palace, published in *Signs of Life: Symbols in the American City*, exhibition and catalogue, Renwick Gallery, Washington, D.C., 1976. Venturi, Scott Brown & Associates, Philadelphia, Pa. Photo: Deborah Marum.

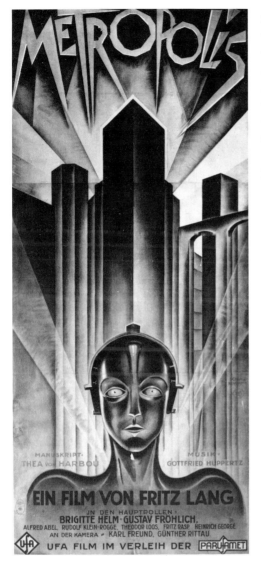

metaphor plays a useful inspirational role, whereas twentieth-century utopias that were intended to be executed are too literal and totalizing. A city designed from scratch, no matter by whom, is condemned to be lifeless from the outset. And here their suggestion of collage as a better method makes more sense. At any rate, despite their critique of modernist utopias, like Bloch they try to maintain a constructive aspect of utopian ideas. Alas, that seems to belong to utopias of an earlier age. *Collage City*, although subtly argued, is, on the whole, retrospective.

In *The Time Machine* (1895), H. G. Wells wrote about a regressive future—a future that has a pretty surface. The small, beautiful, but mindless Elois live in lush but neglected gardens with overgrown dilapidated buildings from an earlier age. They wear pretty clothes that are made for them by the sluglike, blind Morlocks who live underground. The Morlocks operate the machines that make the dresses that keep the Elois happy. At night the Morlocks eat the Elois. The machines produce in order to support the Morlocks' cannibalism. Wells uses an interesting inversion of normal hierarchies. If we compare *The Time Machine* with, for instance, Fritz Lang's film *Metropolis* (1926), in which the master race lives in the aboveground city while the slave-laborers who work the machines live and work below ground, we find that in Wells's book the workers below ground have become masters—"masters" of a very primitive world in which scientific knowledge gathers dust. The future becomes progressivist again for Wells in his *The Shape of Things to Come* (1933), in which he is, however, probably responding to the rise of fascism.

In literature utopian and futurist conceptions can be readily confined to a metaphoric level. Few people would ask of Wells, "Will this really come about?" On the other hand, with architectural utopian projects, the question almost always asked is "Was this meant to be built?"

Metropolis poster, 1926. Photofest.

"Opportunities for New Visions"

Wartime destruction creates the most obvious need for reconstruction and opportunities for new visions, as in the case of Berlin. Early efforts, such as the Interbau exhibition in 1957–1958, in which Corbusier, Aalto, Gropius, and others participated, followed the Zeilenbau models of planning of the 1920s by creating large blocks of apartments that did not maintain a street facade. In the late 1970s and the 1980s, under the sponsorship of the IBA (Internationale Bau Ausstellung), an attempt was made to rebuild small segments of the city, to fill in the gaps between the still-standing older houses and the newer structures of the postwar period. An effort was also made to reinstate the old street facades. As a model for housing that is dispersed throughout the city, the example of IBA is impressive. But because of huge subsidies from what was then West Germany for social housing, it is difficult to replicate, and Colin Rowe has found other shortcomings as well.[6]

With unification, however, other problems have arisen. Berlin will become the capital again. To encourage its selection, Berlin politicians promised important buildings to entice the politicians in Bonn. The architectural historian Julius Posener is afraid that public buildings will be planned too quickly, with interest in housing waning at a time when it is needed more than ever because of the influx of new immigrants from eastern

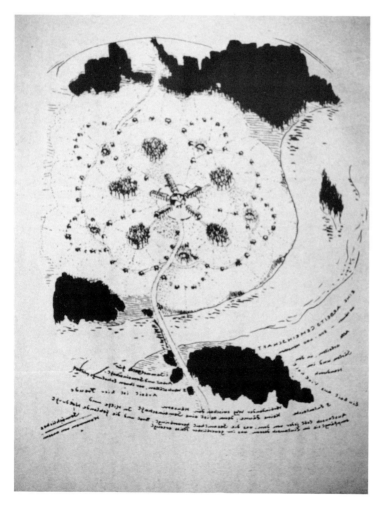

countries. Speculators and business people have been quick to move in. Daimler-Benz already controls much of the land, as well as the reconstruction, around Potsdamerplatz—a place that had been divided by the wall and that will be a major element in relinking the divided city.

In his essay "Modernity, an Incomplete Project," Jürgen Habermas seeks to connect modern culture with everyday praxis. He calls for communicative rationality and speaks against the surrealist attempt to negate art. Modernism still contains some promise for him. The connection between modern culture and everyday praxis can only be established, he writes, if limits to the internal dynamics of an almost autonomous economic system and its administrative complements are set,[7] something that he admits may be difficult.

Bruno Taut's utopian books of the post–World War I period depicted a pacifist, anarchist society that never came about and that he did not expect to see realized. When he returned to building after the German economy stabilized in 1923, he became one of the most important architects of social housing in Berlin. The forms of the housing do not replicate the metaphoric forms of his books. The link between utopia and praxis is very loose yet clear in Habermas's sense of connection between modernism and everyday life.

For Ernst Bloch the fairy tale was the common denominator of all utopias. Utopias might even be possible in the twenty-first century if we consider them not as a physical construct but as imagined places that help us structure social identity.

1 Ernst Bloch, "Something's Missing: A Discussion Between Ernst Bloch and Theodor W. Adorno on the Contradictions of Utopian Longing," *The Utopian Function of Art and Literature: Selected Essays* (Cambridge: MIT Press, 1988), p. 14.

2 Joel Garreau, *Edge City* (New York: Doubleday, 1991), p. 10.

3 Rosemarie Bletter, "The 'Laissez-Fair,' Good Taste and Money Trees: Architecture at the Fair," in *Remembering the Future* (New York: Rizzoli International Publications, 1989).

4 Paolo Soleri, "The Two Suns Arcology," *Architectural Association Quarterly*, April/June, 1975, pp. 33–41.

5 Reyner Banham, "A Home is not a House," *Art in America*, April 1965; reprinted in *Design By Choice*, 1981.

6 See Colin Rowe, "IBA: Rowe Reflects," *The Architectural Review*, September 1984, pp. 92–93.

7 Jürgen Habermas, "Modernity, an Incomplete Project," trans. Seyla Ben-Habib, in *The Anti-Aesthetic: Essays in Postmodern Culture*, ed. Hal Foster (Seattle: Bay Press, 1983), p. 13.

LEFT: Bruno Taut, *Die Auflösung der Städte* (Dissolution of the Cities), nighttime aerial view, 1920. Photo: Rosemarie Haag Bletter.

Spiritual Constructions

ALAN BALFOUR

Two Arguments

The first argument sees blind faith as the only comfort for the majority in the future world. The world population, which has doubled since 1957, will double again within the next thirty years. India, for example, will have a billion people by the year 2010. The results of such exponential growth will begin to consume, with frenzied suddenness, all the dependable surface resources, field by field, valley by valley. Think of a cluster of villages in central India surviving on the meager produce of tiny plots of cultivation, finding fuel for cooking in the dung of cattle and from the branches of the stunted trees that thinly cover the ground. Then consider that in a period of weeks all could suddenly be wasted, and the people must move to find sustenance, and as they move, they are joined by swelling numbers, forced into a search without end, for all the land they pass through is overworked and wasted and there is nowhere left to go but to the great city. And the great city swells like a lake in flood, and the people say, "If India survives, the world will survive."

And there will be a thousand cities like Bombay, with uncountable millions, for whom abstract political order will be meaningless, for whom spiritual construction, no matter how immaterial, alone will maintain order and form the evolving reality. Religious fundamentalism is only the most coherent expression of a much more extensive condition.

The second argument proposes that world industry must manipulate the world

60

Playing Cards: Minchiate Game (Tarot), Italian, 17th or 18th century.
Cooper-Hewitt, National Museum of Design, Smithsonian Institution.
Gift of Mrs. Hamilton Fish Webster, 1901-22-1. Photo: Ken Pelka.

population for the survival of both. Television has made entertainment out of tragedy, making us voyeurs, making us hapless witnesses to a regressing world. Persistent exposure to disaster has blunted the edge of compassion. The increasing tolerance of the obscene and horrific, coupled with an equal feeling of impotence, has prepared the world not just for the droughts and famines, catastrophic accidents, and civil disorder, but also for the exploitation of global resources by the new world industries. Industries whose nature and survival owe nothing to the idea of a nationhood.

The imperial and colonial policies of the nineteenth century often masked their essential economic agendas behind religious and civilizing causes. With their increasing detachment from the constraints of national laws and policies, world industries seek increasing freedom from any constraints in stripping the natural assets of weakened nations. It is clearly in the best interest of such world industries to favor the emergence of weak and accommodating governments, not only to allow exploitation of resources, but also to encourage the growth of apolitical and amoral urban societies with a healthy appetite for consumption. Such exploitation feeds an increasing political and economic regression in which stability is maintained by a combination of military force and the stimulation of artificial realities. The Indian and Hong Kong movie industries are powerful agents in this stimulation. In this devolution there is no return to the natural and the primitive. This is a world in which the most advanced products of destruction and gratification will be instantly put to use wherever they are needed.

Out of these two conditions new constructions of the authentic and the artificial will emerge. They will form the most significant objects in the imagination and in the reality of the new millennium. The forms, of course, will depend on the size and the nature of the illusions and of the mysteries they involve.

Let me offer a few brief tales on the structure of spiritual desire. The many small gods of Japan appear to offer the most convenient instruments of spiritual security. The Shinto shrines on so many streets vie with the automatic drink dispensers to salve the spirit. Throw in some money, clap twice, be quite open about the help needed, and go on through the day reassured that the ancient spirits are looking after you. As I became accustomed to these red structures surrounding simple yet mysterious aedicules, I sensed that all else in these cities could change or disappear, but the community would retain meaning if these temples survived. Constructing small instruments of spiritual comfort fulfills an ancient and deeply felt human need. In Manila, in Naples, in Istanbul, in Bangkok, coexisting with the vast spiritual engines of the privileged, neighborhood shrines are but a step away from the household altars, and through the tolling of bells, the burning of sacred prayers, and the pouring of water, they ease the path of the spirit through the moods of the day into the shifting burdens of life.

New constructions of spiritual desire are emerging in both the old and the new world. These assume forms significantly different from ancient places of ritual. The ubiquitous clapboard shed that now is home in various shapes and sizes to all the necessities of life in the fringes of the towns in the American South more and more often houses the

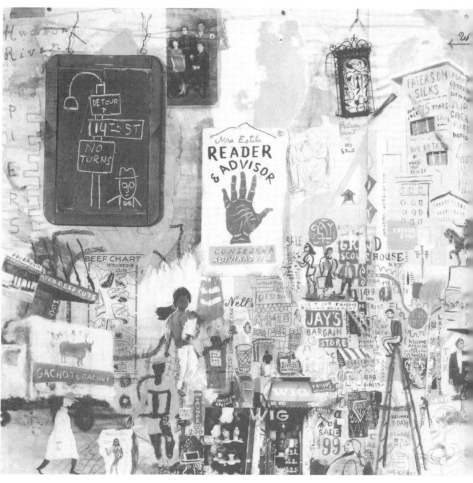

neighborhood palm reader. People increasingly need the guidance of the soothsayers whose inventive futures will give confidence to those whose lives are without distinction. The same form of structure, here made in cinder block, can be found at the heart of the constantly growing settlements that ring Mexico City. These sheds anchor the spiritual life of the people, not in the caste-bound mysteries of Catholicism, but in the accessible platitudes of Jimmy Swaggart and the many other zealous U.S. evangelicals. Through the slums of the cities of Central and South America, the same rude concrete structures carry a myriad of satisfying, though often dark and dreadful, mysteries—from the voodoo clubs in the mud-sliding hills above Rio, to the worship of a tailor's dummy, made up to look like Al Capone, in a solitary shed on the outskirts of a small town in Guatemala.

I find this last place emblematic of both the invention and the desperation of people without hope. The shed with its corrugated roof is approached down a small cobbled lane flanked by some farm buildings. On entering and waiting until the gloom clears, there appears, in the place of the high altar, a department store dummy with gray-pink flesh

Joshua S. Gosfield, *14th Street,* copyright 1992.
Color original published in *The New Yorker*, November 23, 1992.

and painted eyes sitting in a chipped enameled barber's chair. Someone has carefully, too carefully, marked the upper lip with a pencil line moustache. The deity wears a trench coat, collar up, and a snap-brim fedora is pulled down over the eyes. The figure sits casually on the chair, cross-legged, one hand on the rest, the other holding a cigarette in a long yellow plastic holder. The attendants, two middle-aged women, take care of its needs. One ensures that a cigarette is constantly lit, burning in the holder. The other, every few minutes, pours a carefully measured shot of bourbon whiskey down the sodden fibrous lips. The deity, whose origins did not prepare it for receiving continual doses of bourbon, has a weak stomach, with the consequence that the ritual scene sits in the middle of a puddle of muddied whiskey. The smell is strong. In the darkness a few people prostrate themselves before the figure and mumble incomprehensible prayers and requests. This ritual differs little from the hysterical cries of the evangelicals committing themselves to God or the dazed frenzies of the voodoo dancers as they will themselves possessed and guided by fierce external force. The figure in the barber's chair, though, is unusual. Most of the new spiritual activity in poor communities, a rejection of autocratic religions, doesn't require the presence of a symbolic figure to focus the ritual. Rather, the spiritual activity demands shared personal commitment within a trusting community free from any notions of higher earthly authority.

A contrast to these spiritual performances, which appear to seek withdrawal from reality, present and future, has been the construction of artificial destinations. These structures, of a deliberately epochal scale, are elaborate and synthetic and manipulate mass imagination into experiencing the illusion of fulfilled existence. The artificial destination is surely architecture's greatest achievement: from the Temple of David to all the compelling machines of Rome that still constrain the Western imagination; from the Colosseum to its inversion in the metaphysics of Hagia Sofia, whose representation of heaven was to hold the Christian imagination for a thousand years, displaced in the end only with the construction of the cathedrals, whose great shafts of stone sought to consume all other realities. The shift from architectural artifact to instrument and machine occurred in the nineteenth century. The railway train in a literal sense made destination artificial and gave rise to the mass idea of traveling for pleasure. The Crystal Palace became the tempting artificial destination of the nineteenth century and the first world structure concerned with stimulating in mass population the idea of consumption. It added a host of artificial journeys that were much more concerned with action and experience than with symbol and revelation. And the floods of new products that poured from the factories provided

63

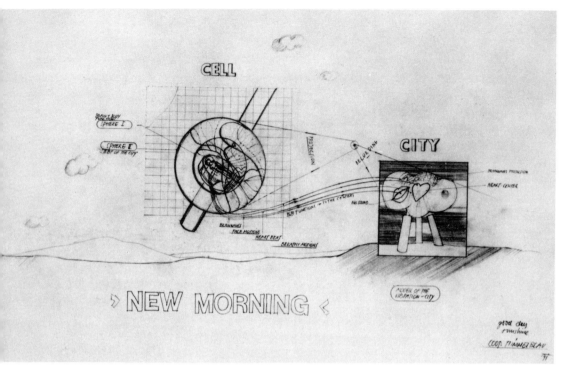

artificial realities, artificial journeys, for all. The landscapes of twentieth-century desire produced the movies and flight and radio and an explosion of invention affecting all aspects of existence. The movies became the great artificial destination in which illusion far overwhelmed reality in the passive imagination. And as testament to its significance and necessity for the spirit of these times, the movie has expanded into machines that can provide infinite manipulations of any conceivable presence, infinite presencing of what is no longer seen as artificial.

In this I see an emerging vision for willful landscapes of artificial reality. The construction of artificial destinations is shared by industries and governments. Cathedrals are constructed to satisfy the mass imagination, as much to deceive and pacify as to inspire and entertain. The dilemma for architecture lies in the ability of such constructions to embody brilliantly monstrous deception. The profundity of this condition was dramatized in a discussion I had with a young Chinese student who had been in Tiananmen Square during the protests. His concern was to share a vision that had haunted and frustrated him since the crackdown. It was a dream. A dream that somewhere in China a community of people, thousands upon thousands, would come together and begin to build a great cathedral. The vision was specific in his imagination. It would be Rheims rather than Chartres. He had read about it in his history books and had subsequently visited and been awestruck by this immense pile of harmonically ordered stone, shaped by innumerable hands to become a perpetual symbol of community and faith. He said he

64

Coop Himmelblau, *Feedback Vibration City*, 1971. Coop Himmelblau, Vienna.

believed that both in the act of building through several generations and in the eventual realization of such an epic structure, a spiritual and political path would emerge that would confirm and secure a meaningful future. I didn't ask if he was Christian, for it seemed clear as he spoke that his visions had all to do with politics and his love of people and little to do with notions of salvation or the life hereafter.

Let me conclude with some dreadful scenarios, not as delphic political pronouncements, but as landscapes of probability forcing the designing of future reality. The new power in the world will be the global industries, whose products will range from the essential to the stimulating to the destructive. They will assume authority over nations and divide the earth into several realities. Among them will be the *reserve* lands, abandoned regions whose small populations and insufficient resources are of no interest to world banks or producers except as a dump for the corrosive wastes of industry. They are excluded from the consumption program except to be used and abused. The *resource* lands are rich in natural resources but poorly developed. Consequently they are dominated by the global industries demanding to be fed through unsparing stripping of their mineral and vegetable assets, particularly where there are docile populations and accommodating governments. Here populations, large and small, will be kept powerless and become essentially the property of industry within which there will be little chance for individuals to prosper. The ambitious will leave for the *great cities*. Here, irrespective of cultural and productive history, uncontrolled population growth and consumption will demand a balance. Stability is essential to consumption. Here, in combination with religions, old and new, vast artificial destinations must be constructed for the spirit and for the flesh. These will become the reality engines of the new millennium.

The idea of making a great and artful construction that will have a compelling influence on the faith and obedience of the masses is an essential characteristic of advanced cultures. Architecture has always been the premier instrument for establishing order and authority. But now I sense something dreadful being cultivated. Monstrous deceptions, cynical creations of vast portentous dimension, conceived as the cosmic palliative, conceived to address what must be a future of intolerable insecurity for the many. Constructions that combine the communal ritual commitments of the new religions with all the elaborate machines of illusion that are now the most fruitful products of the world industries. Construction conceived to give meaning to meaningless existence, subtly tempting and gratifying all the desires of the flesh as necessary indulgence through which salvation will be achieved. Vast and intricate constructions, these spiritual engines will present a reality so completely satisfying that even those who know it is corrupting will be seduced and silenced.

And for most of those involved in the production of these vast constructions, it will seem like a golden age, it will be compared with the building of the cathedrals.

But a few will resist feeding a corrupting reality.

A few will continue to search for ways to create objects exploring the mysteries of existence. And their work will embody the prophetic future.

125th Street: Refiguring the Feminine in the City

PEG ELIZABETH BIRMINGHAM

> *Now, the/a woman who doesn't have one sex organ, or a unified*
> *sexuality (and this usually been interpreted to mean that she has*
> *no sex) cannot subsume it/herself under one generic or specific*
> *term. Body, breast, pubis, clitoris, labia, vulva, vagina, neck of*
> *the uterus, womb... and this nothing that already gives pleasure*
> *by setting them apart from each other: all these foil any attempt*
> *at reducing sexual multiplicity to some proper noun, to some*
> *proper meaning, to some concept.*
>
> — Luce Irigaray[1]

> *"On the West Side above 125th Street, Harlem; below 125th*
> *Street, the City."*
>
> — New York City taxi driver[2]

In the winter of 1988, John Hejduk, like a modern-day Thucydides diagnosing the sickness of Athens, concluded a talk at New York University with the suggestion that there could be no cure for the city until it began to build from the body of the feminine. In order to become well, he said, the city must breathe the breath of the feminine. These remarks were haunting, not the least because they indicate a rethinking of the old dichotomies: body/breath, matter/spirit. In Hejduk's work the spirit is tactile, sensual, embodied. To build from the breath of the feminine would be to build from feminine embodiment. In what follows, I would like to reflect upon what it might mean to build from feminine embodiment.

Is this discussion of the feminine simply another return to sexual anatomy, only this time engaging in a reversal of terms: a celebration of breasts, labia, vulva, clitoris? Is it a matter of sexual anatomy at all? As is well known, Freud answers this question in the affirmative. It is the difference between the male and female body; it is the difference between having and not having, being and nonbeing; it is the difference between the phallus and castration, the one and nothing. There is, then, only one sex. There is only a monosexual logic, a logic that is regulated by the principle of identity. Reality, therefore, is phallomorphic. Freud *seems* to obstinately cling to anatomical referentiality. Or does he? Looked at more closely, this schema reveals that masculine anatomy is itself

66

constructed by a *prior logic*. Surely Freud, focusing on the male body, could have suggested at least a double sexuality: the two testicles, for example. Thus it would appear that phallomorphic logic is prior to, and constructs, sexual anatomy in its image.

The French feminist Luce Irigaray asks, But what if woman were to reopen paths into a state of being that connotes her as castrated? How would this be done?[3] To think, therefore, a logic that is not phallomorphic, a logic that Irigaray calls "vulvomorphic," would be to think a logic *not* predestined by anatomy but, instead, a *symbolic* interpretation of anatomy. In other words, the logic of feminine sexuality would not be based *in* anatomy but, rather, would *construct* this anatomy. This would create the possibility of a new *poesis* of the body as feminine. To go further, this re-metaphorization of a non-phallomorphic sexuality would allow for the very re-construction of reality itself.

Philosopher Michel de Certeau reminds us that in modern Athens the vehicles of mass transportation are called *metaphorai*: "To go to work or to go home, one takes a metaphor—a bus or train. Metaphors traverse and organize places, link them together. They are spatial trajectories."[4] The re-metaphorizing of a non-phallomorphic, feminine sexuality would allow for new trajectories, new organizations of places.

125th Street marks a change of place. Here, on the West Side, just above Columbia University, Harlem meets the City. It is a meeting that separates and divides. 125th Street is also the main street of Harlem. Beginning at the Hudson River and flowing into the East River, there are places where the street gushes. There are places so dense that movement

becomes impossible. The width of the street is twice the width of the usual New York City street—four lanes rather than two. 125th Street has the feel of an avenue running in the wrong direction.

Irigaray warns us of the danger of making the feminine body a *subject* of discussion. To avoid this danger and thus avoid a return to the phallomorphic, we must consider the "*nothing* that already gives pleasure." Irigaray argues that this "nothing" marks and separates the feminine body, giving pleasure (*jouissance*) in all its parts: "And, as *jouissance* bursts out in each of these/her 'parts,' so all of them can mirror her in dazzling multi-faceted difference."[5] To think the feminine, then, is to think pleasure (*jouissance*).

In *The Pleasure of the Text*, Roland

67

Barthes meditates at length on this pleasure that signifies nothing. Implicitly, then, Barthes's text is a meditation on feminine *jouissance*. Barthes begins by making a distinction between *plaisir* and *jouissance*. It is the difference between, on the one hand, pleasure as comforting, assuring, and culturally legitimated (*plaisir*), and on the other, pleasure as shocking, disruptive, and in conflict with cultural norms (*jouissance*). *Jouissance* has the power to unsettle "historical, cultural, psychological assumptions."[6] The site of *jouissance* is a space of increased deviousness, foils, laughter; it is the site of resistance.[7] It is the opposition between the authoritative and its *other*. The resistance of *jouissance* is the resistance of the nonadmissible:

> On 125th Street, most of the merchandise is sold outside the stores. Stoves, refrigerators, blankets, shoes, and lamps vie for the walker's attention. Dresses and shirts made of brilliant orange and red fabrics are also for purchase. Every few yards there is something to eat. Large spicy shrimp with sweet red peppers are served up on large paper plates with generous napkins. In the summertime, the vendors (a woman and her two sons) on the corner of Lenox and 125th sell the best coconut ice. The merchants inside the stores are angry: they have paid good money for people to shop inside.

Barthes contends, however, that there is no clear-cut distinction between the two senses of pleasure—comfort (*plaisir*) and disruption (*jouissance*): "Terminologically, there is always a vacillation.... There will always be a margin of indecision; the distinction [between *plaisir* and *jouissance*] will not be the source of absolute classifications, the paradigm will falter, the meaning will be precarious, revocable, reversible, the discourse incomplete."[8] This vacillating *site of jouissance* unsettles and resists at the *edge* of our more comfortable and culturally sanctioned pleasures.

> 125th Street is filled with laughter and music. Most of it comes from outside the stores, although on occasion a merchant inside a store puts a speaker in the window. Often people suddenly stop in the middle of the sidewalk and listen to the end of a song. Some sing. Those who just bought the spicy shrimp also tend to stop; it is difficult to eat these while walking. Many people stop to talk to old friends. Fabulous stories are told; gossip is exchanged. People are often unaware that at the end of the week they usually leave their apartments because they are hungry for stories. Often so many people stop in the same place that those who want to keep walking end up in the street. On Saturday afternoons there are many people walking in 125th Street itself.

Barthes, moreover, argues that pleasure contains the further difference between *representation* and *figuration*. Pleasure in the first sense, pleasure as predictable and legitimated, works itself out as representation. Representation, he asserts, is "embarrassed figuration, encumbered with other meanings than that of desire: a space of alibis (reality, morality, likelihood, readability, truth, etc.)."[9] Here desire never leaves the frame, the

enclosed space of the building. According to Barthes, "that is what representation is: when nothing emerges, when nothing leaps out of the frame: of the picture, the book, the screen."[10] Representation is shut up inside itself; its concern is with operation, regulation, discipline: "Here we are not dealing with perversion, but with demand."[11] The site of representation is static and frigid.

At Park Avenue and 125th Street is the large Metro North train station. A restoration project has just been completed. The city removed all the backs of the benches to ensure that no one falls asleep. The benches themselves are extremely narrow. Riders now mill around reading the schedules: no one sits down. If the passengers have extra time, they leave the station, crossing the street to Twin Donut for a cup of coffee. A sign on the wall tells them that paying customers can sit for a maximum of fifteen minutes.

At 125th and Morningside is a small park filled with a large iron sculpture. In front of the park is a bus stop. On sunny mornings those waiting for buses used to sit on the benches surrounding the park. Children used to climb up and down on the benches, secretly longing to climb over the back of the sculpture. One spring morning the city came and took an ax to the benches. Everyone, including the children, now stands and waits for the buses. Sometimes tired children sit on the sidewalk.

Pleasure in the second sense, pleasure as excessive and subversive, plays itself out as *figuration*. Figuration, Barthes contends, is the way in which the erotic body appears; it is concerned with desire, with refiguring desire. It is preoccupied with embodiment as the site of desire. This is a desire that breaks out of the frame of representation. Hejduk remarks in *Mask of Medusa*, "There was never, ever a frame at Cooper... a structural frame."[12] This remark suggests that Cooper Union is a site of figuration, a site of feminine *jouissance*. In relation to representation, figuration remains indefinitely other; its strangeness does not surface. More precisely, its surfaces are characterized by what Hejduk calls the "density of the opaque void." To illuminate what he means by this, he invokes Ingres's painting of the Comtesse d'Haussonville, a painting that pervades his work. The Comtesse is the figure from whom he builds. Hejduk points out that there is no

69

Jean-Auguste-Dominique Ingres, *Comtesse d'Haussonville*, 1845.
The Frick Collection, New York.

reflectivity in the mirror behind the Comtesse. The mirror is absolutely opaque. She cannot be reflected or represented.

Here Hejduk agrees with Irigaray: "the most opaque matter opens upon a mirror all the more purer in that it is known and knows to have no reflections."[13] To build from feminine embodiment would be to build from this opacity: "to build a house which captures the unrevealed tone, the hidden spirit of the austere, stark, forbidden depth of a presence at once so very simple, even banal yet imploding, leaving a void; to make a house with a voided center."[14]

To build from the opaque *void* is quite different from building from opaque *matter*. More precisely, at the place where one would expect to find opaque matter that would reflect representations, one discovers instead a place that is fissured, open and disjointed. One discovers the mirror that does not reflect but instead begins to radiate. But a word of caution is needed here. The opaque void is not the void of nothingness but of a "multi-faced speleology... for there where we expect to find the opaque and silent matrix of a logos immutable in the certainty of its own light, fires and mirrors are beginning to radiate, sapping the evidence of reason at its base."[15]

The site of figuration, then, is the site of the sensuous, opaque void. This site serves no function. It is, therefore, perverse. Barthes argues that pleasure (*jouissance*) is perverse when it serves no function such as normative or ideological views. Or more precisely, it is not that these are unimportant but that *jouissance* is not subjected to them in any orderly fashion: "It is this site: the possibility of a dialectics of desire, of an unpredictability of *jouissance*: the bets are not placed, there can still be a game."[16] The site of figuration tells of an *eros* at odds with its *ethos*.

Just above 125th Street where Morningside becomes Convent Avenue, Dottie's Coffee Shop is now the Convent Grocery Store. (As Grace tells it, Dottie's sold everything but a cup of coffee.) Next door to what used to be Dottie's, in what once served as a Democratic Club, is the Numbers Hole. The democratic sign was taken down, the door was painted black. For fifty cents, you can win three hundred. To combinate a number costs a dime extra. The Numbers Hole has a slot machine and two lounge chairs. It draws a good crowd. After school, children are sent to find out the number of the day. They return, calling out the number in the late afternoon light. When they are old, they will remember these afternoons when their voices were heard.

Across the street is the C and L Snack Shop. On Saturdays in the summer, Lou herself does the cooking. Early in the morning, she brings the barbecue pit out on the sidewalk. By noon the sidewalk is filled with chairs. People sit under Lou's awning and talk for hours. Up the street is Ramona's laundromat in the basement of her six-story apartment building. Sometimes on Saturday evenings, Ramona holds dances in her basement in the large room next to the washers and dryers. When this happens, the entire neighborhood turns out. Ramona's basement is painted in shades of soft pinks and greens.

70

The figurative sites of *jouissance* are migratory rather than static. These sites are the sites of masques rather than programs. As Hejduk observes, "For as it was necessary for the highly rational pragmatic city of 15th century Venice to create masques, masks, masses for its time in order to function, it would appear that we of our time must create masques for our times."[17] Architectural programs have now become questionable and ultimately, Hejduk argues, they must be replaced by masques—architectural allegories. The masques for our times will be feminine. They can be "conceived of as arriving at anywhere, at anyplace, at anytime."[18] In Hedjuk's Berlin Masques, for example, houses for the single inhabitants must be moved by public conveyances, by metaphors. These movable masques appear in the vacant sites scattered throughout and at the edges of our cities. The feminine masques slip into the transparent text of the planned, disciplined city.

On Amsterdam Avenue, one block north of where it crosses 125th Street, is an outdoor swimming pool. The pool is diagonally across from the police station. The building next to the police station is slated to be an AIDS hospice. It is in the final stages of renovation. All work has stopped for lack of money. During the summer of 1991, the pool was only open for one month because the city was in a fiscal crisis. During that month, children cut a hole in the fence surrounding the pool. They slipped through the hole and swam late at night. The children particularly enjoyed floating on their backs watching the night sky. They were always quiet. One night the police found the children in the water watching the night sky. The fence was repaired.

Thus, to build from the feminine in architecture would not be to build from a representation of the feminine *in* architecture. Instead, it would be to build from the feminine *of* architecture. In still other words, it would be to build from what it is in the architectural project which uncannily resembles the *breach* of the feminine: the occupation of a site that is neither quite outside nor inside the frame but rather is in a powerfully dynamic and disruptive relation to inside and outside.[19] The breach of the feminine, the site of feminine *jouissance*, is the conflicted relation between those comfortable pleasures of all that is culturally legitimated and those raucous pleasures of all that is excluded and pushed to the edge of our cities. I would like to suggest that this raucous and disruptive edge is what Hejduk often refers to as "the edge condition of architecture." And perhaps it is this vacillating site of feminine *jouissance* that awaits us at the edge of the millennium.

71

Carrie Mae Weems, *Untitled, 1990*. The Museum of Modern Art, New York.

One Saturday afternoon in April 1991, a ten-year-old Latino boy ran out of a store on 125th Street. He had with him a piece of jewelry not paid for. The store owner ran outside after him and fired two shots. The boy died on the street.

On 125th Street next to the Apollo Theater, on a fence that encloses a vacant lot, hang a number of large paintings by local artists. From time to time the paintings change. The exhibition site is permanent. The colors of the paintings are so vibrant they never seem to fade. Not even when the rain falls on them.

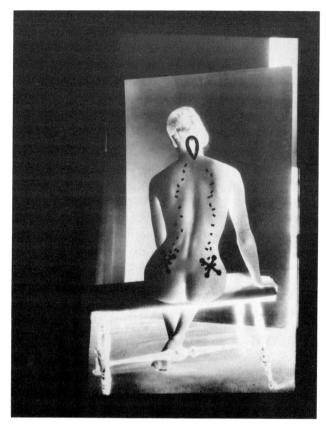

1 Luce Irigaray, *Speculum of the Other Woman,* trans. Gillian C. Gill (Ithaca. N.Y.: Cornell University Press, 1985), p. 233.

2 New York City taxi driver, driving north on Amsterdam Avenue, January 10, 1992. The remark was delivered at the stoplight at the intersection of 123rd Street and Amsterdam Avenue.

3 Irigaray, p. 142.

4 Michel de Certeau, *The Practice of Everyday Life,* trans. Steven F. Rendall (Berkeley: University of California Press, 1984), p. 115.

5 Irigaray, p. 239.

6 Roland Barthes, *The Pleasure of the Text,* trans. Richard Miller (New York: Noonday Press, 1975), p. 14.

7 Ibid., p. 41.

8 Ibid., p. 4.

9 Ibid., p. 56.

10 Ibid., p. 57.

11 Ibid., p. 5.

12 John Hejduk, *Mask of Medusa* (New York: Rizzoli International Publications, 1985), p. 35.

13 Irigaray, p. 134.

14 Hejduk, p. 123.

15 Irigaray, p. 144.

16 Barthes, p. 4.

17 Hejduk, p. 152.

18 Ibid., p. 152.

19 Here I am indebted to Jean-Luc Nancy's reference to women in *The Inoperative Community,* ed. Peter Connor (Minneapolis: University of Minnesota Press, 1991), p. 30: "The laceration that, for Bataille, is exemplary, the woman's 'breach,' is ultimately not a laceration. It remains, obstinately and in its intimate folds, the surface exposed to the outside."

Josef Breitenbach, *Negative Back,* 1947. Courtesy Houk Friedman, New York.
Copyright The Josef Breitenbach Trust.

Night Thoughts on Bronx Trolleys

JOHN HEJDUK

The following text was delivered as a lecture at "The Edge of the
Millennium" symposium, sponsored by Cooper-Hewitt, National Museum of Design,
Smithsonian Institution, in January 1992. The symposium was held in the Great Hall
of the Cooper Union for the Advancement of Science and Art.

Preface

To be within the Great Hall of the Cooper Union for the Advancement of Science and
Art is to be within a spiritual place. An institution that is lovingly held in trust.

A place that believes one of society's prime social responsibilities is toward learning
and education. Learning and education in the deepest *sense*. A place of multifaceted parts.

In the Cooper Union's Great Hall, Abraham Lincoln delivered his "Right Makes
Might" speech, the American Red Cross and the NAACP were organized, and the
Women's Suffrage Movement had its offices.

In a way the Cooper-Hewitt Museum is a young, vital relative of the Cooper Union.
Both our institutions are making a cultural mark upon our city, contributing to thought...
free thought. Thought that is exploratory thought. The Cooper Union is a free *place* and,
I mean, a special place that was founded by *one* man—Peter Cooper. A man with a vision.

A vision that *still* sustains and maintains the *spirit of place*. And, I believe, in the year
2000 will continue to do so. For it cares for enlightenment. A necessity... particularly in a
time when chaos runs rampant... and, in some circles, where chaos is celebrated. A neces-
sity... particularly in a time when language is subverted:

Sickness is health
Health is sickness
Thought is sickness
and nonsense is health.

Sometimes we enter places and buildings and we leave not knowing their histories or,
more profoundly, their spirit. We don't stay long enough. At one event we are already
anticipating the next event. We are mobile and free... perhaps?

I think speed fixes, makes things static. I think *to take one's time* opens... expands...
makes things flexible.

I remember as a child living in the Bronx one could *feel* time. The 1930s in the Bronx was *old time...* time to be savored. Yes, the Bronx was filled with *spirit time*. It was presently remote. The trolley cars were the carriages of slow times. Neighborhoods in the Bronx of the 1930s were older than any neighborhoods imaginable in Europe. It just *felt* old. A child knew that it was a place that somehow always had a gray dust *sense* in the air, even when the sun came out.

One understood what the end of the line meant. It meant the farthest distance that the trolley car went. It ended at remote areas where the woods began. The woods were sinister places, not for playing. Implied murders were referred to. A trolley line even went out to the water's edge located on City Island. City Island felt like 1918. It held the docks where a ferry departed to Potters Field—prisoners dug the graves. The end of the line even touched the borders of Yonkers. When the trolley man reached the *stop end name end*—Clausen Point, Hunts Point, Pelham, Woodlawn—he would remove his driving wrench, walk down the length of the car, and reset the wrench for the return journey. Before leaving, he got out to adjust the electrical mechanism making contact with the suspended overhead lines. Everyone looked up as the sparks flew upon contact. The trolley man also had a long crowbar in hand. He adjusted the steel trolley tracks. The sound of the steel thud was unique to the movement of the rails. The trolley man's uniform was made of a very heavy dark blue, almost black cloth and he rarely smiled. His shoes were black and thick. He enforced the no-smoking rules. He always asked your mother if you were over five. She would reply, "He is big for his age." He didn't believe it for a minute. Sometimes in her embarrassment she paid the nickel even though she didn't have to. The trolley was always old-looking and was painted yellow, orange, red, green, black, bright colors that became dull even when newly painted. It didn't need to *look* new the way autos needed to look new.

The trolley took time to get where you wanted to go. It stopped, I think, at every corner or maybe every other corner to take on passengers or to let them off. It passed through very poor neighborhoods. At night one always felt afraid in the trolley car, no matter what the neighborhood. When you looked out through the double-hung wood windows during the evening, the buildings appeared umber brown, sepia, and in the apartment blocks the shades with their string pulls were usually drawn. The seats in the car were made of hardwood, some slatted, some cane woven. You faced front or faced the other passengers across the aisle. It was a thrill to receive a transfer because the paper was so thin and the colors soft pastel. Once in a long while the conductor before starting his trip let you sit on his steel-supported driver's stool.

Many trolley lines intersected at *places* called *squares*, such as Westchester Square, West Farms Square, the Hub Square... the squares usually were in a location near the els. The el structures were rusty and the rivets masculine. The squares reminded one of the uniforms the soldiers wore in World War I when marching in parades. The squares were Bronx-American. The aftertaste of having been over there in the forests of France was hardly spoken of by your uncles.

One sensed poverty throughout. The Bronx was a frugal place; its atmosphere gave off an air of emptiness and had a profusion of vacant lots. The trolley was connected to the earth by its wheels on track and connected to the air by its electronic wires. When moving, the passenger felt both connections. He felt the slow, harsh, distant rhythm of the Bronx and he also sensed the reality of ghosts, particularly while waiting in a winter snowstorm at night, when suddenly through the white a single light appeared in the distance and a warning bell sounded.

Figures, edge figures came to the apartment door; they lived in one-room boarding houses. The man with a small valise pressed horizontal to his chest when he clicked it open. Inside were shoelaces, buttons, safety pins, needles and thread, a few small bars of soap, and matches. Another man who sold on credit. Items: dish towels, washcloths, fine handkerchiefs, and a tie or two. He came every week for part payment, which he recorded on a card 4 inches wide by 8 inches long. When there was no money, our mother told you to keep quiet until he stopped knocking and finally left. And also the encyclopedia man lugging a complete set.

In the Bronx there was a Catholic Protectory where the boys wore long-sleeved white shirts with open collars and large black high shoes with brown knee socks that fell down upon open shoelaces; some wore knickers. They marched single file. Some men of the Bronx wore gray caps and rolled paper rectangles for their tobacco. There were people actually called "aunt" and "uncle." Coffins were placed in the living room. Japanese beetles were plucked from roses and dropped into kerosene-filled jars. Boys drowned among punk reeds of dead creeks, and hearses were parked in the middle of the block. And the shrill voice of the "I cash old clothes" man could be heard. It was a time when teachers were respected and gave you self-respect. I am not speaking of a nostalgic time, I am speaking of a real time.

Name/place carries weight. Something inevitable about name/place Dr. Thron and the east Bronx. The name/place Kafka/Prague equally carries a remote darkness. I imagine Munch/Oslo might be another and surely Hopper/America with the added necessity of confining dates. Kafka/Prague—Hopper/Bronx not so far away from each other. The sense of remoteness connects. Kafka's *Amerika* captured the tone of the overhanging sense of dread. The feeling that something was wrong and the terror of an undefined situation about to happen. That is to be in a state of suspended time.

Medical services meant Dr. Thron and Dr. Bikak. They made house calls, both carried black leather satchels. When sick, you waited for them to come to your room. Both wore three-piece suits, Dr. Thron in heavy brown tweeds, Dr. Bikak in heavy black. The name struck me. Dr. Thron—somehow the name sounded foreign. Its volume stuck. I recently was touched when I read a piece by Cynthia Ozick in which she speaks of Dr. Thron. He too was her childhood doctor and I bet he impacted upon her. Dr. Bikak was equally mysterious. Somehow within the family (the Czech part) he was considered somewhat the radical or more specifically "modern." He practiced medicine through injection. I remember he also lived near Woodlawn Cemetery.

Other aspects up there were the empty lots and the solid cube brick apartment blocks and their silent awnings. Empty lots permeated throughout the Bronx. They were unattended and were pocked with weeds, scrub trees, boulders, and rocks, homes of stray cats. Open-air community centers of the lonely Bronx. They were framed areas, dirt filled, of unknown goings-on. They were the leftover spaces of a city. You were warned not to go near the lots at night. One did not have to be told, you already knew that.

The cubic apartment blocks were the sentinels of the lots. They were unmoving and unrelenting. Many were isolated brick-faced blocks set upon horizontal planes surrounded by perspectives of receding telephone poles. Yet the compacting image upon my soul was the awning suspended on the six-story gridded deep-windowed blocks. These volumetric awnings were supposed to keep the sun out, but I think that they hid things going on within. They were the multiple enlarged three-dimensional eyelids of encapsuled souls inhabiting six-story walk-ups attempting to survive. We know there are structures that are alive or at least give off a haunting afterlife, the gondolas of Venice, for instance, or even the Concorde, not to forget the *Bacchus* of Michelangelo where breath comes out of the marble statue's lips. Nonetheless, the awning imprinted, and many years later, silently looking at a Hopper drawing of little girls playing in an empty lot next to a singular brownstone building with awnings, one knew that Hopper knew. A unique sense of moment. Only in America.

Then I crossed the Harlem River and began my studies at Cooper Union. And it was here in 1947 in a humanities class taught by a professor named Caldiero, who looked like Savonarola and was graced by his love of literature, that I read Kafka's *Metamorphosis*, a singular architectural event of my life. That is the precise description of that space of dread or, more specifically, the space of night that later on I came to know as the meaning of *to bear witness, and not to forget.*

One can not remember the future.

The two places that have provided me a sanctuary for my thought have been the Bronx and The Cooper Union—*places of spirit.*

And where I met my wife, Gloria Fiorentino.

76

RIGHT: *View of Florence,* Loggia del Bigallo, 1352, published in Leonardo Benevolo, *History of the City* (Cambridge: MIT Press, 1980), p. 441.

At the Edge of the Urban Millennium

ALAN PLATTUS

There are worse characterizations of the thousand-year period now drawing to a close than the one proposed by the historian Josef Konvitz, who entitled his book on the development of the city in the west *The Urban Millennium*. For all that such millennial references exploit the arbitrary chronology of the so-called Christian Era, it is undoubtedly the case that since the revival of trade in the tenth century, Western civilization has been characterized by a virtually continuous and dramatically accelerating curve of urban growth and development. The city has been the privileged site of cultural innovation, political and social change, and until very recently, the preferred place of work and residence for the most dynamic elements of the population.

That does not mean, however, that we should necessarily find ourselves discussing the end of the urban millennium today. No doubt there is a great deal of evidence available to sustain such a discussion, from the economic geography of late capitalism, to

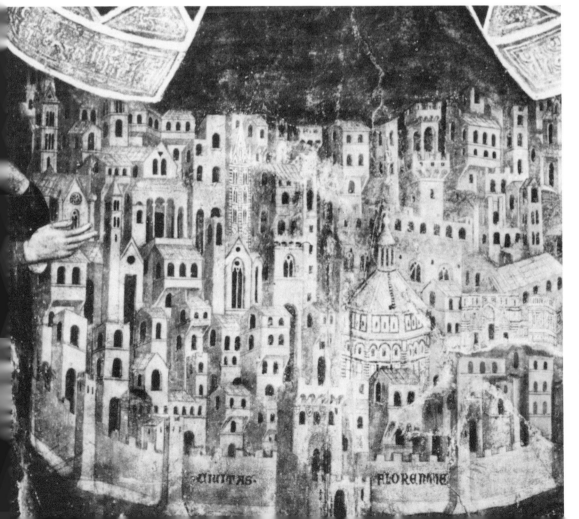

postindustrial technologies of transportation and communication, to demographic pat-
terns that, since the 1960s, in this country at least, have made the suburbs more populous
than either the city or the country. Perhaps we should recall, lest our phenomenology of
world cities become an exercise in forensic pathology, that round about the last millenni-
um some of the gloomiest prophets of doom, such as the Burgundian monk Raul Glaber,
turned only a few years later to the celebration of the "white robe of churches" donned by
a postmillennial Europe.

Admittedly, that sort of optimism now seems remote in many respects, and not only
because the problems faced by contemporary cities seem so intractable. (No doubt the
approach of the anti-Christ looked intractable in the tenth century.) In fact, critical
thought and theory in the twentieth century has dwelt on only the dark side of millenari-
an discourse, with its constant reference to the *end* of things, but has lost the utopian com-
ponent of that discourse. Glaber's "white robe of churches" was more than the
characterization of a building boom. His metaphor invokes the *church*, both in general
and in particular, as the metonymic embodiment of the Heavenly City to which all earth-
ly cities, insofar as they aspire to redemption, must refer. Whatever hopes are now sus-
tained for the redemption of the contemporary city, whether they are associated with a
"white robe of convention centers" or a rather more gray robe of homeless shelters, are
cast in terms of an instrumentalized discourse of economics or social reform rather than
discredited and deconstructed utopian models.

The intellectual weaponry deployed against those models has had devastating effects
well beyond the limited business of a critique of utopia. In this new age of nominalism, we
are not simply in a prolonged retreat from the grand narratives of utopian thought and
urbanism; we have even become reluctant to indulge in weaker versions of suspect habits
of thought, such as those that posit paradigmatic cities or "world capitals." We may be
tempted by the comfortable simplification, and uncomfortable ethnocentrism, that pro-
duces the heroic urban genealogy leading from Athens and Rome to Florence and Rome
again, to Paris and London, and then on in its westward trajectory to New York, Los
Angeles, and perhaps even Tokyo, but one has too many multicultural scruples, not to
mention theoretical reservations. In retrospect, it seems that the ability of any single city
to summarize, characterize, or otherwise represent the state of world culture and urban-
ism was already exhausted by the end of that period dominated by increasingly desperate
attempts to project the "world city." The period bracketed by the great *world's fairs* of
1851 and 1939, and brought to an end by the last *world war* was also, not accidentally,
precisely the golden age of the modernist utopian urbanism now so thoroughly discredit-
ed. Not only is there no consensus candidate for the capital of the late twentieth century,
but we doubt that there should be and we recognize that world culture, and especially
global capital, passes through (when it does not bypass altogether) cities, creating at best
the temporary illusion of focus and concentration.

Taken to its logical conclusion, then, this new urban geography casts doubt not
merely on the quaint idea of *the* world capital city but on the very idea of the city as a

RIGHT: Hartmann Schedel, *Registrum Huius Operis Libre Cronicarum*
(*Nuremberg Chronicle*) (Nuremberg: Anthonius Koberger Nuremberge, 1493).
Smithsonian Institution Libraries, Cooper-Hewitt branch, New York.

coherent, unified, and imageable entity or concept. Even to talk as if particular cities, much less *the city* in general, exist as delimitable, describable entities is, in this context—the context of megalopolis, edge city, and poststructuralist theory—taken to be nostalgic and *arrière-garde*. The contemporary urban realm is described as fragmented, disjunctive, unbounded, ephemeral, and the site of radical difference. Urban and architectural design, predicated upon some idea of the "city as a whole" or upon shared public values is, therefore, suspect and apt to be labeled utopian, however modest its claims. Ironically, then, but perhaps not surprisingly, both avant-garde and conservative design converge in their antiutopian avoidance of the *problem* of the city, in favor of the *image* of the city. Both, therefore, inevitably reinforce and actually represent deep structural forces in the economic and social spheres, which tend increasingly to produce the city as a series of discrete and largely disconnected enclaves: self-contained microcosmic "cities," which may simulate in form, image, and nomenclature some notion of a city, but do so in the service of a limited use and constituency.

Therefore, in our skepticism or despair about the city in general, we have produced, at the end of the first urban millennium, a curious recapitulation of some of the conditions prevailing at the beginning. Indeed, the medieval city was the quintessential city of discrete enclaves, where each corporate entity—church, monastery, university, guild, etc.—each political authority and even each extended family had its identifiable district, each of which frequently functioned as an autonomous "city within the city." The process of urban modernization since the Middle Ages could, from this perspective, be viewed as a process of opening up or suppressing those separate enclaves and corporate identities in the interest of the city as a whole. From this perspective the city is increasingly

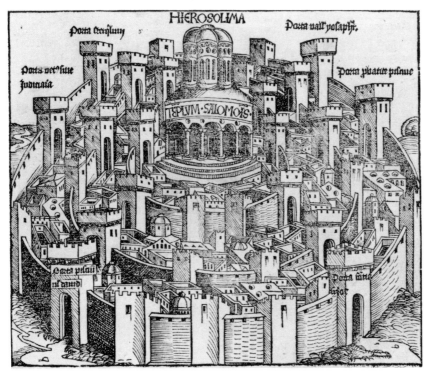

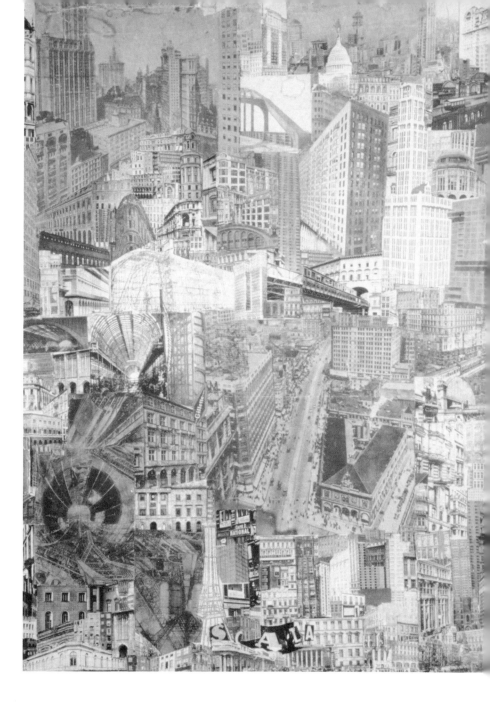

Paul Citröen, *Metropolis,* 1923. University East, Leiden, The Netherlands.

understood and constructed as interconnected and potentially unified networks of power, social structure, and physical form. This highly self-conscious tradition of urban design, from Brunelleschi and Sixtus V to Haussmann and Robert Moses sought to obliterate urban difference in the name of urban unity, beauty, grandeur, control, sanitation, and speed of movement. In its utopian hubris, it sought to actually build the heavenly city in any number of places, rather than isolated symbols of it. The curious and ironic notion of the withering of the city and its replacement by a regional or megalopolitan network is only a late stage in the development of that progressive tradition.

How urban modernization eventually turned back into its opposite—the city of radical difference and differentiated social and cultural enclaves, described recently by Michael Weiss as *The Clustering of America*—is a long and complicated story. One aspect of that saga is the strange and alarming process by which technologies of connection, through the monumentalization of transportation and the ephemeralization of communication, have become the agents of extreme disjunction and the displacement, if not the death, of the public realm. As Rosemarie Bletter has pointed out, the utopian modernism that romanticized those technologies (and, for that matter, the neo-avant-garde that continues to promote them) takes on a more apocalyptic appearance in retrospect. The grand boulevards of the Renaissance and City Beautiful tradition, which were—quite literally—aimed at the monumental ordering and interconnection of the whole city, became the high-speed, single-use superhighways of postwar Europe and America, dividing neighborhoods, separating city and suburb, and eventually spawning a whole new category of pseudo-urban formations: cities without—rather than within—the city.

Reacting against urban *modernism* and *modernization*, postmodernism has, in many respects, simply confirmed emergent tendencies within those uncomfortably twinned movements. The postmodern preoccupation with the image of the city—whether the conservative image of the traditional town or the avant-garde image of the postindustrial landscape—when monumentalized as architecture, reinforces the tendency of the contemporary city to implode into isolated metonymic pieces while simultaneously continuing to explode beyond conventional boundaries and limits. No wonder we are reluctant to continue to talk about cities in colloquial terms, when both the consumer culture and the elite culture of late capitalism have conspired to produce urban simulations, from Disneyland and the Houston Galleria, to Seaside and the Getty Center, where the spectacle of consumption and the spectacle of culture converge, ultimately producing the spectacle, but not the reality, of the city. The "world city" is thus anywhere, and nowhere at all.

Given the date, there is an enormous temptation to see this as a terminal, rather than recurrent, condition. Will we be able to *talk* about cities again, much less *build* them? Can an urban phenomenology produce something other than a new and ingenious stock of consumable images? Might we begin to discern in the particular patterns of particular places not only the familiar and increasingly dysfunctional clichés of urbanism but, in the interstices between isolated enclaves, populations, and individuals, the possibility of a

discursive reconnection, based neither on utopian models that repress differences of place and people nor on postmodern models that reify them? If we ignore the calendar, it may be possible to steer a course between the utopian project of the "first city" and the millenarian obsession with the "last city," in order to get down to the business of building the next city.

London Beyond the Millennium

PETER COOK AND CHRISTINE HAWLEY

We come with few illusions of London's reality: a marvelous city of rich combinations of urban fabric and a true cosmopolitanism. It has reached great size without achieving great height or great density. It does, of course, encompass many monuments, set pieces, and picturesque corners, yet the whole is often unfathomable.

It has often been noted that London is "a collection of villages," and this is both historically and organically true. The privileged villages remain as highly identifiable gems: Hampstead and Highgate in the North, Chelsea and Chiswick in the West, and Dulwich and Blackheath in the South East. There is no doubt that many, many people would really wish to live in such metropolitan villages, and so, bearing in mind the innate conservatism and nostalgia of the English, we should not be surprised that much recent domestic architecture is presented by developers as "neo-village": a form of marketable romanticism that contains, of course, few of the dynamic elements that would really have generated a village.

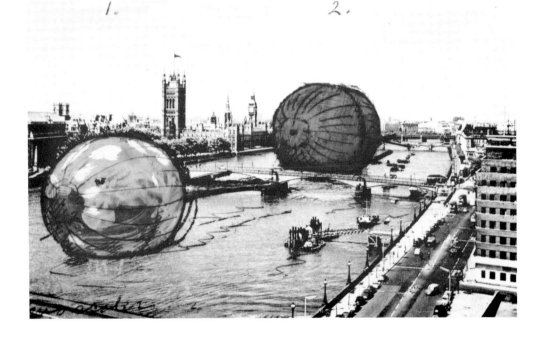

Claes Oldenburg, *Proposed Colossal Monument for Thames River: Thames Ball*, 1967.
Carroll Janis Collection.

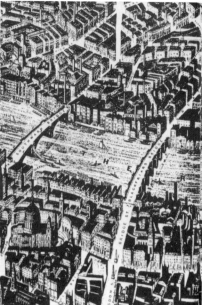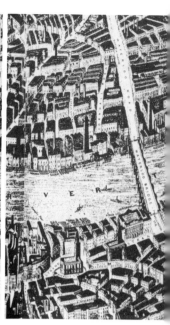

Between the "generic" villages, the nineteenth- and early-twentieth-century developers laid down great patches of infill. It is interesting to compare different idioms of such patches. There were attempts to make classical compositions, of course, but the instinct for the picturesque overtook the legacy of the Georgian squares. Many middle-class or workers' dwellings were offered with a variety of prefabricated ornament. Urbanistically, these patches of (what is now) inner suburbia belonged neither to the radical "village" system nor to a hierarchical matrix such as one would find in most continental European or American suburbs.

We can therefore see an immediate future of London where a radically restructured system is unlikely, where the patchwork of villages and infill is left, with a second or third generation of dispersed centers. The twentieth-century components are a tube station and a supermarket instead of a "green," a church, and a hostelry. In recent years there have been deliberate attempts to create dispersed centers on the American pattern of mall and supportive complex. Brent Cross in the North West is the least affected by historical remnants, whereas Wood Green and Stratford in the North East and Wandsworth in the South West are necessarily based upon "old village" origins, and the insertion of the mall and its supporting parking lots is usually an architectonic nightmare.

Yet London is tough enough and also elastic enough to survive all this, aided perhaps by another pattern of change. For it has become a major tourist town. With the tourists has come the relatively benign rediscovery of the Covent Garden area in the center as a more pliable instrument than Soho for the type of ubiquitous demands of an international clientele: street theater, bright clothes, street eating, a good mix of arcades, alleys, piazzas, and walkabout areas such as are available everywhere from Brussels to Toronto.

84

A View of Central London, 1851, published in Leonardo Benevolo, *History of the City*
(Cambridge: MIT Press, 1980), pp. 742–743.

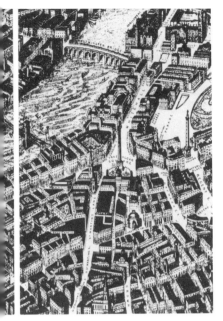

More interestingly, some latent charm has been extracted from previously tack localities like Camden Lock, Islington, Battersea, and Whitechapel. Remnants of the 1960s and 1970s "alternative" world have been grafted onto more relaxed drinking hours. And again the results of international travel have called attention back to the potential of an open shop front and an idiosyncratic perambulation.

Nonetheless, the great opportunity for London still remains untapped: its river. For the Thames is a picturesquely formed and well-bridged piece of water. It has become a cliché to observe that "London turns its back on the Thames." Yet this suggests that the next generation need not do the same. We have moved past the stage of needing a pair of highways (one each side) in order to make it approachable.

The departure of working ships from London and the construction of a barrage that can control flooding give us a patch of tame water with a typical range of buildings that could change their use, as well as a high proportion of "soft" sites where new buildings could occur. It is not surprising that the Thames is a constant theoretical test-bed for the student projects that are highly regarded elsewhere in Europe for their inventiveness and lack of inhibition. In the two schools that we represent (Christine Hawley, the East London University; Peter Cook, the Bartlett School of University College, London), there are a number of schemes that take advantage of the power and dynamics of the tides, the flowing water, the existence of floating parts of buildings, and, naturally enough, the English tradition of inventive boat building as an architectural approach.

In contrast with this interactive and essentially dynamic approach lies the sleeping colossus of the Developers' Men: Canary Wharf. By our reckoning it posits a sterile architecture full of pomposity, reminiscent of an American downtown—without the character. At certain times of the evening or night it can impress as a pictorial set piece, but seems to make no active impression on the river.

Elsewhere, the extraordinary challenge of building in among the recently vacated docks and wharves seems to have been interpreted as another voyage down "memory lane." Typically, the notion of some yellow-brick village, of an England of pointed roofs with pennants aloft, with some faint waves in the direction of high tech in the detailing, crops up. But our fear is that this architecture—if encouraged to spread onward over all of Docklands—will add up to what the English call "noddy land." A "toy town" both aesthetically and organically.

We should like the next millennium to welcome a series of architectural insertions into the water that are as bold and active as those original docks were: perhaps boats-as-buildings, perhaps multiactivity buildings where you can both live and make things and then lower them down into a waiting barge or hydrofoil. Marvelous hybrid buildings that

would encourage enterprising people back into this core of London rather than spending their time zapping back and forth around the periphery from home to work.

More specifically, though, we have both responded to the parts of London in which we each live: Christine Hawley to Peckham and Peter Cook to lower Hampstead.

Christine's scheme is a response to the reality of her old, battered inner suburb. For Peckham is a district filled with character, with hidden gems of domestic and commercial architecture of the nineteenth century interwoven with neglect and even hostility. There are rotting fences and walls. There are streets of violence. There are corrugated-iron sheets and meshed fences. There is burnt wood. Instead of despairing herself, however, Christine has observed the minutiae of a small site near the Peckham Road, documenting the graffiti, the torn protest posters, the heaps of wood, the flapping sheets of boarding, the rusting metal, and the tough remnants too. It must be remembered that the scale of all this is much finer than it would be in a large American city.

Her resulting architectural invention is also fine-grained: effectively a collage or "fitment" created out of these same materials where appropriate and out of new materials when necessary. The whole intermixed. The plan's form is like an armature that contains a wayward organism—somewhat in the manner of a Chinese junk or rickshaw—working and facilitating, but (almost) bending with the wind. Close inspection of the drawings reveals a design attitude that is very much in the English "engineering daredevil" tradition. Sweeping curves and thin skins just within the limits of lateral or tensile strength. The project should be read not as a direct prototype for all of London but as a marker

86

Christine Hawley, *Peckham Perspective*, Cook and Hawley Architects, London.

that suggests the optimistic and opportunistic creativity that might lie in the most unexpected quarters. A kind of scavenger's architecture.

In Peter's scheme, a recurrent characteristic of London—its weather—is the basis for a local project. In this case, the coincidence of a number of watercourses and the characteristic of "dampness" are combined. A series of apartment blocks, running east to west from the hill of Hampstead down into an underused area of railway sidings and residual land, are to be invested with dampness. Water is drained down from the hill and caught in overhead pans. It can be trickled slowly and cunningly down the facade and along small channels. Vegetation is then encouraged to emerge from this dampness.

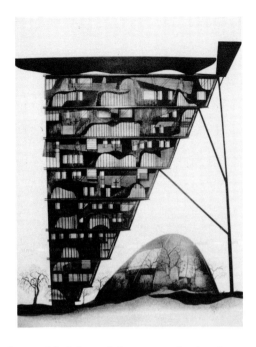

The area also enjoys a tradition of Edwardian red brick, and the same color is adopted to house the mossing-over and planting-over. The housing itself is designed to leapfrog over the majority of the ground, so that backyard industry and greenhouses can return to the area.

In many ways this project is seen as a prototype for *directional* development that connects the old "village" centers through to the less defined infill areas. It is also clear that railway land, as with dock land, offers a chance to augment inner London as a place in which both to live and to work. It is rhetorically not "toy town" in scale, yet every apartment can express its personality out to the sky.

In the next millennium, London could be the testbed of architecture that is crafted and invented, as it has been in the past, with a combination of indigenous characteristics and the newest technologies. A city that is creatively "living on its wits."

Peter Cook, *Hampstead Apartment Building*, Cook and Hawley Architects, London.

Tokyo: Real and Imagined

MARC TREIB

Every city is, in fact, at least three cities. The first is the artifact: physical, indisputable, the network of streets and urban places and the buildings that surround and define them. The second city is perceptual, and it introduces the human presence to the urban conglomeration. The perceptual city is a negotiation between the artifact and the human being. It is form limited and redefined by the human senses. Here the city can be sensed as brilliant or depressing, glorious or terrifying, odoriferous or fragrant, loud or quiet—this is the realm of how it seems. Finally, there is the cognitive city, the product of the brain and its experiences: how the inhabitant structures his or her perceptions and links them to the physical network.[1] We think the city into existence as we think any situation into a state of truth—a theme so beautifully explored in Akira Kurosawa's film *Roshomon*, in which three people each present their own version of an unfortunate event.[2] There is no single truth, no single explanation; even observation itself is open to scrutiny.[3]

This tripartite classification of cities fits Tokyo quite suitably. Particularly for those of us foreign to Japanese culture, Tokyo appears as an urban process rather than a product, a series of experiences and perceptions in flux. The pattern appears at times labyrinthine, thwarting every attempt to ascertain its rationale. Streets are for the most part unnamed, and even the districts that form the elements of Japanese addresses appear diffuse, the exact edge or border between ward or district vague and difficult to distinguish.[4] In place of identification, we offer guesses; instead of certainty, we entertain negotiation. In a sprawling megalopolis of some 12 million people (depending on how you count them), one tries less to structure the city as a whole than to establish where one is and how to get from point to point. But, of course, Tokyo does have its structure and, of course, its meanings, and these are quite transparent to its inhabitants. In this short overview I would like to offer some brief comments on Tokyo, in particular its structure, its development, its buildings and life, and even some hints about how people attend its structure.

Until the seventeenth century Tokyo, or Edo as it was known, was a provincial center. But with the ascendancy of the Tokugawa clan and their control of the military government, in whose hands temporal power lay, the face of Edo changed profoundly. The cluster of villages, which we in the West might associate with the settlement pattern of London or Los Angeles, was a grouping of somewhat distinct villages that were swallowed and

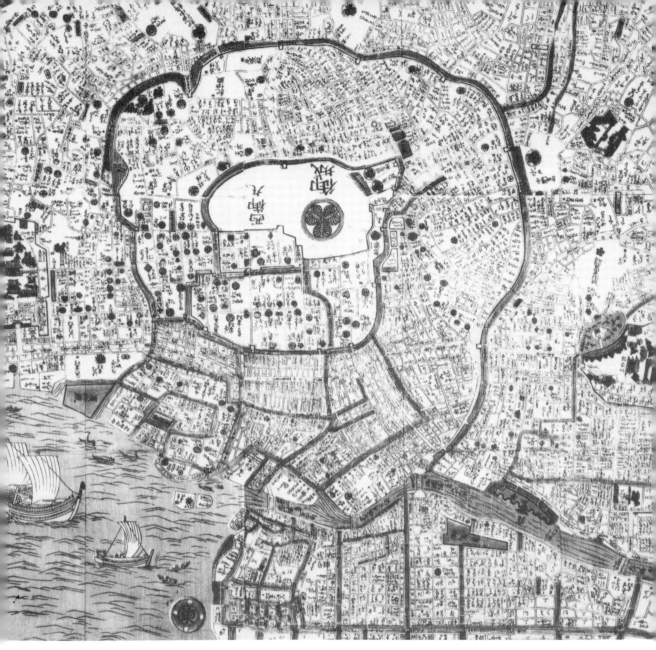

submerged by the growing city.[5] From settlements determined by roads or the water's edge, Edo was re-formed into a loosely radial city, with the Tokugawa castle occupying the center. Radial here should not be taken as a pattern in which streets emanate from a central palace complex, but instead as bands of hamlets or districts positioned according to social rank or trade and organized in a loosely spiraling, concentric arrangement extending out from this ceremonial center. The *tenshugaku*, or keep, of the castle was the highest structure in the city and formed the central marker—as the Eiffel Tower might serve as a locus for Paris and as today's Tokyo Tower might mark the Japanese capital.

To examine in detail the developments of the city during the period from 1603 to 1867,

89

The Daimyo of Edo (Tokyo), 1849.

which gave the Edo Period its name, is well beyond the scope of this essay. But life in Edo could generally be described as falling into two major patterns linked to geographic location. In the *shitamachi*, or lower town, dwelling and commerce were dense and teeming, while in the *yamanote*, or higher hill districts, land was given over to the estates of the upper strata of society. In addition, the relationship of estate or household position to the castle was a literal diagram of status or need. If there were structures best characterized as palaces within the walls surrounding these estates, there were also gardens. And the private greenery of the *yashiki* stood out in marked contrast to the the packed *nagaya* or *machiya* townhouses of the lower city.[6] As the density of commercial buildings and dwellings in all areas of Tokyo has increased over time, the differences between the various districts have been somewhat mitigated. Today the contrast between the houses and tiny, bustling shops of the *shitamachi* and the estates of the *yamanote* has been lessened, and the contrasts are primarily between high-density low-rise construction and high-density high-rise construction. Tradition persists, however, and in areas such as Asakusa, the shops, skills, and tastes of Edo still remain.

With the fall of the Tokugawas and the reinstitution of the Emperor Meiji in the late 1860s, the face of Edo—renamed Tokyo or the Eastern Capital—began to change at an increased pace. After almost a thousand years as the capital of Japan, Kyoto relinquished its title. The emperor and the imperial compound moved east to Tokyo, an important port

and a location more central to Honshu, the main island, and commerce. Edo, the center of the shogunate, thus became Tokyo, the national capital. Foreign cultural influences accompanied the importation of Western technology. And for the first time, Westerners saw the process that has characterized the history of so much Japanese culture, wittily described as adopt, adapt, adept.[7]

Japanese architecture of the late nineteenth century, like the manners of the people themselves, could be a curious conglomerate of East and West, uneasy meetings such as top hat and boots with kimono, or banks that were forthright mixes of the Japanese traditional storehouse and Western classicism. The Mitsui Bank, built in 1872 by Kisuke Shimizu, provides a representative example of the trends. It is a building that could better pass as a castle than a bank in the Western manner. Only

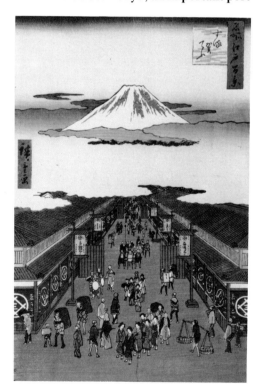

90

Andō Hiroshige, *Suruga Chō* (Suruga Street),
from the series *Edo Meisho Dzuye* (Views of Edo), c. 1840.
Cooper-Hewitt, National Museum of Design, Smithsonian Institution.
Gift of the Estate of Mrs. Robert H. Patterson, 1941-31-301. Photo: Ken Pelka.

the reliance on building mass and the wall, rather than the traditional beams structure with infill panels, distinguishes the bank from traditional Japanese architecture.[8] Examples such as this illustrate that the notion of the city as a collage of institutions and styles began in the Meiji Period. In the West the classical ideal has sought uniform facades or building height, regarding the city as a conglomerate that ideally represented unity and order. The Japanese city, even in monumental sectors, grew more organically, following no preconceived formal patterns.[9]

Japanese urbanism centered on the street and thus was projected linearly rather than as a field. In the Greco-Roman tradition of western Europe, the plaza or square provided the central point of the town—as St. Peter's Square does in Rome, or the Piazza San Marco in Venice. This tended not to be the case in Japan. For example, the central precinct of the Tokugawas, later the imperial castle, was a private rather than public space. Even before the destruction of most of its buildings, Tokyo had acquired what Roland Barthes has termed the "sacred void": an imperial precinct of which everyone was aware but few actually knew.[10]

During the first decades of the twentieth century, landmark buildings in Western modes continued to be constructed, but the traditional city plan and building practice still predominated. Isolated masterworks such as Frank Lloyd Wright's Imperial Hotel of 1922 may have established a new standard of architectural excellence—at least in Western eyes—but they remained foreign to vernacular building, and decades were to pass before they exerted even a diluted influence.[11]

In 1923 the Kanto area was devastated by a powerful earthquake and a fire that virtually destroyed six wards of the lower city.[12] While Tokyo was rebuilt and thrived in the decades following this natural disaster, a tragedy of even greater suffering accompanied the firebombings that led to the termination of the Pacific War. If the capital was spared the agony of atomic bombardment, few structures for housing or business remained standing in usable condition within the central city. Maps plotting areas destroyed during the American bombing raids reveal a numbing degree of desolation.

Postwar recovery provided an immense opportunity to revise the form of the traditional city and to implement alien planning ideas, although financial resources for grand schemes were nonexistent until decades after the signing of the treaty ending hostilities. For the most part, reconstruction replicated what had been. Some new roads were cut; new subways were laid; and additional canals were paved over to serve as major traffic arteries. Although these waterways remain beneath layers of expressways superimposed upon street traffic, their aquatic origins are revealed in such place names as Kyobashi, Edobashi, and Nihonbashi, in which *bashi* refers to a once important bridge over a canal. Until this century, Tokyo was a city of waterways, and to a considerable degree, urban development in the city was predicated upon the reshaping of the land through draining, dredging, and filling.[13] Even as late as 1960, Kenzo Tange's Tokyo Bay plan proposed building housing and freeways over the water; his revised projection of 1990 extended the vision to span the bay with a bridge to join Chiba prefecture with central Tokyo.[14]

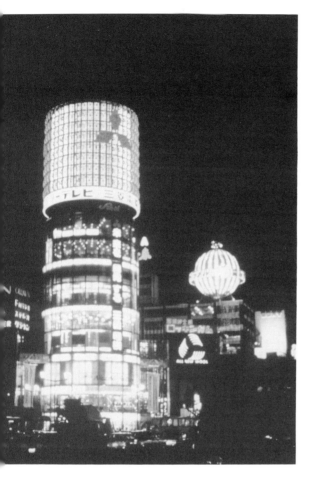

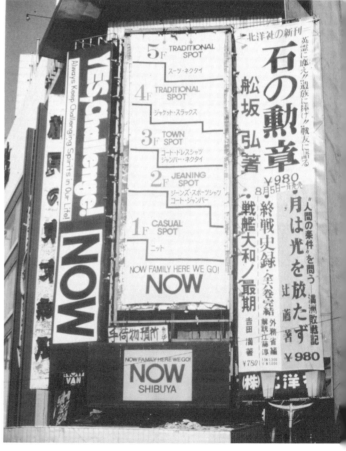

LEFT: *Ginza at Night, San-Ai Dream Center*, 1971. Photo: Marc Treib.

RIGHT: *The Facade Stripped Bare: Building Directory as Elevation*, Tokyo, 1978.
Photo: Marc Treib.

When land is limited, the prospect of claiming water is attractive. However, implementation has been constrained by seismic and ecologic concerns, financial resources, and projected economic return.

In pockets of congestion like Nihonbashi, Marunouchi, later Shibuya, and Shinjuku, the stakes and the buildings began to rise, giving way in time to high-rise building clusters. But for the most part, the pattern of low-rise high-density construction continued to dominate the consciousness of the people—and like the Angeleno, the Tokyoite has learned to accept the commute as a normal part of daily life.

How does one see Tokyo today? The city can appear as a bewildering collage of marks and patterns that only native speakers decipher and read as information. Buildings of architectural distinction are low in percentage, and one is faced instead with a transitory city. Within a space of four months at the end of 1987, our neighborhood received a fine noodle restaurant and a hotel; a four-story building was torn down; and a replacement five times its size was well on its way toward completion. With the city changing so rapidly, no one seems too concerned with the merits—or the impact—of any particular building. One can accept most anything, from the ridiculous, such as the bulldozer on the top of the Komatsu heavy equipment building, to the sublime, such as the Oxy or Face towers that all but turn their backs to the city.

The Japanese appear to be untroubled by what Westerners perceive as a lack of functional clarity, confused circulation patterns, an apparent disregard for the environment and its management, and even the sacred cow of economic return.[15] Buildings that are regarded as artworks punctuate the skyline; what they mean to anyone except their patron and their architect—if even to them—is questionable. And one can even question whether anyone ever raises the question of their meaning.

For a considerable portion of the built environment of Tokyo, the building's own expression is secondary to the semantic burden it must bear. In many instances, the building itself is reduced to a framework upon which the sign is mounted.[16] Nowhere is this more apparent than in the Ginza, a fashionable shopping and restaurant district in downtown Tokyo. From the 1960s on, the prevalence of electric signing grew until, by the early seventies, the Ginza could be said to have become a veritable light show. During the daylight hours, the district displays a restraint, elegance, and homogeneity that is rare in Tokyo. When night falls, however, the impression changes drastically; from stasis springs animation; from basic palettes of beiges and grays spring clusters of variegated colors.

For the most part, these multistory signboards are vertical extensions of middle-rise buildings, each advertising a consumer product or business. But what distances these electronic billboards from their contemporaries in other countries is not only their location on virtually *every* building—office, apartment, or commercial—but also the extended period of their programs. Their repeat time has gotten longer and longer. Signs not only broadcast; they also illuminate. Light is reflected in the faces of the Tokyoites and visitors who inhabit these districts until morning. It is common to come upon traffic jams

at eleven at night and even at one in the morning as different categories of restaurants, bars, and clubs bring their hours of service to a close.

The people of Tokyo use their city. Lacking space within their own homes, often shared with a parent until relatively later in life, young people treat the city as their living rooms. *Kissaten*, or coffee shops, are built as distinctly neighborhood hangouts, often constructed around exotic themes of escape. It's all in the decor, as the products and services tend to be pretty much the same. And even more exotic in form and iconography are the so-called "love hotels," which rent rooms by the hour for assignations of various types to couples (and perhaps to larger groups as well) who seek a moment of privacy and/or intimacy within the frantic whirl of the city.

Seeking tranquillity in Tokyo is a never-ending quest, and a quest that has virtually no solution, even in the suburbs that extend out from and girdle the city. Although it has been effectively curtailed in the recent years, pollution of various sorts still seeps through every dwelling; if not air pollution, certainly the sounds of commerce are ever present. The architect Takefumi Aida once stated that the one gift that architecture could still provide is a moment of silence in the noise of the everyday world.[17] Indeed, this is one direction that Japanese architects today take in formulating an architecture to cope with the phenomenon that is Tokyo.

Of the current generation, no designer is better known for this than the Osaka architect Tadao Ando. Ando, who has stated that there is virtually nothing in the contemporary environment he wishes to embrace, contrives the residence as a castle in which to escape its surroundings.[18] His houses are turned inward, rejecting their neighborhood, their architectural context, and the society that was the norm for the residential/commercial street.

The Kidosaki residence (1987) on the outskirts of Tokyo is a complex building for three family groups: a married couple, her mother, and his father. Ando masterfully

Tadao Ando, *Kidosaki House*, Tokyo, 1987. Photo: Marc Treib.

weaves their living quarters together after walling the entirety from the street and the neighborhood—a social gesture some might easily question. Each living unit has its own court, each its connection with the other and with the sky. The link between human and nature is vertical, with the skies, instead of the more familiar horizon. In this configuration the house serves as its own universe, architecturally, socially, and philosophically.

If Tadao Ando literally rejects the city and organizes buildings as sanctuaries from urban existence, few other architects address the pattern of the city and its buildings. Instead, each conceives his or her structure as virtually the only structure on earth, whether the polished shaft, the fantasy shape, or the high-tech skin. Everything can—and often does—go. Tokyo, as a result, has become and will remain a conglomerate in flux. Architects such as Fumihiko Maki, who address the city and understand both its positive collective presence and limits, are relatively rare. Singular, too, are works such as Maki's Spiral Building (1984), which derives the form of its facade from the fabric of its context without succumbing to its banality. The complexity of the composition is equaled by the degree of formal resolution, and the resulting design ultimately transcends its context. Like Ando, Maki presents an alternative to the status quo.

Of the three cities that are Tokyo, I have addressed most of my comments so far to the physical entity. But how is Tokyo perceived? How is it structured? To begin with, we must extend our range of possible sensations and we must add the smells and the sounds of the city. A district such as Akihabara, with its seeming mountains of electronic goods, is conjured as much by the sounds of cassette, compact disc, and television as it is by the buildings that hawk them. Series of television images on display, each in synch by default, provide an animation that mimics or contradicts the movement of real people marching past their screens. In almost every sense the replication opposes the actual, and the boundary between the physical and the perceptual is blurred.

In other districts the smells predominate: the smells of roasting chestnuts or squid on the street; the smells of the Central Fish Market at Tsukuji; the perfume samples on the first floors of certain department stores; or the incense burning at the Asakusa Kannon or numberless other temples and shrines throughout the city. We may rely principally on

95

Fumiko Maki, *Spiral Building,* Tokyo, 1984. Photo: Marc Treib.

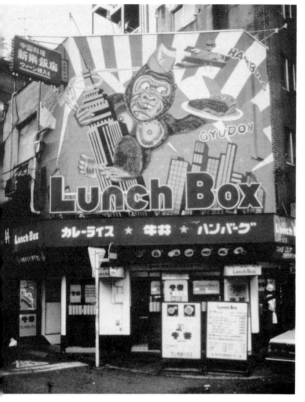

our sense of sight, but these other senses add immeasurably to our experience and our collective image of the city.

On my first visit to Tokyo in 1971, I questioned how people could move from one place to another with any degree of efficiency and satisfaction when their streets were not named and houses were not necessarily numbered consecutively.[19] Certainly the Japanese are willing to accept a degree of uncertainty in their searches for places that would be quite unacceptable to the average American weaned on the grid. We like to know exactly where our destination lies and have a good sense of how we will get there—even before departure. The Japanese, on the other hand, rough things out, first ascertaining their general direction, then finding the district, then the neighborhood, and gradually narrowing it down to a point sufficiently definable to ask at the local police box (structures themselves growing more spectacular with the passing years). From this point on, they may have to ask directions, although neighborhood or merchants' associations may provide district maps to help orientation.

Of course, one usually sets off with a map, these days faxed to your hotel by your would-be host. Maps are ubiquitous in Tokyo, and arguably the most important piece of design in Tokyo is the subway map, which, like almost every such map, is based on the prototype of the London Underground. The underground map is everything the city itself is not: it is highly structured, clear, a defined constellation with a perceptible structure. It firmly fixes the precise location of each district and shows the station as the locus of the district, which is not necessarily the case in three dimensions. To the visitor and to many natives, the subway map, paired with the Japan Railroad's Yamanote circular line, structures the urban universe. It is the new mandala of consciousness. All well and good.

But how do we know we are there when we *are* there? The building as information system completes the work of the map. The building may serve literally as a directory, each sign providing a one-to-one correlation between occupant and floor. Almost as if the facade has been stripped from the building, its contents are made visible for exterior scrutiny. A building can stand out as an individual as a Japanese citizen never quite will. Perhaps this is the ultimate irony. That within a society relatively homogenized, or so it would like to believe, one can display such external architectural differences. Perhaps all

The Lunch Box, Tokyo, 1984. Photo: Marc Treib.

this is really bogus. Architect Minoru Takeyama once offered that the Japanese can adopt any fad, any style, from any place, because in the end it just really doesn't matter. The form upon which the drapings are hung is solidly Japanese—and that is what matters. The collective presence of the city will absorb and dominate any extreme individual expression. Due to the enormity of the project, the whole will always dominate and neutralize the parts. This fact, and the essential heterogeneity of the urban fabric and its structures, allows for a bewildering variety of architectural typologies, forms, and styles. Virtually anything can be accommodated within the continually evolving urban pattern, from heroic novelty to maudlin nostalgia. Exterior facades, as well as interior decoration, collectively offer a conglomerate image that parallels the back lot of the movie studio. The cosmopolitan urge and the purchasing power of the yen provide access to a collection of urban fragments from any time and any place. The Roppongi district embodies this idea of the city as an imagistic scrapbook in which foods and building forms conjure a sense of escaping the limits of the Japanese metropolis. Authenticity is rarely the matter; instead, the place need only suggest the "taste" or "spirit" of its foreign or historical source. That alone is sufficient to create a sense of the exotic.

Tokyo may be a manifestation of the new city, and it may have more in common with the laissez-faire architecture of Los Angeles and Houston than it does with other Asian cities. Beyond that crude parallel, however, the Tokyo model is not easily replicable. One needs geographic isolation, population density, a Japanese temperament, a boom economy, and an architectural and building climate that caters to the whims of clientele while satisfying the aspirations of the design profession. Tokyo is ultimately a city in transit; a city in the future tense; a city in which the process of building, and the process of becoming, is more important than what it is now or what it has ever been before.

1 The theme of the cognitive or imagined city, as opposed to the urban artifact, is central to Kobe Abe's novel *The Ruined Map*, trans. Dale E. Saunders (Tokyo: Charles E. Tuttle Company, 1971). Historically, the perception of space was always linked to time in Japan. Both the word and character *ma* include a spatial as well as a temporal aspect, as in the space (interval) of time and the time (event) in space. See Arata Isozaki, *Ma: Space-Time in Japan* (New York: Cooper-Hewitt Museum, 1979).
2 "In more ways than one, *Roshomon* is like a vast distorting mirror or, better, a collection of prisms that reflect and refract reality.... Here, then, more than in any other single film, is found Kurosawa's central theme: the world is illusion, you yourself make reality, but this reality undoes you if you submit to being limited by what you have made." Donald Richie, *The Films of Akira Kurosawa* (Berkeley: University of California Press, 1973), p. 76.
3 See Yi-Fu Tuan, *Space and Place: The Perception of Experience* (Minneapolis: University of Minnesota Press, 1977).
4 "How can foreigners hope to grasp the tenets of Oriental philosophy if they stumble over such trivia as the *banchi* system! Will they never get it in their heads that Japanese *like* their houses dark, their words obscure, their ambiguity of speech matched by circumlocution in space, their garden paths crooked, their house entrances hidden!" Bernard Rudofsky, *The Kimono Mind* (Tokyo: Charles E. Tuttle Company, 1965), p. 270.
5 Henry Smith II has written about the similarities and differences between the Japanese and English metropoles in "Tokyo and London: Comparative Conceptions of the City," in *Japan: A Comparative View*, ed. Albert Craig (Princeton: Princeton University Press, 1979).
6 See Marc Treib, "Dichotomies of Dwelling: Edo/Tokyo," in *Tokyo: Form and Spirit*, ed. Mildred

Friedman (Minneapolis: Walker Art Center, and New York: Harry N. Abrams, 1986).

7 Rapid industrialization during the closing years of the nineteenth century also brought forth a powerful war machine, tested successfully in the 1905 Russo-Japanese War. See John Whitney Hall, *Japan: From Prehistory to Modern Times* (New York: Dell Publishing Company, 1970).

8 The appropriation of storehouse techniques for the new architecture is speculated upon in Marc Treib, "The Japanese Storehouse," *Journal of the Society of Architectural Historians,* May 1976. Meiji Period architecture went through three basic stages, although they were neither neatly formed nor precisely defined chronologically. In the first stage Japanese master builders built as best they could in a Western manner. The next stage brought foreign architects building in Japan and, later, Japanese architects trained abroad. Finally Japanese architects educated in Japan began to take the primary responsibility for monumental building.

9 Planned, rather than controlled, urban growth is rare in Japan. There is little of the comprehensive formal ordering that characterized baroque Rome or the Paris of Napoleon III. One could speculate about what Camillo Sitte might have come up with had he been asked to study the order of the Japanese city. A certain organic sense pervades both the cities of medieval Europe that Sitte examined and the Japanese towns and cities other than the gridded capitals at Nara and Kyoto. The attitude toward urban space—generalized as street versus plaza—is quite different in spite of some basic similarities.

10 "The city I am talking about [Tokyo] offers this precious paradox: it does possess a center, but this center is empty. The entire city turns around a site both forbidden and indifferent, a residence concealed beneath foliage, protected by moats, inhabited by an emperor who is never seen, which is to say, literally, by no one knows who.... One of the two most powerful cities of modernity is thereby built around an opaque ring of walls, streams, roofs, and trees whose own center is no more than an evaporated notion, subsisting here, not in order to irradiate power, but to give the entire urban movement the support of its central emptiness, forcing traffic to make a perpetual detour." Roland Barthes, *Empire of Signs,* trans. Richard Howard (New York: Hill and Wang, 1982), pp. 30–32.

11 After its destruction in the mid-1960s, the front portion of the hotel was reconstructed at Meijimura, an open-air museum of Meiji Period buildings near Inuyama.

12 See Edward Seidensticker, *Low City, High City: Tokyo from Edo to the Earthquake* (Tokyo: Charles E. Tuttle Company, 1984).

13 A number of woodblock prints from various series of *meisho-zue* (views of famous sites) show storehouses lining the waterways, symbols of activity, prosperity, and wealth.

14 For details of the Tokyo plan, see Kenzo Tange, et al., *The Japan Architect,* April 1961.

15 For an extended discussion of these issues, see Marc Treib, "Standards of Evaluation: Thoughts on Recent Japanese Architecture," *Architecture + Urbanism,* April 1989.

16 For a more developed presentation of building imagery, see Marc Treib, "Reading the City: Maps, Signs and Space in the Japanese City," *Idea,* November 1979.

17 "Nothing is so hard as to pursue silence in a tumultuous urban life." Takefumi Aida, "Silence," in *New Wave of Japanese Architecture* (New York: Institute for Architecture and Urban Studies, 1978), p. 2.

18 "Actually, I am attempting to produce not spatial abstractions but spatial prototypes. My spaces are born not of intellectual operations, but of the emotions rooted in the desires of many different people." Tadao Ando, "A Wedge in Circumstances," in *Tadao Ando: Buildings, Projects, Writings,* ed. Kenneth Frampton (New York: Rizzoli International Publications, 1984), p. 134.

19 See note 16.

98

RIGHT: *The Towers of Satellite City,* Queretaro Highway, Mexico City, 1957, Luis Barragan in collaboration with Mathias Goeritz. Photo: Armando Salas Portugal.

Mexico City, Its Three Foundations: A Postmodern City

EDUARDO TERRAZAS

Six or seven years ago I received a letter from Rimini, Italy, inviting me to organize an exhibition on Mexico City called "The Exploding City." I agreed to do it, on the condition it not bear that name, which seemed to convey a mistaken impression. Mexico City is not on the point of exploding; on the contrary, it is a place full of energy and vitality, which, given its historical and cultural circumstances, its present size, and the speed at which it has developed, has functioned well and has served the needs of the country. The title finally agreed upon was "The City of Mexico—A New Urban Paradigm." It was based on the idea that urban definitions and theories of the past could no longer be applied to this human artifice. This metropolis represented a new category in the typology of human habitation, with unique causes and origins resulting from the specific conditions of its time and place. A new way of perceiving and analyzing it is necessary, just as

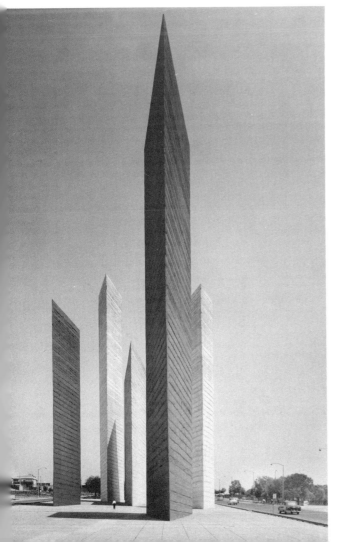

its management and configuration will have to be different and innovative. The distinctive nature of this metropolis cannot be reduced solely to functional and geographical explanations; rather, the specific components of its identity through time must be examined to understand its development and present conditions.

Differences Between the Terms Civitas and Urbis

The historian Fustel de Coulanges, in his book *The Ancient City*, speaks of the difference for ancient peoples between the Latin terms *civitas* and *urbis*, and although his theory is based on European towns, it may also be applied to our tradition on the American continent. The *civitas*, the author tells us, refers specifically to a social organization: a group of families or tribes who join together to establish a community, sharing the same gods, form of government, modes of production, social organization, and so forth. That is to say, the *civitas* is not related to any particular place or construction; its significance refers to the alliance itself and the social arrangement established between its members. He also observes that, for this union to be created, a series of acts and negotiations has to be undertaken that by necessity will take time. Furthermore, when the groups band together, they do not totally lose their identity, for they preserve a certain degree of independence and some of their own traditions. The *civitas* is in essence a federation.

The *urbis*, on the other hand, is related to the particular geographical site where a social group decides to build the abode of its gods and to dwell as a community. The *urbis*, unlike the *civitas*, is founded in an instant, usually symbolized by a religious ceremony or a founding act consecrating that particular site as the sacred territory of that *civitas*. The decision regarding location is of such importance that its designation is left in the hands of

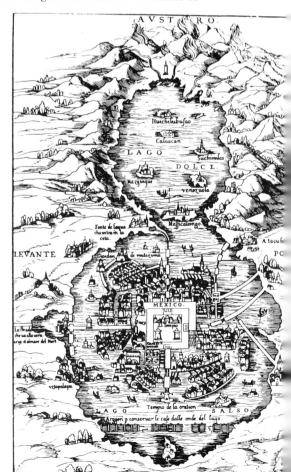

the community's gods. The urban and architectonic configuration of the *urbis* is structured by the political and religious principles underlying the *civitas'* cohesion, essence, and organization. Two of the most notable examples of this *civitas-urbis* phenomenon have been the foundation of Rome on the European continent and of México-Tenochtitlán, today known as Mexico City, on the American continent.

The Three Foundations of "Mexico City"

The first foundation of this *urbis* took place in the year 1325 when the Aztec *civitas*, after many years of migrations, found the site foretold by their gods. On a small islet located in the center of the lake occupying a considerable portion of the Valley of Mexico, they found the sign: an eagle perched on a nopal cactus fighting a serpent, an act that metaphorically referred to one of their fundamental beliefs—the struggle of opposites as origin and mover of the cosmos. In the central part of this site, they constructed a sacred precinct for their gods and their emperor, who concentrated absolute power in his person; he was king, high priest, and supreme leader of the armies. From this nucleus toward the four cardinal points spread four causeways that joined the islet to the mainland, dividing the *urbis* into four zones. There was a clear correlation between its *civitas* (socio-political organization) and the resulting structure of the *urbis*. The Aztecs or Mexicas built one of the most important, spectacular urban centers in the world of that time: México-Tenochtitlán. This *urbis*, and the Aztec *civitas* that gave rise to it, came to an end on August 13, 1521, when it was conquered and destroyed by Hernán Cortés and his army, subjects of the king of Spain.

The second foundation of the *urbis* took place only a few years after the conquest, in 1524, at the moment Hernán Cortés decided to found the vice-regal capital of New Spain on the same site that had been occupied by the *urbis* México-Tenochtitlán. The sacred enclosure of the Aztecs was replaced by Main Plaza, on whose sides were built the seats of the two authorities dominating the Spanish empire—civil power, represented by the king, and the power of God, represented by the church. The crown and the cross became the symbols of the new *civitas*. In 1554, Emperor Charles V conferred upon it the title of "The Highly Noble and Royal City of Mexico." By the close of the eighteenth century, this *urbis* was one of the most important centers on the American continent. Its population totaled close to 250,000 inhabitants.

The third foundation of this *urbis* did not take place at the crucial moment when Mexico gained independence from Spain in 1821; the new era of the nation did not begin until many years later when the 1917 constitution was promulgated. During the period from 1821 to 1917, it was not possible to establish a majority consensus on the foundations and principles for the creation of a new *civitas*. The government and society were busy defending the country from foreign powers, trying to establish an identity and an appropriate form of government befitting the nation's independence. The principles underlying the creation of a new Mexican society arose from the Mexican Revolution,

LEFT: *The City of Tenochtitlán,* 1325–1521, published in Leonardo Benevolo, *History of the City* (Cambridge: MIT Press, 1980), p. 617.

from a symbiosis of a pre-Hispanic past, a Spanish heritage, and modern civilization. The new "Mexico City" *urbis*, capital of the Mexican Republic, hailed a new era from the 1920s. The country's integration into this trend not only took place internally but was manifested externally in the growth and progress of its capital. Many emigrated to the capital, the ultimate symbol of modernity, in the hopes of partaking in this dynamic process of expansion.

Nevertheless, the outstanding growth of the *urbis* during the first few decades following the third foundation began little by little to generate an intense concentration of population, industries, services, vehicles, and so forth. It was converted into a negative situation for the general well-being of its population and for the harmonious development of the country. This situation was not caused, as many critics say, by a lack of planning and foresight, but rather by a complex interaction of forces, including the specific circumstances of the era and of Mexico's unique history. The speed at which reality was transformed was a new experience; it was impossible to foresee its growth and to keep pace with it.

The *urbis* now has a continuous urbanized surface area of 1,300 square kilometers, inhabited by 16 million people, 50 percent of whom are under the age of twenty-one. This population is greater than the combined population of Denmark, Finland, and Norway. It represents 19 percent of the total population of the Mexican Republic, which has 83 million inhabitants. This ratio is similar to the one that exists between Paris and France. Thirty-six percent of the gross national product of the country, equivalent to $66.6 billion, is produced in the Mexican capital, which makes it the thirty-fifth most important economy in the world, greater than 169 of the 204 countries that exist today.

Geographically, it is located in the Valley of Mexico, at a height of 2,250 meters above sea level. It consumes an average of 65 cubic meters of water per minute, 70 percent of which is obtained from water-bearing layers found in subsoils and 30 percent of which is obtained from external sources. The pump system that is used to bring water to the city is the most powerful one in the world.

The *urbis* suffers from one of the worst cases of air pollution that exists in the world today. This comes from 2,800,000 motor vehicles, 35,000 industries, and 12,000 pieces of equipment that rely on internal combustion. All of this produces 4,350,000 tons of conta-

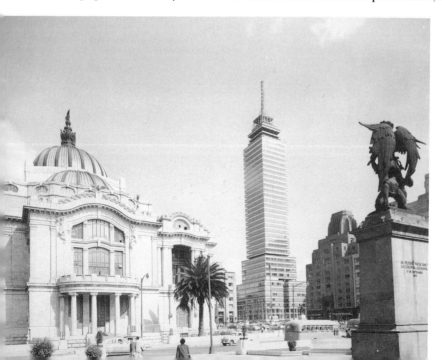

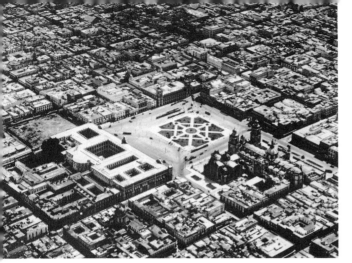

minants per year. The city of Los Angeles, in comparison, produces 3,460,000 tons. At present, $4.6 billion dollars have been invested in Mexico's program to fight air pollution, which is one of the most ambitious projects of this decade in the world. It is located in a zone of seismic activity. In 1985 the city suffered one of its most serious earthquakes, 8.1 on the Richter scale, causing 20,000 deaths and severely damaging many buildings in the downtown area. The *urbis* has an average density of 12,000 inhabitants per square kilometer, approximately 123 inhabitants per hectare. It has the largest public transportation system in the world, known as Ruta 100, which transports 1,533 million passengers per year. Its subway system moves 1,670 million people annually. To improve the traffic situation and decrease air pollution, each vehicle is prohibited from circulating one day of the week. Twenty-five thousand tons of food, transported in approximately 50,000 trucks, arrive at this *urbis* every day. This quantity of food would be enough to feed the combined populations of Berlin, Madrid, Copenhagen, Rome, Athens, and Budapest for a day. Eighteen thousand tons of trash are collected daily. From 1988 to the present, the level of delinquency has decreased and there are no serious problems with drugs or gang violence in its population. The urban texture of the metropolitan area extends to half the territory of the Federal District and seventeen municipalities of the state of Mexico. The government of the Federal District is under the jurisdiction of the president of Mexico, who delegates it to the head of the Department of the Federal District, also called the regent. Each municipality is autonomous and is governed by a municipal president and its respective town halls. In the Federal District there is an organization of political representation of citizens in the Assembly of Representatives, which is composed of sixty-six elected members.

The population and growth percentage of the urbis from decade to decade from 1910 are shown in the following table:

Year	Population	Year	Population	Growth in %
1910	471,000	1920	615,000	30%
1920	615,000	1930	1,030,000	67%
1930	1,030,000	1940	1,803,000	75%
1940	1,803,000	1950	3,138,000	74%
1950	3,138,000	1960	5,250,000	67%
1960	5,250,000	1970	8,800,000	67%
1970	8,800,000	1980	12,500,000	42%
1980	12,500,000	1990	16,300,000	31%

LEFT: *Mexico City Square*, c. 1950. Photofest.

ABOVE: *Aerial View of Mexico City*, c. 1950. Photofest.

The Postmodern Urbis

The preceding description shows us that the *urbis*, Mexico City, has undergone one of the most dramatic transformations that has ever taken place in the history of urbanism. Because of these drastic changes in the *urbis*, the *civitas* has undergone equally drastic changes. In order to adapt it to contemporary life, we must reassess not only the original characteristics of the *civitas* but also the incredible, complex situation that we face today. For this, a process of study and reflection must be undertaken of its present political, economic, social, and cultural characteristics and of its potential future, focusing on its different dimensions: local, regional, national, and international. We need to establish a constructive dialogue to reach an agreement between "families and tribes" and thus generate the parameters of the new *civitas*. Only then, once these principles are clearly articulated, will it be possible to create an *urbis* that meets the desires and needs of the *civitas*.

To provide a vision of today's *urbis*, I include a rough transcription of a talk given by the Chicano artist Guillermo Gómez Peña:

> *The City of Mexico is now the postmodernist* urbis *par excellence. Walking from neighborhood to neighborhood is like traveling from continent to continent and*

System Map, Station Pictograms, Mexico City Metro, 1969. Photo: Lance Wyman Ltd.

vertically from one era to another. Pre-Hispanic myths and pyramids are found next to buildings in Spanish colonial, French neoclassic, or modern International style. Houses constructed in the last four centuries are located next to skyscrapers, corporations, and modern banks. Native traditional markets and discotheques with videos are within easy walking distance, and all of this, in some way, makes sense. The sounds of folk music coexist on the radio with classical European music and rock and roll in English and Spanish. On any day one may witness a native ceremonial dance in the central plaza and from there walk to a nearby theater or gallery and watch a performance or see an exhibition of vanguard art.

In spite of this overwhelming reality, official culture provides, and tries to contaminate us with, an idealized version of who we were, pure Indians, and of who we are, modern Mestizos, which denies and distorts the intense and operative syncretism of our daily reality. From Aztec to post-punk, all the styles and eras are part of our cultural expression and are intermixed in this "megapastiche" called the Federal District, and those of us who grew up in this context, we developed what I call a vernacular postmodern sensibility, which originates in an intercultural fusion. It is through the prism of this sensibility that we perceive pop culture, "high" culture, politics, rural and urban expressions, and so forth. All of this is presented to us as logical dualities belonging to a same time and place. We are immersed in a syncretism and our attitudes and knowledge move between times and cultures. We have no other option, we have no other place to move. The plurality and diversity exist within us, and multiculturalism is the backbone of our biographies as individuals and as a group.

The urban center is one of the least understood constructs of our time, plagued by a series of preconceptions, misconceptions, and prejudices about how it should or should not be. Perhaps a return to basics is in order, a return to the distinction between the *civitas* and the *urbis*. Urban planning requires a clear understanding of the organization, values, and goals of the *civitas*. Once these premises are established, they should constitute the basic principles used to develop urban designs. In the last part of the twentieth century, modernization has essentially created a new world with different social conditions, political relations, technologies, and values for each *urbis*. Old categories of urbanism have fallen by the wayside as we invent new typologies for human habitation; Los Angeles, New York, Dallas, Mexico City, and Tokyo are striking examples of this process. In the specific case of Mexico City, the *urbis* is undergoing major transformations in all sectors (politics, economics, society, culture, technology). Given these rapid changes, the *urbis* has worked very well because it has grown with a certain degree of awareness of the changing nature of the *civitas*. However, now we need to specifically address the issue of the identity and future of the *civitas* in order to create an environment that allows us to meet the challenges of our ever-changing world.

The Form of Los Angeles's Quotidian Millennium

JOHN KALISKI

It occurs to her that what she most appreciates about this City
of the Angels is that which is missing, the voids, the unstitched
borders, the empty corridors, the not yet deciphered.[1]

We must insist, over and over and in a variety of ways, on
the troubling ambiguities of this new "hyperspace."[2]

A spatial thread of continuity, in essence a collective space of becoming, is emerging in Los Angeles. Though still conditional, it sets forth once again a path toward the fulfillment of millennial urban aspirations. This path winds between the nooks and crannies, the places overlooked, or the places that in the rush of daily life are looked at everyday but not seen. This path incorporates southern California's well-known attractions, such as Disneyland and Rodeo Drive, but is not solely defined by their glitz and fantasy, as it equally connects the barrios and the vast stretches of suburban tracts that are everywhere and nowhere. For now, the space of this path is best defined as the quotidian in-between.

Los Angeles, despite its 210-year past, is still typically understood as an "instant townscape" set in suburban surroundings amid palm trees.[3] Yet this definition, based on the tourist's or newcomer's view and media stereotype, has become more problematic in the last ten years as the population has increased and large sections of the Los Angeles basin have grown dense. In fact, the population of the political city has grown by almost 20 percent during the past decade, while growth in outlying areas has doubled, tripled, and more.[4] As the numbers of people swell, Los Angeles, the city of suburbs tied together by a freeway system, is affronted by the reality of urban densities, if not places, equivalent to those found in eastern North American cities. In select areas of central Los Angeles, crowding approaches and even exceeds the congestion of Manhattan.[5] Even the single-family house, bedrock of the American dream and the characteristic settlement pattern addressed in Reyner Banham's mid-century tour of Los Angeles, is now built in outlying counties at densities of more than twenty units to the acre, triple that of the 1920s through the 1950s.

Concurrent with changes in population and the density of the city are changes in the ethnic and racial makeup of Los Angeles's diverse peoples. While the city's Anglo popu-

RIGHT: Simeon Lagodich, *Morning View Hollywood Freeway*, 1988.
Tatischeff Gallery, Inc., Santa Monica, Cal. Photo: Brian Forest.

lation has decreased over the past decade as a percentage of the whole population from approximately 60 percent to just under 40 percent, a "new majority" of Hispanic-Americans, African-Americans, and Asian-Americans has begun a struggle to form a coalition for control of the city's urban and suburban turf, bypassing the city's dissolving liberal and westside-Anglo, Jewish, and Black alliance. As Edward Soja demonstrates in his book *Postmodern Geographies*, when these demographies of change are mapped, it can be seen that Los Angeles is segregating itself spatially at an unprecedented regional scale not only by race but by class and occupation as well.[6] This segregation is evidenced in the increasing inclination toward the carving out of protected neighborhood enclaves. Whether behind the closed security gates of affluence or the drug enforcement barricades of the Los Angeles Police Department or the neighborhood associations of home owners and tenants, Los Angeles is crammed with groups looking out for immediate spatial interests.[7] First and foremost, regardless of locale, the vast majority of these groups are centered on safeguarding and nurturing so-called "community values," tenaciously holding onto the image and myth of Los Angeles as a thousand suburbs in search of a city, even as that myth is challenged on a daily basis by the arrival of newcomers and the consequent compression of space.

With the residential neighborhood defined as the constituent unit of urban form, the communities of Los Angeles coalesce to form a fragmented and tense city with thousands of competing microspheres that are social, political, and geographical. Thus it is not surprising that single-family home owners place a premium on the preservation of private

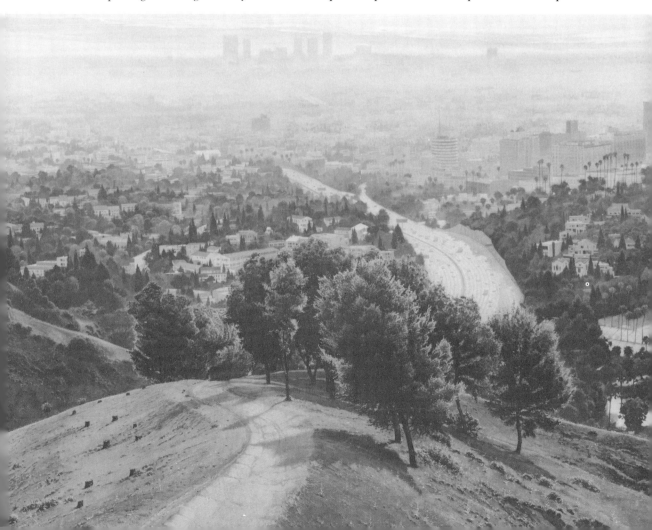

ABOVE LEFT: John Portman & Associates, *Bonaventure Hotel Lobby Atrium Interior,*
Los Angeles, 1975. Community Redevelopment Agency of the City of Los Angeles.

ABOVE RIGHT: John Portman & Associates, *Bonaventure Hotel,* Los Angeles, 1975.
Photo: John Portman & Associates, Atlanta.

RIGHT: Frank O. Gehry and Associates, *Frank Gehry House,* Santa Monica, Cal., 1978.
Photo: Copyright Tim Street-Porter/Esto.

space at the expense of the enhancement of a collective public realm. However, the fact that 60 percent of Los Angeles's housing is now multifamily suggests yet a further strain born of the disparity between the controlling vision of the private single home enclaves and the multifamily urban reality of the majority.[8]

The issue of who controls Los Angeles's space segues with the discussion of alternatives for the evolution of the city's physical urban form. Given that Los Angeles's rapid evolution is caused by the expansion of its population, older images and myths regarding the proper shape and form of the future city are necessarily challenged, and new models and typologies for the design and control of space and place contemplated. The present search for the spatial cement that can link Los Angeles's diverse peoples, cultures, and visions, even as individual groups or communities maintain their enclaves of hegemony, is the search for the Los Angeles form of the millennial future. Assuming that Los Angeles's struggle for form both mirrors and prefigures those of other evolving American metropolises, the defining of its future townscape becomes predictive for much of North America's urbanized landscapes.

Starting with the study of objects of architecture, the utopian as well as dystopian potential of Los Angeles's socio-physical future is suggested in Fredric Jameson's book *Postmodernism, or, the Cultural Logic of Late Capitalism.*[9] In this book Jameson examines two of Los Angeles's most iconic monuments—John Portman's Bonaventure Hotel and Frank Gehry's own house in Santa Monica—and identifies two prototypes of "wrapped" or in-between space, which become the fulcrum for a discourse on postmodern cultural frameworks. The first in-between that Jameson describes, defined here as "urban simulacrum,"[10] is the scaleless and disorienting volume of shops and restaurants placed at the base of the five Bonaventure Hotel towers. Turning inward and away from the downtown Los Angeles grid of streets and sidewalks, this vast vessel of Piranesian space lies between an exterior of five-story blank concrete walls and a quintet of elevator and stair shafts that vertically penetrate the hotel towers. Here nestles a safe space-city of shops, restaurants, and ballrooms that screen out, like Disneyland's Main Street, the chaos of the city beyond, and exhibits for the guest/consumer a controlled simulation of urban excitement.

Jameson's second in-between, defined as "dirty realism,"[11] is the complex of living 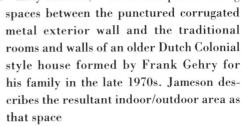 spaces between the punctured corrugated metal exterior wall and the traditional rooms and walls of an older Dutch Colonial style house formed by Frank Gehry for his family in the late 1970s. Jameson describes the resultant indoor/outdoor area as that space

...which our bodies inhabit in malaise or delight, trying to shed the older habits of inside/outside categories and

109

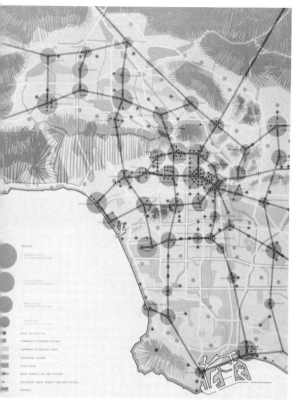

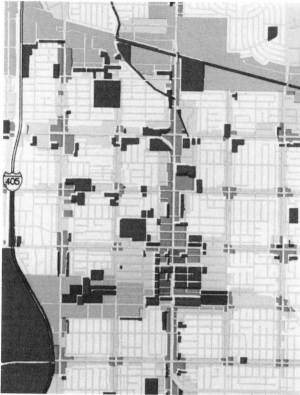

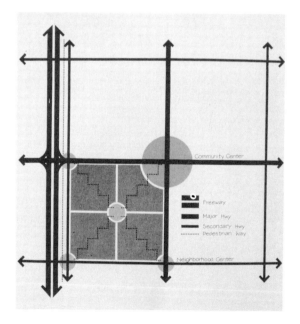

TOP LEFT: *The "Centers Plan,"* a 1974 vision of the city, published in
Concept Los Angeles: The Concept of the Los Angeles General Plan, 1974.
Light-colored areas represent single-family homes; gray dots, centers.
City of Los Angeles, Department of Planning.

TOP RIGHT: *A Los Angeles Detail Illustrating the Linear Grid of the City.*
This sector, centered in Van Nuys, includes commercial, higher-density residential, and
industrial uses in gray; schools or open spaces in dark gray; and single-family
residential in off-white. City of Los Angeles, Department of Planning.

perceptions, still longing for the bourgeois privacy of solid walls... yet grateful for the novelty of the incorporation of yucca plants and what Barthes would have called Californianity into our newly reconstructed environment.[12]

Thus Gehry's in-between, in contrast to Portman's impenetrable spaceship, opens itself up to the surprise of the outside world even as it closes itself off from its threats.

The two in-betweens described by Jameson can also be understood as metaphors for Los Angeles's pessimistic limits and optimistic possibilities. Destinations of escape, like the Bonaventure, or the countless shopping malls, theme parks, and teasing skylines, as well as the freeways that connect them, increasingly define the place culture of Los Angeles's dominant yet degraded public realm. The economic, political, and social forces that inexorably shape these environments reject acknowledgment of a broad spectrum of pressing urban issues, just as their doors, elaborate security, and climate control systems screen out inclement weather, the crisis of urban crime, and so-called "undesirables." Pessimistically, these are the forces that generate the homogeneity of the modern urban landscape and cause the employment of most architects and planners.

The more difficult, yet ultimately optimistic, spatial reality represented by the Gehry house does not turn its back on Los Angeles's themed centers, mythologized Mediterranean topos, and privatized enclaves. Rather, these latter landscapes are accepted and transformed by the city's "dirty" and prosaic environment. Los Angeles's "real" landscape, the dirty realism that wraps the city like Gehry's corrugated wall, is the province of an anonymous but provocative in-between punctuated by palm trees and occasional destinations of hyperconsumerism. It is a vast gridded network of surface streets, linear commercial strips, low industrial buildings, shopping/office centers, and adjacent residential neighborhoods. Despite being the space that the vast majority dwell and recreate within, these places are typically a void in the imagination. Professionals hardly consider them worthy of documentation, much less consideration, as a model for the further development and enhancement of urban life in Los Angeles.

A clue toward the shaping of a more inclusionary Angeleno urbanism incorporating an optimistically defined dirty realism is revealed by comparing the 1974 *Concept Los Angeles: The Concept of the Los Angeles General Plan*[13] with the City of Los Angeles's 1990 *Generalized Planned Land Use.*[14] *Concept Los Angeles* was conceived during the late 1960s and early 1970s and remains to this day the city's fundamental basis for land use planning and urban design. After an extensive public review process that included the input of neighborhood interests determined to preserve the sanctity of suburban Los Angeles by preventing encroachment on single-family house neighborhoods, a growth scenario was prepared by the city's planning department that concentrated future development into approximately sixty dense urban centers connected by a high-speed transit system. These centers were represented as large dots on a map and supposedly left the vast majority of the city's suburbanized infrastructure untouched. The dots of *Concept Los Angeles* are a graphic precursor to the "not in my backyard," or NIMBY, debates of

111

LEFT, BOTTOM: *Conceptual Diagram of a Suburb,* published in *Concept Los Angeles: The Concept of the Los Angeles General Plan,* 1974. City of Los Angeles, Department of Planning.

the present, which always define inevitable growth as additional development that will always occur somewhere else. By moving growth elsewhere, the designers of *Concept Los Angeles* were able to assert the primacy of Los Angeles's fundamental building block, the suburban enclave, to win acceptance for further growth (always elsewhere) and approval for the plan as a whole. The genius of the "Centers Plan" was that it seemingly preserved Los Angeles's dominant suburban typology while at the same time giving new direction to of one of the city's dominant growth industries, real estate development.

One of the ways that suburbia was buttressed in the Centers Plan was its further isolation from the perceived ills of the surrounding city through the proposed evolution of Los Angeles's grid of streets into conceptual superblocks where residential, commercial, and institutional uses were strictly separated. Like a medieval city, the Los Angeles superblock suburb was to be surrounded by moats of traffic arteries and watch towers of neighborhood retail. At the heart of the residential enclave, completely surrounded by houses, like covered wagons around a camp fire, lies the elementary school. A diagrammatic small town where Ozzie and Harriet fantasies could be played out, the idealized suburb of the Centers Plan turns its back on the adjacent city. Like the five-story concrete walls of the Bonaventure, each superblock suburb simultaneously repels the chaos beyond while creating an interiorized daydream life within.

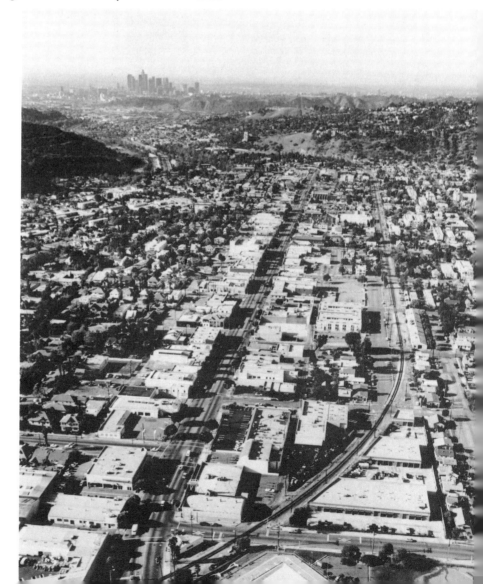

112

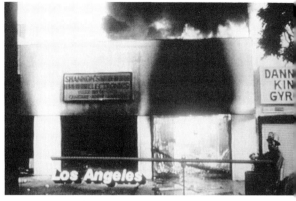

In comparison to these introspective and fortresslike diagrams of suburban enclaves and urban destinations, a look at the city of Los Angeles's actual generalized land use two decades later reveals not a city of sixty centers surrounded by an embalmed and bucolic suburban fantasy topos, but a continuous urban landscape of approximately five centers woven by a network of commercial strips that adhere to the grid of Los Angeles's major boulevards. Like the transparent wall of cheap materials that surrounds the Gehry house, these boulevards are best understood as a continuous yet porous wrapper for the patterns and tasks of everyday life. Both reveal a "hyperspace" that interdependently maintains, yet juxtaposes, the safety of home life with the integrating adventure and risk of urban life. The boulevards of Los Angeles, in this interpretation of the form of the city, protect, yet open to view, the adjacent interstitial residential communities. Unlike the Bonaventure or the insulated ideal suburb of the Centers Plan, "Boulevard Los Angeles" is a reciprocal world where the boundaries between inside and outside are permeable and linked, each reflecting different aspects of the same complex whole.

The boulevard corridors of Los Angeles are not a recent phenomenon. Since the advent of the automobile, these swaths of concrete and asphalt have defined the fundamental spatial organization of Los Angeles even as the city's official plans have resisted their inexorable shaping power.[15] Boulevards serve Los Angeles as both commercial corridors of convenience and a linear belt of entrepreneurial opportunity. The commercial corridors, particularly the commercial strips and the ubiquitous corner mini-malls, serve as the place of first employment and nurture the nascent businessperson. The boulevards are the location where everyday needs are found, as well as the framework for many of Los Angeles's most vital urban locales, such as Melrose Avenue, Hollywood Boulevard, Brooklyn Avenue, and Venice's Main Street. The boulevard corridors are also the out-of-the-way and in-between places of factories and sweatshops. The boulevards are home for the United States's largest bus network, serving over a million passengers everyday.

Unlike Los Angeles's new centers, such as the gated shopping malls or inward-oriented office parks, boulevard corridors are always available for use, open themselves up to the populace as a whole, and cut across, yet link, class and social differences. Boulevard corridors in Los Angeles are the places where wealth and opportunity are most accessible and poverty most apparent and terrible (as was demonstrated during the Rodney King rebellion in 1992). In all their forms, Los Angeles's corridors are ubiquitous in the pattern of every Angeleno's quotidian life. They constitute that space between home and destination of work, learning, or play. They are the space where citizens can freely come

113

LEFT: *Los Angeles's "Real Landscape."* Vast gridded network of surface streets: linear commercial strips, low industrial buildings, and adjacent residential neighborhoods in Highland Park. City of Los Angeles, Department of Planning.

ABOVE: *Los Angeles Riot,* 1992. Cable News Network.

together, whether in commerce, conflict, or conflict resolution. In short, the boulevards are Los Angeles's true public realm.

Given the ingrained omnipresence of Los Angeles's boulevard corridors in everyday life, their lack of standing in terms of the official spatial morphology of the city is surprising, unless one recalls the false promises of the Centers Plan, which spatially institutionalized a fantasized city form that closely matched the parochial interests of the suburban enclaves.[16] The reality is that Angelenos, even those who live in the gated communities or the few existing centers, value the automobile convenience afforded by the boulevards more than the official planning dogma of centers.

While superficial explanations of the ideal form of convenience or the inevitable shape of automobile-oriented cities are compelling in their ability to explain the present unconscious form of Boulevard Los Angeles, deeper North American and Western compulsions toward the construction of an ideal urban landscape are also at work. For instance, the escape to a suburbanizing countryside from urbanized cities is certainly a movement in American settlement patterns that reached its apotheosis in the building of Los Angeles. Equally, the Western utopian urge to build a city as a Garden of Eden naturally took hold in a southern California climate where plants could flower all year long and where every household, at least through the 1960s, could seemingly realize the dream of a backyard with a citrus tree. For the most part, except in those areas of the city such as Downtown, where the availability of extensive subsidies jump-started an anomaly of centralization, developers have followed the daily choices of people to such an extent that Los Angeles's Centers Plan has been largely ignored, though continuously promoted, even as Boulevard Los Angeles has become more vital with every passing year.

Los Angeles has always been associated with the ideal of the city as garden realized, a place where the best of two worlds, both tamed nature and the amenities of urban civilization, are available for all. Possibly, the emerging form of Boulevard Los Angeles, with its lower scale of residential neighborhoods alternating with bands of intensely active mixed-use streets, comes closest yet to meeting this age-old ideal. Yet the fact that the wrapped space of everyday life, as exemplified by both the Gehry house and the city of Los Angeles's boulevard landscape, is not yet part of an official statement of place is a testament to the degree to which the conscious forces that generate the urban simulacrum of environments like the Bonaventure, or the equally depressing fantasy landscapes of southern California's edge cities, ignore the positive (and possibly profitable) aspects of quotidian life.

One searches, mostly in vain, for precedents for the further evolution of Los Angeles, indeed, for a prototype for a future North American urbanized place that will transcend the wasteful environmental destruction of the suburbanized edge yet move beyond the tired and overused nineteenth-century prototypes of village, town, and industrialized city. However difficult the search for alternative urban forms proves to be, the nascent presence of Boulevard Los Angeles invites and inspires further exploration of its possibilities as a model that incorporates both the individual introspection and public

114

connection suggested by Jameson's interpretation of Gehry's own house. Architect and urban planner Kevin Lynch has come closest yet to describing the physical and social sensibility of just such a place and, curiously, it bears an abstract similarity to the evolving form of Boulevard Los Angeles.[17]

Lynch, in *Good City Form*, develops a strong case that a physically desirable city is not defined by good form alone. Rather, this city is shaped by universal "dimensions of performance" that are subject to a sliding scale of diverse cultural interpretations.[18] These dimensions are limited to just five: "vitality," "sense," "fit," "access," and "control." Two meta-criteria, "efficiency" and "justice," are used as further guides to interactively discuss the function and equity of the first five. With these dimensions, Lynch claims to create a cross-cultural framework that enables each society to describe and define the parameters of its own good place.

These... are the inclusive measures of settlement quality. Groups and persons will value different aspects of them and assign different priorities to them. But, having measured them, a particular group in a real situation would be able to judge the relative goodness of their place, and would have the clues to improve or maintain that goodness.[19]

115

TOP: *"Alternating Net,"* published in Kevin Lynch, *Good City Form* (Cambridge: MIT Press, 1981), p. 286.

BOTTOM: LPA, Inc., with Legoretta Arquitectos, *Tustin Market Place,* southeastern fringe of Los Angeles's megalopolitan sprawl, 1991. LPA, Inc. Photo: Hyma Photography.

The fact that the dimensions do not dictate form but rather create a framework to evaluate it never bothers Lynch, for his ultimate goal is to empower everyday people, not architects, planners, or urban designers.[20] Nevertheless, urban form giver that he is, Lynch can not resist asking if it is "possible to think of a model which deals with form, process, and associated institutions in one whole?"[21] The imaginary model of the good city which he then sketches is described as an "alternating net," and it bears an uncanny resemblance to an idealized conception of Boulevard Los Angeles.

Like Gehry's wall wrapper, Lynch's alternating net defines a permeable environmental order that is between a garden and a city, literally a new typology of urban space stretched amid a public outside and a private inside. The tension in between this inside/outside is an attenuated grid of major arterials that becomes the net of social interactions. Lynch proposes that the lines of his net are the places of intense use and public access as well as the corridors of heavy urban infrastructure such as transit. Lower-density uses, agricultural land, even wilderness park lie within the interstices of land formed by the proposed grid of infrastructure. He recognizes that the capital-intensive nature of the heavy infrastructure and intense uses of these arterials require the oversight of a regional and democratic political voice. On the other hand, Lynch proposes absolute local control, whether of an individual, family, or cooperative community, of the areas between the arterials.

Lynch's model is unusual in that it rejects neither the poetry of the city nor that of the country but convincingly suggests a merging of their forms, even as their political and social orders remain distinct yet linked through participation in local and regional forms of government. Set within a Los Angeles context, the alternating nets can be interpreted as defining a linear urbanism where people of different backgrounds can come together and live as *flaneurs* along the sidewalks of twenty-first-century boulevards. Meanwhile, these sidewalks can be contrasted with the adjacent inward-turning, protective neighborhoods. If these neighborhoods suggest an older order, replete with the possibilities and limitations of homogenized community life, then the grid of streets marks the latest iteration of Thomas Jefferson's national grid or Frank Lloyd Wright's Broadacre City, now even more mobile, more urban, and more full of choices. The in-between of this place, the Los Angeles boulevard, is in essence the hyperspace between the individual or the local community and the now globalized city. Within this hyperspace occurs the daily ritual and form of the Los Angeles commercial sidewalk, mini-mall, strip center, and shopping mall, simultaneously worldly in its response to regional or global networks of capital and communication yet specific to the social and typological order of the adjacent neighborhood literally just around the corner. However, it must be remembered that while this superimposition of Lynch's model on Los Angeles's reality is propitious and suggests a path for future urban design action, it does not yet fit within the boundaries of current City of Los Angeles planning practice.

Recently much has been written of the advent of a poorly designed "middle landscape,"[22] so-called peripheral cities or "edge cities"[23] that threaten to overwhelm the

environment. Los Angeles is often mentioned as the city that best typifies this trend. Unfortunately, in the search for urban forms that address the more abusive environmental conditions associated with this expansion into the landscape, most architects, urban designers, and planners now look backward in time and promote variations upon "neo-traditional" towns,[24] "pedestrian pockets,"[25] "urban villages," or even the construction anew of obsolete nineteenth-century downtowns. Indeed, Los Angeles is now thought to be ready for new interventions based upon these older typologies. Yet all of these models insist upon a centripetal reinvention of urban space that is antithetical to Los Angeles's historic growth patterns. Despite the frustrations of disorder, daily ugliness, and placelessness, it is doubtful that Los Angeles will accept these current prototypes in its quest for the form of its good city. Unfortunately, the design and planning professions barely know how to think of, much less draw, a better version of the preferred reality of the Los Angeles that is everywhere among us. In this regard, the alternating net

117

Edward Ruscha, State Board of Equalization, 14601 Sherman Way, Van Nuys, from
Thirtyfour Parking Lots in Los Angeles, 1967. Courtesy of the artist. Photo: Art Alanis.

overlaid on Los Angeles's boulevard form is one millennial future that surely deserves further study as a preferred form of North American place.

If the millennium in general bespeaks a time of peace to come, indeed an idyll, a millennium with an Angeleno edge suggests the presence of nature with something else, something vital and full of urban surprise. Los Angeles's urbanizing boulevards, juxtaposed with suburban neighborhoods, may offer a glimpse of this something else. For now, however, these boulevards incorporate both the good and the bad of present society; they are the sidewalk where one can touch the intricacies of cultures coming together in creative work as well as the paths where one experiences the distressing and anonymous violence of drive-by shootings and class warfare. They offer a place for unfettered greed as well as a locale to ameliorate the depressing tendency for people, communities, and forms of development to hide within enclaves of simulation that turn away from society's ills and ugliness. Observed in their current pessimistic state, Los Angeles's boulevards are indeed what Jameson calls "some new hyperurban configuration... whose extreme form is the power network of so-called multi-national capitalism itself."[26]

However, another extreme form of Los Angeles's boulevard configuration can be dreamed. Through the reinvention of local and regional forms of governance and land use, the boulevards may evolve into the social and physical linkages that bring together the people, opportunities, and delight of Los Angeles's urbanized nature. In this nature one should be able to find quiet on tree-lined residential streets, safety through an intimate knowledge of community, and a sense of balance with the environment, while down the sidewalk, around the corner, over the trees, and beyond the backyards, on the boulevard, all the conveniences, amenities, opportunities, adventures, and culture-sustaining frictions of the collage of urban life are discovered anew everyday. This latter dream is the quotidian work of Los Angeles at the edge of the millennium.

1 Kate Braverman, *Palm Latitudes* (New York: Penguin Books, 1989), p. 33.

2 Fredric Jameson, *Postmodernism, or, the Cultural Logic of Late Capitalism* (Durham, N.C.: Duke University Press, 1991), p. 115.

3 Reyner Banham, *Los Angeles: The Architecture of Four Ecologies* (New York: Pelican, 1978), p. 21.

4 See City of Los Angeles Planning Department Memorandum, "RE: Release of 1990 Census Data," April 8, 1991.

5 Harold Meyerson, "Latter-Day Lower East Side," *LA Weekly,* August 2–8, 1991.

6 Edward Soja, *Postmodern Geographies* (New York: Verso, 1989), pp. 190–219.

7 *LA Weekly,* January 3-9, 1992, p. 17, reports that there are more than 500 gated communities throughout Los Angeles County. William Christopher, founder of "Plan LA," an umbrella organization of home owner groups, anecdotally estimates that there are more than 450 home owner associations in Los Angeles plus thousands of block clubs.

8 Frank Clifford, "City's Planners See More Crowding as Cure for L.A.," *Los Angeles Times,* August 25, 1991.

9 Jameson, pp. 97–129.

10 Ibid., pp. 38–45. While Jameson does not attach the word *urban* to *simulacrum,* he does "parody" Heidegger when he states that the Bonaventure lets "the fallen city fabric continue to be in its being." As Jameson notes, the interior of the Bonaventure is so confusing that it becomes, at its best, an image of other people always shopping. In fact, one does get lost constantly as one seeks out the place across the void where activity is visible. The Bonaventure retail has always suffered as a consequence and has gradually failed, being replaced by equally

dismal office space. Over the years attempts have been made with signs and graphics to provide a sense of orientation. More recently, street-facing spaces were created and a more traditional sense of entry emphasized. With the 1992 collapse of the Los Angeles economy, these efforts seem futile. Rumors persist that the whole complex will be torn down. Perhaps the implosion of the Bonaventure will be late modernism's equivalent to the dynamiting of the Pruitt-Igoe housing complex, which, at least for Charles Jencks, was the moment modern architecture died.

11 Fredric Jameson, "Demographies of the Anonymous," in *Anyone*, ed. Cynthia C. Davidson (New York: Rizzoli International Publications, 1991), p. 53; an impossibly "pink" book.

12 Jameson, *Postmodernism,* p. 115.

13 City of Los Angeles, Department of City Planning, *Concept Los Angeles: The Concept of the Los Angeles General Plan,* April 3, 1974.

14 City of Los Angeles, Department of City Planning, *Generalized Plan Land Use,* August 1990.

15 See Douglas R. Suisman, *Los Angeles Boulevard: Eight X-Rays of the Body Public* (Los Angeles: Los Angeles Forum for Architecture and Urban Design, 1989), for complete discussion of the development of this prototypical Los Angeles form.

16 In early 1992, for the first time, serious acknowledgment of the boulevards as an organizing pattern for the future growth of the city began to be articulated at official levels. The mayor's office sponsored a boulevard lecture series; Los Angeles's schools of architecture jointly sponsored boulevard studios; and the Los Angeles County Transportation Commission, in cooperation with the City of Los Angeles Planning Department, undertook the development of a "station area and transit corridor" policy that explicitly considers the potential of intensified boulevard corridors.

17 Kevin Lynch, *Good City Form* (Cambridge: MIT Press, 1981).

18 Ibid., pp. 111–120.

19 Ibid., p. 119.

20 See Kevin Lynch, *The Image of the City* (Cambridge: MIT Press, 1970), for a discussion of good (albeit mostly Western) form.

21 Lynch, *Good City Form,* p. 286.

22 See Peter G. Rowe, *Making a Middle Landscape* (Cambridge: MIT Press, 1991).

23 See Joel Garreau, *Edge City; Life on the New Frontier* (New York: Doubleday, 1991), for a breathless look at the raw edge of American cities, an edge that the central portions of Los Angeles have already evolved beyond.

24 See Andres Duany and Elizabeth Plater-Zyberk, *Towns and Town-Making Principles,* ed. Alex Krieger with William Lennertz (New York: Rizzoli International Publications, 1991). The ultimate test of "neo-traditional" planning will be Playa Vista, an ambitious 800-acre project in a Los Angeles wetland designed by Andres Duany and Elizabeth Plater-Zyberk. The project studiously appropriates the built residential typologies of 1920s–1930s Los Angeles even as it denies their intrinsic urbanism by overlaying the enclave planning attitude of 1950s and 1960s suburbanism.

25 See *The Pedestrian Pocket Book: A New Suburban Design Strategy,* ed. Amy S. Weisser (New York: Princeton Architectural Press, 1989).

26 Jameson, *Postmodernism,* p. 127.

Squeak Carnwath, *Equations I Just Don't Know,* 1981. Courtesy of the artist.

Photo: Lee Fatherree.

Product and the New Technological Juggernaut

We bought Manhattan for a string of beads
And we brought along some gadgets for you to see
Here's a crazy little thing we call TV
Do you have electricity?
 We're humans from earth
 We're humans from earth
 You have nothing to fear
 And I think we're going to like it here
I know we may look pretty strange to you
But we have know-how and the golden rule
We're here to see manifest destiny through
And there ain't nothing we can't get used to
We're humans from earth. We're humans from earth.
 — T-Bone Burnett, from "Humans from Earth" [1]

In another millennial scenario, the landscape of objects eclipses the landscape of architectures. The forests can't be seen for the trees, which have all become telephone poles, and the buildings can't been seen for the gadgets, which have become the global village. It's too crowded; we have to move "off-planet."

At the turn of the last century, the average household of four could count approximately 500 objects—furniture, utensils,

tools—within its domestic domain. Today that same household might inventory more than 3,000 articles of late-twentieth-century goods and chattel.[2] Add to that figure the myriad electronic games and programs and the spaces they create on our screens the intangible, hidden products of our purchases. It is the latter brand of commodity—the dematerialized realm of limitless subdirectories—that commands our attention at the edge of the millennium, for it threatens to crowd out what might be the one landscape left open to us—the virtual space of our thought. It is time to break the habitual tendency to equate design solely with its material expression, for everything we know tells us that the most powerful forces in our lives are rarely graspable.

The word *juggernaut* is derived from one of the titles of the Hindu deity Krishna, whose idol is drawn on a huge car or wagon in an annual procession under the wheels of which worshippers are said to have thrown themselves.[3] In the twenty-first century the technological juggernaut that will seek our sacrificial offering is not the crushing pile of hardware that we used to call possessions, nor even the strangling labyrinth of computer cables that keeps those possessions operational. This juggernaut is enshrined in the weightless, interactive software that has already opened "a window into our own

consuming souls."[4] A space that has found its apotheosis in the juggernaut of cyberspace:

A consensual hallucination... A graphic representation of data abstracted from the banks of every computer in the human system. Unthinkable complexity. Lines of light ranged in the non-space of the mind, clusters, and constellations of data.[5]

Once the exclusive territory of the initiated—the military, corporate researchers, sci-fi writers, and hackers—data networks are now accessible, at least in principle, to millions of individual computer users equipped with modems. Nonetheless, despite the touted ubiquity of virtual technologies, for most people this is a territory that they enter only when they use their credit cards. The degree to which we will be players or pawns in the various applications of these new technologies is one of the most critical issues facing designers today.

Furthermore, designers bear the burden of protecting the fragile self-esteem of the vast numbers of those people who do deal with the hardware that delivers these technologies—VCRs, faxes, e-mail, voice mail, et al. Promising alternative frameworks for product development are emerging from new understandings of the behavior of learning that acknowledge the role of the senses and the psyche. The leading edge of this research

models the human body, not the hardware, with voice controls, touch pads, and other sensory modes of access.

However, the ideal of seamless merger of human and electronic brains must also take into account a concomitant loss of personal privacy and diminished sense of identity. Intelligence technologies, from bar code scanners to supermarket surveillance cameras, are becoming so refined that our most ordinary purchases have descriptive powers that we never intended them to have.[6] With the statistical facts known from our shopping habits and the behavioral insights drawn from the research of social and cognitive science, designers find themselves participants in an unprecedented experiment in behavior modification, and uniquely positioned as the consumer's advocate and interlocutor. Moreover, they must see themselves as both subject and author— viewing situations from within while also apart—if they are to make a genuine contribution to the new culture.

As nations retool to compete in global markets, the designer is cast not just as the subconscious of the shopper but also as the conscience of a new consumerism. "Products are the new political currency, as well as an economic and social force, counting more than military might, ideology, or religion in the global balance of power and prestige."[7]

Consequently, the practice of design requires "a far more agile sense of values than the venerable thou shalts and shalt nots,"[8] particularly when there are counter pressures for economic survival among nations, among corporations, and among the designers who work with them.

There has always been ample rhetoric, much of it emanating from the project of utopic modernism in this century, claiming a larger social project for designers than most institutional agendas afford. Now there is a growing call for accountability. Accountability not only for the literal consequences to the environment but for the consequences to cultural environments around the world.

To ensure that emerging cultures are not sold wholesale in the rush to service the infinite needs of a fictional, transnational consumer, it is encumbent on designers to penetrate the opacity of things—both virtual and real—to more fully understand the meaning of objects and to respect the myths they reinforce and create.

We are no different from any who have lived before us in our dependency on iconography and mythology. Science no longer affords the illusion of objectivity; the planet is as populated with gods and goddesses, talismans and charms as it was in ancient civilization. And in the late twentieth century, "the pop image of cyberspace as a

'frontier' alerts us that the allegorical mode arises most forcefully in lawless, anxious realms."[9]

In their own "lawless, anxious realms" of practice, designers are searching for the myths of the next millennium. The self- knowledge that is bound in memory is the self-knowledge that is critical at the edge of the Virtual.

— S.Y.

1 T-Bone Burnett, "Humans from Earth," copyright 1992 Arthur Buster Starr Music (BMI), administered by Bug.

2 Andrea Branzi, "Territories of the Imagination," in *Learning from Milan: Design and the Second Modernity* (Cambridge: MIT Press, 1988), p. 14.

3 *The American Heritage Dictionary, The Second College Edition* (Houghton Mifflin Company, 1982), p. 692.

4 Erik Larson, "Supermarket Spies," *Health,* September 1991, p. 62.

5 William Gibson, *Neuromancer,* quoted in "A Computer, A Universe: Mapping an Online Cosmology" by Erik Davis, *The Village Voice Literary Supplement*, March 9, 1993, p. 10.

6 Larson, p. 66.

7 Katherine McCoy, panel remarks made at Cooper-Hewitt, National Museum of Design's "The Edge of the Millennium" symposium, New York, 1992.

8 Ibid.

9 Erik Davis, "A Computer, A Universe: Mapping an Online Cosmology," *The Village Voice Literary Supplement*, March 9, 1993, p. 11.

124

RIGHT: Andrea Branzi, *Foglia* lamp, 1988. Production Memphis. Photo: Santi Caleca.

Design and the Second Modernity:
Theorems for an Ecology of the Artificial World

ANDREA BRANZI

The coming of a mature postindustrial society will involve important cultural innovations—the critical features of which are laid out here:

1. The End of the Culture of Complexity

· The differences around us are more apparent than real; they come from a productive culture based on competition and economic trends.

· The great chaos around us, in this artificial megalopolis, is not a real chaos (i.e., unknowable matter); it is, rather, a phenomenon of turbulence between homogeneous slag and rubble, which produces violence and fights but never threatens the global balance of the capitalistic industrial system, which today is winning over its own alternative, socialism.

· The great *discontinuity*, seemingly savage, which lies in the postindustrial environment, is a reality ruled by a sort of *inner ecology*, balancing spontaneously all the most seemingly different pushes and pulls of social need.

· Thus the real innovations in the world are not produced by exalting separatist formal languages.

2. New Internationalism

· The research and evaluation of all the local and minority cultures started in the seventies is now at a declining point. One must invent new dialects ex-novo, because the existing ones are useless and declining.

· The world scene is getting a new shape on the base of a new international social majority, colorful and conflictual but everywhere the same. A colorful majority refiguring its relationship with creativity, which until now has been a *useless* mass-value. Useless because it's a limited creativity, wholly concentrated in realizing itself (now) only in consumption.

· The only model is postindustrial capitalism, in which the world is shared between rich countries and those that are not but want to become rich. In fact, the differences between West and East are not alternative, and their tendency will be to disappear or simply find different ways and sensibilities inside the same development model.

· Design planning must recover its own skill as an international language, but a language derived from exceptions, dialects, or local problematics, becoming an expressive code of the international society living in our planet.

3. New Industrialism

· Inherent in the physical scenery of postindustrial society is the co-presence of many productive and cultural logics that don't compete but coexist as a richness in a self-regulating ecology of the artificial world.

· If this is true, it means that there is no substantial difference between artisan and industrial production. It's just a matter of signs, technologies, and number of copies.

· Thus anything is industrial. That is, there is no productive system of industry but only different forms of a new industrialism, where new industrialism means new functionalism, new corporate strategy. This is the result of a worldwide industrial culture that has removed any other alternative but wants to make its own rules, assuming new codes of flexibility, quality, and respect for differences of consumption. But with all of those features operating inside a unitary international industrialism.

4. New Functionalism

· The strongest season of *Nuovo Design** corresponds to the season of its utmost isolation, not a social isolation but a cultural one, because *Nuovo Design* faces the objects alone, in the absence of an adequate analysis of the metropolis and of the rising postindustrial society. Thus the creative energy of *Nuovo Design*, in touch with new technologies and goods on a relatively small scale, points out the urgent need for a larger analytic plan.

· Within this critical pressure, the design culture of *old functionalism* is completely obsolete—a part of a historical culture that, from a general view, could be reduced to such details as tools and technologies. On the contrary, what has gone forward is the research for a new concept of functionality of objects, that has to correspond to uncontrollable parameters of poetry, psychology, and spiritualism.

Finally, today a new (at least analytical, if not projectual) view of the whole landscape of postindustrial society is taking shape all over the world. According to these analyses, it is possible to read design in terms of social events and their relationships. Thus *Nuovo Design* discovers it is not the result of a minority culture but corresponds, on the whole, to the technological and cultural needs of the postindustrial society on a worldwide scale. *Nuovo Design* becomes the functional reality for a new historical age—the answer to the quest for new functionality. Contextualized in culture, design thus becomes more suitable and more responsive to the present international society and to the global market.

* ed. note: *Nuovo Design* was defined in *The Hothouse: Italian New Wave Design* (Andrea Branzi, MIT Press, 1984) as design predicated not on "ideology or style... [but] changed market and production conditions," among whose adherents number various avant-garde designers, including Allessandro Mendini, Ettore Sottsass, Gaetano Pesci, and Andrea Branzi.

Gods Too Ancient and Contradictory:
In Response to Andrea Branzi

MICHAEL McDONOUGH

Andrea Branzi has proposed what he calls a Second Modernity. A Sweet New Style (*Dolce Stil Novo*) based on a balanced, "ecological" notion of design as a benign management tool, a mediator between the technological and humanistic cultures of Europe. The key is a revitalization of what he calls "reformist design," or design's "reform-oriented, progressive cultures"—designers who "create objects that speak to a non-aggressive code of values that respect man." Technology and its legacy in the form of products are in his view so pervasive that they have become our second nature. His Second Modernity is the "ecology of the artificial world."[1]

However, technology has evolved differently in the United States than in Europe, reflecting the differences between our cultures. At the beginning of this century, Europe saw it as a break with the past, a potential utopian modernism expressive of a revolutionary political agenda. The U.S. saw it as consistent with the task of building a nation. In Europe its advocates were an intellectual elite opposed to an ancient order, seeking a shining option after the collapse of outmoded civilizations. In the U.S. technology was seen through a populist eye, the means to more of a good thing, a leg up in the day-to-day work of making a buck. For them, a kind of poetic curative, an impetus for social change. For us, labor saving and seductive, something that could accomplish nearly everything.

It might be said, then, that Americans are at once both more and less romantic about technology than Europeans ever were. Regardless, on both continents throughout this century (and in Asia as well), we have all manifested a curious belief system. It holds that benign management of technology by reform-oriented progressives relieves us of individual responsibility for our lives. Pick your reform. Whether fascism or communism, isolationism or imperialism, modernism or postmodernism, we believed in turning ourselves over to experts who would run the show.

In America at the end of this century, we know better, and it is knowledge hard won. We don't trust experts anymore. We have learned to be cynical about the promise of our own passivity, cynical about our belief in the benign management of technology. Recent history haunts us. Vietnam was managed by experts, a technological affair, with think tanks and electronic battlefields. So was Three Mile Island, the accident the nuclear power industry said could never happen. So was the Exxon *Valdez*, a state-of-the-art supertanker in calm waters. What could go wrong?

We are cynical too about what Branzi calls reform-oriented, progressive design

cultures, especially in their more heroic manifestations. In the 1960s they promised us technological relief from the problems of urban decay through a special brand of architecture, planning, and social engineering. But as the new cores of our cities rose, their perimeters burned, and their populations scattered. (Perhaps that was the intent.) Nonetheless, thirty years later we are still trying to solve the problems exacerbated by the "reform" of warehousing our poor in progressive public housing.

In the 1980s we believed we could manage our moral exhaustion through the "technology" of economics. We became rich, temporarily, but our industries faltered, and our cities became fractured killing grounds. In our Cold War with the East, in our Low Intensity Conflicts in the Third World, in our police action in Southwest Asia, in our war with the earth for its resources and its riches, we have won every time, and lost every time. Benign management of technology and progressive reforms have done some of what we Americans asked of them—spawned houses full of objects of desire, given us a myriad of pleasures—but with little resonance and much misery in the balance.

Branzi is very much a product of the European utopian culture of technology. His Second Modernity preserves much of the first modernity without challenging its methodologies or its fundamental assumptions. It is to be guided now by ecological ideals rather than social ideals. It is green rather than red. But it is still rooted in the European tradition of concentration of power at the top, power among the few, the privileged, the isolated. Things proceed in this system from the top down. This is oligarchy, a circumscribed canon of thought, with methodologies rooted in elitist prescriptions about how the rest of us should live. This is monoculture, and it is dangerous.

We all love good design. It is only natural to find joy in display and delight in form. And technology is a fact of life in our time: short of total cataclysm, it will not go away. And somebody has to run things, sooner or later, and concentrations of power are necessary to a certain extent because that is how things get done. But Branzi's theorems, his Second Modernity, his Sweet New Style, is too sweet, too seductive, and too simple. Despite the new packaging, it is business as usual.

As a baby-boom American, I am unromantic about modernity. Technological modernism to me is a fact of life, a confluence of industrial policy, resource availability, marketing, economics, and mass-media manipulation. Emotionally I am not seduced by its revolutionary possibilities so much as alarmed by its sad failures, its excesses, its ability to dehumanize through induced mass passivity. Branzi has said it is our second nature. It is not. It is a tool, blunt on one end, sharp on the other, available. Like any tool, we best use it intelligently.

In America things proceed from the bottom up, not the top down. The bottom being a teeming mob, pragmatic, rife with spontaneous generation. It can be violent and painful to live in such a culture, as it lacks the depth and wisdom of other places. We are enormously young. But we enjoy true diversity within our borders. Our history is multiple, overlapping, simultaneous.

It is from this matrix that American designers emerge and within it that we must

function. Forced together in a vast consumer market, we are judged principally on our ability to interact with that market. Whether we make pornography or poetry, a ruthless democratic populism holds sway. Our credo is, no matter how vulgar, "serve the user." In this we are more communistic than the communists ever were. In this our country is a microcosm of an emerging global culture. As we are, so too the world will be.

So why should we turn back to a Second Modernity from a distant shore? Why should the perpetuation of theorems hatched in 1920s Europe be the standard that we bear? We need to understand the richness of our experiment—its failures and its promise. This is our profound responsibility as Americans. We cannot leave it to Alexis de Tocqueville, Jacques Derrida, and Jean Baudrillard. It is our obligation, our gift to the world. We need theorems about our culture, objects inspired by our experience. America, it might be said, is everything for which we have an affected disdain. We need to get beyond that affected disdain.

America is about combining unlikely things in unexpected ways. The music of the Mississippi Delta, of the rural South in general, is a blend of Irish and West African folk tunes. So Robert Johnson owes something to the fishing cultures of Aran. And Hank Williams owes something to the lion hunt. Cajun cooking is a mix of French Canadian fare and Seminole Indian spices. Navaho silver shows strong Spanish influences. The wheat

of the plains, the eucalyptus trees of California, the apple trees of New England all came from somewhere else. There are Russian-speaking towns in Alaska. Who would have thought this possible?

None of it was managed, none of it handed down from above, none of it designed skillfully or translated by a knowing eye. It was accidental, experimental, happenstantial. And from it comes, in part, our genius as a nation. Europe left such things behind millennia ago; it is a very different place now. Europe has its treasures, but it does not have the unguent discordance, the sheer innovative brilliance of jazz musician Miles Davis. Nor does it have the brown paper bag virtuosity of outsider artist Bill Traylor. Nor the refuse architecture of folk sculptor Grandma Prisbrey. These things excite me. They inspire me. They exist despite the methodology of design, of oligarchy, not because of it. And there is much to be learned from this.

130

What troubles me about what Branzi says, and implicitly about so much of what we have inherited from European high culture, is that it all seems so pat, so safe, and so untrue to my experience of what it means to be an American. It says we do not have that much to learn, but everything to teach. It is not humble. It offers resolution, but it diminishes the rebellion, skepticism, provocation, perverse thinking, and sheer contrariness that are my heritage. It says I need not resist.

I think I should resist.

America, I think, will never take to the Sweet New Style. It is ruled by gods too ancient and contradictory for that. America is too untidy, too strange for that. We need to embrace the strangeness in ourselves and sing it in our work.

A coda: Branzi's view of architecture in Europe is that of a profession providing an endless procession of unprecedented, useless objects, devoid of long-term strategies and devoted only to preserving its own historical continuity and good composition. What he says is equally true here, if not more so. We American architects still imitate and reflect the value systems of European architecture. We are still good colonials.

The failure of American architecture to develop a broader cultural consensus than it has, its descent into economic powerlessness, and its relative irrelevance as a profession have been paralleled by an increasingly isolated, self-congratulatory, and conformist elite. Much of architecture's intellectual wing has abandoned social responsibility, preferring obscurantism to activism. Architecture now, with its superficiality and redundant formal virtuosity, reminds me of late Beaux-Arts renderings—spectacular irrelevancies.

Branzi warns us that design, if we designers are not careful, is at risk of being as trite, and silly, as architecture has become. He says design must be saved. But what will save it, I think, is not his reform-minded, progressive culture, his utopian longings, or his call for broad horizons.

I think what might save design is its humble materiality. Product design is about things you can touch. It must interact with its market. It must interact with the politics of production. It must function. And that is why I agree with Branzi that energy has moved away from architecture to product design. It is design's lack of theory, its vulgar link to real people's lives, our lives, that makes it so interesting, so fertile just now. Architecture cannot really make that claim, so it is entertaining a less provocative set of ideas than it used to. When it steps back into the arena of real life, it will garner the vitality and validity of real life. In the meantime, a global recession might just foment some new ideas. The threat of ecological disaster may create some new products. Change may come accidentally, experimentally, happenstantially. Design is, almost by default, too vast, too fragmented, too chaotic a system for benign management, for organized reform. This may be its genius. At the edge of the millennium, I certainly hope so.

1 Quoted phrases excerpted from "Design and the Second Modernity: Three Theorems for an Ecology of the Artificial World," a paper presented by Andrea Branzi at Cooper-Hewitt, National Museum of Design's "The Edge of the Millennium" symposium, New York, 1992.

LEFT: Bill Traylor, *Exciting Event, Blue Man, Snake*, 1939–1942.
Collection of Trisha Hammer. Photo: Ricco/Maresca Gallery, New York.

Design and the New Mythology

MICHAEL McCOY

At the approach of the new millennium, design is becoming a projection of contemporary myth. Products symbolize new stories about consumer culture, mythic stories that we create to explain our urges and actions. They are the props and the set designs for the new mythology. The Harley-Davidson motorcycle carries with it the myth of Odysseus transported to our times as *Easy Rider*. The cubic black volume of the NeXT computer echoes the mysterious obelisk of *2001* and the myth of an omniscient rational god. These

are examples typical of the objects of choice of cyberpunks, madonnas, homeboys, urban cowboys, and road warriors. Myths have an explanatory or etiological purpose; they explain natural phenomena or a psychological state, engendering beliefs or customs. They are stories that serve to unfold part of the world view of a culture or rationalize a practice or a belief.

Design cannot predate or prefigure myth, but may be complicit with the mythmaking, especially within subcultural phenomena like cyber networks or extreme sports where the designers may have a close connection to the activity. Most of the new design/mythology has to do with explaining technology and our relationship to it. At the end of the millennium there is tremendous ambivalence toward technology. At the same time that it plunges us into severe social and ecological problems, it offers us hope by expanding our reach and understanding of the world. It is threatening and enabling at the same time. Thus new design often embodies this paradox, presenting possibilities that are both exhilarating and frightening. Design is not a neutral act of simply packaging the established trend. It can be proactive, proposing possibilities. One of the strategies is through experimental design projects that hypothesize new ways as well as criticize existing ways. Polemical work, such as some of the projects of the Cranbrook Graduate Design studios that I will discuss, can serve to set the agenda for debate about the future.

Science fiction attempts to predict and explain the future. It extols and it cautions. Design can do this also by proposing scenarios, becoming like a physical science fiction. If science fiction is the mythology of our future, then design and science fiction can collaborate to create the mise-en-scene of that future. But just as the current science fiction speaks of both the possibilities and dangers of the future, current design resonates with both hope and caution. It contains elements of irony and danger as well as wonder and optimism.

I would like to look at examples of new design that suggest new stories, or new versions of old stories, about life and nature in our age. In each case the designer is not creating myth but simply has an ear to the ground, picking up the sense of the culture and interpreting that sense in objects. Their projects are in the spirit of science fiction, drawn from a subconscious pool of collective myth. These objects are not the reason for myth; they simply populate and support it. It is people who are central to the construction and maintenance of myths. Design exists between desire and necessity, and myth speaks both to desire and to necessity. It amounts to a matter of survival. We need metaphor and myth to survive. We need to construct a dimension beyond the visible plane that gives us hope and models of behavior beyond ourselves.

The mythic object is especially potent in subcultural groups that use it as a private

133

LEFT: *Easy Rider*, 1969. Photofest.

ABOVE: *2001: A Space Odyssey*, 1968. Photofest.

symbol of belonging. Myth helps create group identity. It provides a continuity, a link to the past and to the future. It supports and extends political and cultural agendas, but it also helps us deal with life. One of the key components of contemporary myth is technology. Since technology is an extension of ourselves—physically, psychologically, and socially—it follows that the objects of technology might serve as props in the myths that we construct as a society or as subcultures.

It is hard to imagine the mythic stories presented in *Easy Rider* and *Road Warrior* without their central objects. The chopped Harleys of Peter Fonda and Dennis Hopper are virtually Arthurian in their symbolism of the cultural journey or crusade into the dark heart of America in the 1960s. Likewise, the collage vehicles of *Road Warrior* embody the threat of the postapocalyptic landscape they move through.

One of the central features of contemporary science fiction is the hero (or antihero) in dystopia—the technological utopia we all hoped for gone bad. It not only doesn't work but is malevolent, threatening human freedom and life itself. The myth of dystopia projected in works like *Neuromancer*, *Brazil*, and *Blade Runner* resonates with our fears of our mismanaged future, environmental and social entropy, and our perceived inability to control our destiny. The Bladerunner moves through, and survives in, an urban dystopia. Our society is so intertwined with technological systems that when they fail, we believe that the society itself also fails. In accordance with myth, it then falls on the individual to fight his or her way through the dysfunctional systems and malevolent machines to the requisite shining goal—usually the rescue of an innocent or of a symbolic object, or sometimes the destruction of the system's controlling force. Hal, the rogue computer in *2001*, must be unplugged after killing most of the crew. The machine has become the

134

dragon that must be slayed. At the same time, in many of these mythic science fiction works, the hero employs a benevolent technology (like R2D2 in *Star Wars*) to conquer an evil one. This leads to a kind of object that plays a prominent part in the new mythology: the tool or device that expands the powers of the individual in a hostile world—the corollary of the sword in the stone.

Much of the new work explores the mythology of technology as servant, pet, or a kind of synthetic nature, in the mythological tradition of Mary Shelley's *Franken-stein*. Technology as the image of ourselves or of nature manifests itself in anthropomorphic, zoomorphic, and biomorphic imagery.

Mike Scott's computer and desk for a medical researcher are creatures with translucent rubber skin covering the technological bones beneath. They gesture and move in response to their masters' needs. A single knee joint allows the screen to bend, stoop, and twist in response to the nature of the information presented. The technology is present but barely visible beneath the surface of the skin. It is not lifelike but life-referential.

The *Satori Television* by Peter Stathis is another kind of creature. A pet that wakes up when you touch it. When the television is turned on, the head rotates up to look at you. The body is covered with a stretch fabric skin. It projects the idea of technology as a friendly but alien presence. But it also conjures up the vision of the lonely guy in his tiny New York apartment late at night, the television his only friend.

Many mythic objects seem to be about the transport of mind and body—physical and metaphysical transport. The Harley-Davidson's outlaw journey appeals to the need not only to leave home but to also assume a new outlaw identity. The *Gossamer Condor*'s Daedelus-like flight is poignant because the plane glider is powered by a gravity-bound human. The disastrous flight of the space shuttle *Challenger* has a mythic resonance with the flight of Icarus, and the sense of the limits of technology.

We often yearn to be set free, to roam the world and fly over the land, and that yearning manifests itself in real and metaphoric travel. The Greek and Roman myths are filled with stories of the journey and the search. The *Odyssey* is transmuted in our culture through the lore of Kit Carson and Jack Kerouac. And the contemporary objects of the journey replace the galleys and sails of the ancients. As Joseph Campbell, the leading scholar of mythology, said, "Automobiles

have gotten into mythology, they have gotten into dreams. And airplanes are very much in the service of the imagination. The flight of the airplane, for example, is in the imagination as the release from earth. This is the same thing that birds symbolize in a certain way. The bird is symbolic of the release of the spirit from bondage to the earth, just as the serpent is symbolic of the bondage to the earth. The airplane plays that role now."[1]

Similarly, the new design supports the myth of our senses being expanded to global dimensions: seeing and hearing or being heard far away. Electronics are making possible the godlike feats of communicating with many friends around the world simultaneously or gathering knowledge from distant places instantly.

Often technology is seen as prosthesis, but a prothesis that is very close to and empathetic with the body. Some of the most exaggerated examples can be seen in extreme sports equipment in which skills and strength are magnified and extended, sometimes heroically. There are small passionate groups of enthusiasts that imbue objects with mythic dimension. The equipment often takes on a power beyond its technical description. Extreme skiers fly off from the faces of cliffs with high-tech skis, miraculously landing without injury; surfers with highly crafted carbon-fiber surfboards face impossible waves. There is a metaphysical relationship between body and equipment. The gap between the intention of the wearer and the desired movement becomes less and less until human and equipment become one. The high-tech ski and boot become almost part of the body.

Lisa Krohn's wearable computer becomes a technological second skin. The body itself begins to become an electronic neural network. The hardware becomes softer, the software anticipates your needs and perceptions. Information gets closer and closer to the body, instead of residing in a separate objectified entity like a traditional computer.

The most interesting aspect of the new design is that designers are moving closer to their audiences, the people who use the technology. They are trying to understand and empathize with a particular culture and its needs. The designer of a high-tech ski is more than likely a good skier as well. This characterization also holds for most experimental design in electronics. The new work combines the desire of some people (cyberpunks included) to be connected to the world data space and also to be independent as they move through that space. In fact, somewhere in the world, the semi-mythic Steve Roberts, well known to readers of the magazine *Mondo 2000*, is roaming the world with his solar-powered-multicomputer-heads-up-display-satellite-uplink-equipped bicycle, pedaling his way through data space.

On a low-tech level, the small intense groups that spring up from the streets develop an ethic about appropriating that which is necessary to survive. Hip-hop and "house music" collect and collage from many sources. Kevin Fitzgerald and Scott Makela have tried to listen to the street in making a CD player with its welded-steel speaker horns, large cast controls, and body constructed of the wood used in baseball bats. There is a contemporary urban mythology of outlaw appropriation and survival in the music suggesting that design can look beyond pastel plastic for the materials it chooses to render technology.

136

The new design ethic is not to simulate nature and present it as part of culture but to sign its synthetic qualities and, in fact, celebrate them in many cases. The result is a design language that represents a "second nature." These projects are at the heart of the dilemma we face regarding technology—our monster/child. They embody all the ambiguity that we as a culture feel. As technologies like bioengineering, microelectronics, and micromachines approach some of the capabilities of life, the questions become more and more urgent.

A drive-up phone booth by Eric Williams represents a second nature in its insectlike form. The vertical poles sign its presence on the street, the exoskeletal machine pivots down to engage the car, and the shell-like hood protects the driver from the rain. The driver can leave the car window rolled up while the phone kisses the window, turning it into an interactive video phone screen with the driver remaining safely locked in the car.

In realizing the emergence of a "second nature," design can also generate the sense of wonder that we genuinely feel in the presence of some technology: the magic of the computer or of instantaneous global communications. Bill Wurz's round computer emerged from a dream about a magic pool in which images appeared. It breaks from the computer-as-machine tradition, proposing a pool of information that can be approached from any side and manipulated with the hands. The magic of the computer is reaffirmed as a landscape of elements to be touched and used as informational tools.

The myth of the pilgrim in the wilderness is projected by Brian Kritzman's *Celestial Navigator*. A wooden and wrought-iron walking stick is topped by a crystal that is intended to display navigational information (from the satellite global location system) to the traveler anywhere in his journey. The crystal display is like a polished gem or stone.

137

The staff itself is a substantial wooden shaft bound by a wrought-iron tip and crown. There is an intersection of traditional craft and microelectronics.

Masamichi Udagawa's work epitomizes the idea of the traveler navigating his or her way through the urban landscape. His information grabbers are devices allowing invisible text and images transmitted from buildings in the city to be accessed, giving the wearer a kind of superman's x-ray vision into activities going in each building. The devices symbolize a kind of instrumentality, simultaneously ancient and future fictitious. Components of the city are continuously propagating images about their content. When the traveler sees something of interest, she squeezes the instrument and grabs the image. The true architecture of the city thus resides in the electromagnetic spectrum. His information projector is a device that allows those captured images to be manipulated and dissected later at one's worktable. The projected electronic images coexist with books and objects on the desk.

Don Carr's computer projection display and hand controller conjure up a sense of navigation and exploration through data space. The saillike fabric image projectors celebrate information as light and movement. The hand controller harkens back to the early archetypes of ancient hand tools. The flexible membrane interprets hand gestures into movements on the screen. Scott Makela's software design envisions information as a landscape or geography into which one plunges in successive layers. The image printer celebrates the transformation of electronic impulses into a physical marking process as the cart carrying the thermal wax moves across the paper, manufacturing images along the way, a kind of electronic Gutenberg.

While these projects do not represent a complete sense of our emerging techno-mythology as we approach the edge of the millennium, they do give clues to a position that is both healthily skeptical and optimistic about design and its collaborative role in envisioning a future strategy. Technology is an extension of ourselves, not an alien virus injected from another planet. It reflects the worst and the best of us, from the atom bomb to the Macintosh computer. If designers have any responsibility, it is to help ensure that technology reflects our best aspirations and to help shape technology that is connective and enabling, not controlling and limiting.

1 Joseph Campbell, with Bill Moyers, *The Power of Myth* (New York: Doubleday, 1988), p. 18.

Masamichi Udagawa, *Information Grabber*, 1989.
Photo: Cranbrook Academy of Art, Design Department.

A Response to Myth

HUGH ALDERSEY-WILLIAMS

I remember everything.

I remember every little thing as if it happened only yesterday.

I was barely 17 and I once killed a boy with a Fender guitar.

I don't remember if it was a Telecaster or a Stratocaster, but I do remember that it had a heart of chrome and a voice like a horny angel.

I don't remember if it was a Telecaster or a Stratocaster, but I do remember that it wasn't at all easy.

It required the perfect combination of the right power chords and the precise angle from which to strike.

The guitar bled for about a week afterward.

And the blood was—oooh dark and rich like wild berries.

The blood of the guitar was Chuck Berry red.

The guitar bled for about a week afterward but it rung out beautifully, and I was able to play notes that I had never even heard before.

So. I took my guitar and I smashed it against the wall; I smashed it against the floor; I smashed it against the body of a varsity cheerleader; smashed it against the hood of a car; smashed it against the body of a 1981 Harley-Davidson.

The Harley howled in pain. The guitar howled in heat.

And I ran up the stairs to my parents' bedroom.

Mommy and Daddy were sleeping in the moonlight.

Slowly I opened the door, creeping in the shadows right up to the foot of their bed.

I raised the guitar high above my head and just as I was about to bring the guitar crashing down upon the center of the bed, my father woke up screaming:

Stop! Wait a minute! Stop it boy!

What do you think you're doing?!

That's no way to treat an expensive musical instrument!!!

And I said: Goddammit, daddy! You know I love you, but you've got a hell of a lot to learn about rock and roll.

— Jim Steinman, from "Love and Death and an American Guitar"[1]

Michael McCoy writes of the power of myth and the difficulty designers face in deliberately setting out to create potentially mythic products. There is abundant evidence that certain products have indeed attained a mythic status, but how did they achieve that status? And what part, if any, did the designer play in getting them there?

I'd like to pursue some of his points made with reference to subcultural groups, as well as to examine the more hard-wearing, full-blown cultural groups that we call nationalities. For the attraction and persistence of national styles in design is perhaps more widely and deeply felt than affiliations to many subgroup identities. In both cases, however, the myth content is absolutely key. The creation or reinforcement of myths in design is very like what the British historian Eric Hobsbawm has called "the invention of tradition."

Designers are the new inventors of tradition. At the turn of the millennium, designers have the power to give identity to the objects associated with subcultural groups, but they are also in a position to shape national character. Perhaps if they use their skills sufficiently they can satisfy nationalist demands that might otherwise find their expression through the barrels of guns. Then again, perhaps not.

The aim to sustain myths in product form grew logically out of the exploration of product semantics. I must admit "product semantics" as a term and as a movement has always bothered me. Some still think product semantics is a style to be taken or to be left. Corporate design directors ask for products with some of that semantics stuff the way some CEOs send their minions out in search of "corporate culture." Neither can be purchased by the pound.

I have a number of other difficulties with product semantics. One of them is that its widespread use encourages people to read too much into things, to find references and allusions where no reference or allusion is intended, and, more insidiously, perhaps to come to believe that a product is incomplete if it does not appear to reveal such messages.

More commonly, there is too much emphasis on the signifier over the signified—the cleverness of the designer gets in the way of the function of the product. It does no harm to be reminded that a 7-Eleven store can stay open twenty-four hours a day or that a high-fashion store in London can stay in business despite being named Droopy and Brown. The sign is not all. Sometimes product semantics allows only one interpretation of a product, offering one reference, allusion, or joke of which the user might soon tire.

Fortunately, product semantics was a means to an end in the search for the mythic object. It is welcome that the progenitors of product semantics have gone further and are now exploring what they call the outer limits of problem-solving beyond function.

Of course, whether people have analyzed it or not, the best design has always striven for this extra dimension, even during the modernist period, which is so frequently slandered as being devoid of deeper meanings and intent. Sometimes too this extra content has been made visible in a more or less readable symbolism. Think of Le Corbusier's Ronchamp Chapel. It has not one reading that quickly becomes boring but, as the critic Charles Jencks has pointed out, a whole catalogue of them, all subtly and ambiguously expressed, for people to decode if they will and if they can.

140

But can the designer deliberately build in myth? Should the designer try? McCoy suggests that to set out with the specific intention of creating mythic design is not viable. Any mythic power of an object (as opposed, it seems, to a building) tends to be conferred with the passage of time as our image of the object is transformed and manipulated by other media. The Harley-Davidson was mythologized by the movies, the Fender Stratocaster by the people who played it.

But what of the Macintosh computer, the Mont Blanc pen, or the Tizio lamp? Are these not objects which have not had this treatment? Perhaps. But perhaps they too have been subliminally mythologized into design icons by more anonymous means (as styling accessories in a thousand advertisements). Did their designers set out to imbue these objects with mythic status, or is it simply the birthright of excellent design to be so interpreted?

A myth is a story that has become separated from its source; it is no longer verifiable in some way. So a mythic design can surely only be one where the designer has lost control over the object and the ways in which it is projected into our consciousness.

Nevertheless, it seems designers can assist in the mythologizing process. Keyboard symbols for Olivetti by the Milan designers Perry King and Santiago Miranda draw on Egyptian hieroglyphics for some of their symbols. This is not something explicitly articulated in the design. It is not something that the naive user will perceive and identify while using a photocopier or fax machine. But it makes an ineffable contribution to the presence of the object.

Among many Sony Walkman designs, one model has a hard, almost translucent, white enamel casing. Its designer says the inspiration came from a traditional ceramic chopsticks holder. Whether the Japanese people who buy this product (it is only on sale in

141

Ed Paschke, *Guitao,* 1978. Private collection.
Phyllis Kind Galleries, Chicago and New York. Photo: William H. Bengtson.

Sony's domestic market) recognize the allusion is unclear. However, the product has had a longer shelf life than many other Walkmans.

Frogdesign's NeXT computer is another candidate just begging to be mythologized. It's partly to do with its enigmatic appearance—like the monoliths in the film *2001*, as McCoy suggests. In fact, it's not a cube but a slightly distorted cube. Just as Greek architects knew to create columns that were not parallel sided, so Frogdesign has created a computer with the modern equivalent of entasis.

The success of the myth depends on sublimating its narrative (interface graphics as hieroglyphics, personal stereo as Japanese ceramic) within the product so that the user can no longer read it in any explicit way but can nevertheless sense it.

This level of (attempted) mythmaking is on a higher plane of subtlety than the instant mythology of objects associated with certain subcultural groups such as the dangerous sports fanatics that McCoy includes in his study. The styling that is employed to connote belonging to some subcultural groups is highly suspect. It is as arbitrary as it is garish. As the owner of a sailboard and some ski equipment, I'm still looking for ways to erase the graphics off my gear.

The inflicting of an unwanted lifestyle upon the unlucky buyers of this equipment by means of an obnoxious appliqué is a poor starting point for "mythic" design. It enforces a group identification where it should be virtually irrelevant—in activities that celebrate individualism. The colors and patterns change each year, not encouraging group identification but enforcing division between owners of last year's kit and this year's.

Classical musicians form another, very different subcultural group. The tools of their trade are equally potent—and more durable—signifiers of belonging to a set. The shapes of instruments have been refined over decades and centuries. The cases to carry them serve as musician's badges as they move around outside the concert hall. But the significance of these objects lies not in superficial graphics or form giving but as the result of their being used, that is to say, through the music they create. Musical instruments are generally not even thought of as designed objects but as craft items. The mythology of musical instruments is sufficiently powerful that we continue to believe they are handmade even when they are not.

Where they are made by craftspeople, musical instruments are perhaps the last bastion of meaningful craft. How unlike the modern craft objects created in Appalachia or the Cotswolds that have no relevance and no myth content. However much their well-meaning creators steep themselves in the local heritage, such articles exist to signify their handmadeness and nothing else.

The emptiness of most craft production tempts the proposition that contemporary industrial design is the better vehicle for modern myths. The presence of technology does not preclude the presence of myth. This is not to say, however, that technology should be the sole focus of the contemporary designer's mythmaking. Once technology makes it possible to do something, there is always a phase when designers rush around celebrating the fact. Recent improvements in the ability of computer graphics to simulate "reality" have

led engineers and graphic designers to produce images with tricky optical properties, such as shiny chrome ball bearings or droplets of water, at the expense of the message that it was their job to communicate.

There are more thoughtful treatments that reflect our ambivalence toward the technology we have created:

• Technology can be revealed and, to some extent, explained, as in Eliot Noyes's old IBM mainframes with windows to the wiring or the radio in a transparent PVC bag designed by Daniel Weil at London Royal College of Art.

• It can be expressed with a more intuitive subtext, as in Lisa Krohn's wrist computer or David Gresham's video camera.

• It can be shrouded and made mysterious and enigmatic like the *2001* monoliths, as in the NeXT computer or the Bang and Olufsen hi-fi.

• Or, finally, it can be dissected and criticized as in the work of designer David Teasdale and the dystopians that McCoy discusses.

In literature people used to write about utopias—Thomas More, H. G. Wells, Jules Verne, et al. Dystopias came along in the 1920s, first with Yevgeny Zamyatin's *We*, then Aldous Huxley's *Brave New World* and George Orwell's *1984* in subsequent decades. The term dystopia was coined after all of these were written, in 1950. What provoked this shift from utopia to dystopia?

Perhaps movies became the favored medium of the utopians. Or perhaps more destructive wars made utopia untenable. Perhaps new technology made utopia untenable.

Writers, of course, have a notoriously low threshold of technology tolerance. Designers, obliged to be technologically literate in their work, do rather better. But with ever greater microelectronic intelligence built into objects, could it be that they too are now reaching their limit? If so, we may see an outpouring of dystopian products as the millennium approaches.

Technology is a source of fascination, but perhaps more for the designers who must at least begin to understand it than for consumers for whom how things work becomes less

143

David Hockney, *Yellow Guitar Still Life, L.A., 3rd April*, 1982.
Copyright David Hockney. Courtesy of the artist.

and less important. In trying to create products with mythic content beyond function, it would be dull to get hung up on simulacra and metaphors based solely on product technologies. It would be the three-dimensional equivalent of all those tedious TV computer graphics that were more concerned with boasting new technical capabilities than with meeting a high standard of design.

As other creative fields show, the sources for allusion, comment, and reference can be much wider. Such devices are widely accepted in architecture and music. There are historical references and allusions, such as the phrase from Beethoven's Ninth Symphony found in Brahms's First Symphony. There are many examples in modern—or postmodern—music that quote not only a phrase but also the precise orchestration of an older work. Shostakovich's Fifteenth Symphony quotes Rossini's William Tell Overture; Alfred Schnittke's First Symphony quotes Beethoven's Fifth; Luciano Berio's Sinfonia uses the entire scherzo from Mahler's Second Symphony as a background to a new musical drama. Parallel strategies for design praxis can be identified in the architecture of Robert Venturi and Denise Scott Brown, James Stirling, and others.

Deliberate acts of reference and quotation are commonplace in other arts. For better or worse, we do not generally find these games played in our object culture.

A 1987 project for Dictaphone by Design Logic, a Chicago firm, sums up several of the arguments for this kind of appropriation. The brief called upon the designers to speculate on the new forms that might be taken by telephone-answering machines, one of a class of objects in which the miniaturization of technology has greatly loosened the constraints of form giving. One version, which takes after a U.S. mailbox, quotes from that object literally. As in the Shostakovich or the Schnittke symphonies, no one could miss the reference. The reference has the added value that it is functional as well as visual. A message is flagged on the display in much the same way that a mailman indicates you have a letter. This passes a social more than a technological comment on our changing way of doing things. It is also an example of deliberate design nationalism, choosing to pay homage to a quintessentially American object.

The growing realization that products do not live up to our need for cultural or subcultural identification makes these sorts of explorations more likely and more acceptable. We already see and hear their analogue in other arts. All that remains is for designers to articulate the debate with sufficient refinement that clients are persuaded to transform such ideas from polemic to commercial reality.

1 Jim Steinman, lyrics from "Love and Death and an American Guitar," record released by Epic Records (now CBS Music/Sony Entertainment), music published by Lost Boys Music, 1981.

144

RIGHT: Rick Griffin, *The Man From Utopia*. Photo: Smart Design, New York.

Momentum

BRUCE STERLING AND TUCKER VIEMEISTER

What follows is based on a conversation held between science fiction writer Bruce Sterling and industrial designer Tucker Viemeister at the Cooper-Hewitt 1992 conference "The Edge of the Millennium." The Texan author of *Islands in the Net* and the vice president of New York's Smart Design explore a range of topics, from the crossover possibilities of their respective professions to the management of the future.

Viemeister: We decided to call this conversation "Momentum" because we feel progress is going ahead on its own and no one seems to really be in charge of it.

Sterling: I think that momentum in a machine creates drive, the momentum in a fluid creates turbulence, and technology is a machine, but society is a fluid. The situation we face now is that the machine is immersed in the fluid.

Viemeister: I don't think politicians or religious leaders are really leading us as much as they used to. No one seems to be in charge. So it seems like the future is just going to show up on its own, and no one will have had any input into how it got that way.

Sterling: Right. First I'd like to talk a little bit about the technologies that changed us in the past but have lost their momentum in the nineties. Rockets—the American rocket state is currently clearly in decline. Nuclear power—we have Chernobyl victims who remember energy too cheap to meter. The Berlin Wall—population containment technology no longer useful in an era of electronic networks.

Viemeister: Cars.

Sterling: The automobile—once a symbol of complete freedom, now snarled in traffic jams and destroying the atmosphere. Skylab and the stillborn United States space station. Underwater habitats—very intellectually sexy in the 1960s. Who remembers NOAA, the wet NASA, from around 1965 and 1966? The idea of going out in lead-footed boots to catch the school sub and so forth. Don't hear much of that anymore. LSD—another fine sixties technology that lost its edge.

I need to change tack here and consider some technologies that do have momentum in the 1990s. These are the ones that interact a little more intimately with the fluid of society. Computers, telephones, faxes, television, cable television, video, satellites, America's most successful export—Michael Jackson, cosmetic surgery, anabolic steroids. These are body-image, body-altering technologies, under the skin, subcutaneous technologies. These things are moving ahead on their own. They affect society drastically in unprecedentedly intimate ways. The high-tech, postmodern, globalized free market has won in the 1990s, but its first condition of victory is to break into your home and merchandise the

146

Keith Haring, *No Nukes New York.* Self-published and distributed for free at
the June 12, 1982, "No Nukes" rally in New York City, 1982.
The Museum of Modern Art, New York.

1761-46

sexuality of your teenage daughter. It then sells you your own self-image at a 15 percent markup. I'm interested in second-, third-, and fifth-order effects from technologies. I'm interested in the edges of ideas, not the centers of ideas. The center of the idea of television is probably the cathode-ray tube; the edge of the idea of television is an orange-haired divorcée eating Cheetos on a couch and watching Wheel of Fortune. Momentum means turbulence in society, and turbulence means eddies, backwaters, and niche environments.

Viemeister: Accidents are one thing that is left out of design—they're kind of like the "edge of ideas" you're talking about. Designers tend to overplan because "chance" is the opposite of design. But accidents can lead to interesting coincidences. So we have decided to use it to direct our conversation. I've made up six topics that we'll address in random order because the chance juxtaposition may lead to insights and a real-life sense of adventure.

147

This Island Earth, 1955. Photofest.

The first topic is "Out of This World: IV, Virtual Reality, and Drugs." Let's talk about designing reality—virtual drugs.

Sterling: Oh, joy. Joy unbounded. Yes, and the war against some drugs. You know, if they had a drug around that could lengthen your lifespan by twenty years, the pope would be the first in line. I go to Japan a lot, and I know the Japanese fascination with these quack performance enhancers. This stuff is really spreading in American society right now. What if the cognition enhancers in *Mondo 2000*, my favorite magazine, actually worked? I mean, I kind of like it that you could take a pill that would actually make you smarter—intelligence being a rather foggy and multifaceted concept—but there's probably neurochemistry floating around in the actual tissues of an actual human brain that could be extracted, synthesized, and marketed.

Now, artificial intelligence, when you come right down to it, is a commercial process. It's the process of figuring out how the human brain reasons and extracting that process, then selling it as a commodity. How long before designers find themselves confronting the temptations of Ben Johnson, the disgraced Olympic athlete. "Take a few micrograms of this stuff and your ability to do three-dimensional modeling problems will increase ten-fold." "Look, we've got a deadline on this product, and if we don't do it, the Italians will." Do you know virtual reality's most interesting potential? Its telepresence—not in an artificially flavored world but in our world. It's just like you're there in another real location. The market for five-minute virtual vacations somewhere on the soothing muddied depths of the Mariana Trench five miles down in the Pacific.

148

ABOVE LEFT: Neil Jenney, *Media and Man*, 1969. The Solomon R. Guggenheim Museum, New York, 1987-3512. Photo copyright The Solomon R. Guggenheim Foundation, New York.

ABOVE RIGHT: Pavel Tchelitchew, *Head, I.*, 1950. The Museum of Modern Art, New York.

Viemeister: You mean that designers are going to have a lot more work to do on this virtual reality?

Sterling: No question about it. It's the ultimate designable medium with no material constraints. You can become as abstract and as high-brow as you possibly can.

Viemeister: And all that junk has to come from somewhere, right?

Sterling: That's right. Somebody has to make it, it has to be sold, it has to be marketed, and virtual reality is capable of absorbing infinite amounts of human ingenuity. That's the nifty part about it. An orange juicer—you can only change it so much before it stops functioning. Virtual reality—it's not even subject to gravity. It's not subject to the most elementary laws of physics. You can have things inside things, where the inside is much bigger than the outside. You can change scale. You can build structures that are previously unknown, and if you don't like them, you can just pull the disk and throw it in the trash.

Viemeister: But how is this stuff going to relate to normal people? That's what I want to know. I think television has really changed the way people are now. People who were raised on television are different from me, and I was sort of raised on television.

Sterling: Well, I think virtual reality will allow our average couch potatoes to take root. They're going to be webbed down to their fingertips.

Viemeister: Well, the average American already watches 7.4 hours of television a day. Is it possible to be any more attached to the screen?

Sterling: Oh, I don't know think there's any question that you can be attached much more intimately to television than we are now. With a virtual reality rig, you can experience actually being inside the glass box. You can move around inside the computer-generated landscape. And then there's what's known as computer-assisted perception, computer-enhanced perception. You're actually viewing what we

Ken Kaplan and Ted Krueger, *Bureau-Dicto City,* 1989.
K/K Research and Development, New York.

laughingly call the real world through goggles that are attached to a very powerful computer system with its own perception abilities, say, face recognition. You could go into a meeting, look at people with your goggles, and have the computer recognize them for you and print little virtual name tags on them within the goggles. And also display maybe a quick biography of them. You could instantly make them into known quantities instead of strangers. This is a way computer intelligence can sandwich itself between ourselves and the world and actually serve some useful function.

Viemeister: Is that going to be better than going out and smelling a rose?

Sterling: Is it better? I don't understand.

Viemeister: It seems like a lot of work to do just to get back to something that's a nice thing to do all by itself.

Sterling: I think we're going to find people doing this incessantly, just as we find people who are obsessed with television as it stands. Virtual reality is the crack cocaine of television. It's just television boiled down and amplified more so than it was before. If you can deal with the media, fine. If you can't, then you're going to burn out. It's going to create turbulence. There's nothing standing between us and it. Stop and smell the virtual flowers, Tucker.

Viemeister: OK, now for the next topic: "Who's Planning the Future?"

Sterling: Ah, the course of the future. The invisible hand of the market rules on the wings of technological advance. And the invisible hand is not a human hand.

Viemeister: Well, it seems to me that the future is happening very quickly, and as I said before, nobody's really planning for it. It's going so fast that it seems impossible to plan for it anymore. But I think the big problem now is that no one is even trying to anticipate it. No one's trying to figure out how to make this stuff fit into our lives at all.

Nam June Paik, *Family of Robots,* 1986. Holly Solomon Gallery, New York.

Sterling: I'm inclined to agree that nobody is planning the future, and that it does tend to be that the future comes crashing into your neighborhood with bulldozers in the dead of night in California. When we do face technology, we fight like cornered rats pursued by dinosaurs. This is the "not in my backyard" phenomena. This deserves a great deal of attention. Local people simply refuse to put up with the unattractive aspects of our technology—the nuclear waste dumps, the toxic waste dumps, the nuclear power plants, the genetic research centers, the animal research, the oil refineries, the airports, etc., etc. No new nuclear power plant has been settled in the U.S. since 1978. No fully operational hazardous waste disposal site has been established in the U.S. since 1980. Since 1980?! Communities simply refused to accept them. Not on any kind of large-scale ideological utopian socialist grounds, but simply because nobody wants to live next to these things, not even their engineers. This is how we've learned to control technology to the extent that we do control it. We cut its hydra head off on a local level and burn the stump. Nobody has a scintilla of faith that conventional institutions of democracy can control, or even contain, our social and environmental problems.

Viemeister: In your mind, is there anybody or any institution that has any control over these forces, besides maybe the financial officers?

Sterling: There are groups who are fighting, the way you'd try to fight a violent fight.

Viemeister: Like who?

Sterling: People like Earth First, who monkey-wrench and sabotage. They organize spontaneously. They fight mean and dirty.

151

Max Almy, *Leaving the 20th Century*, 1982. Electronic Arts Intermix, New York.

Viemeister: That's negative planning. There's no one looking at what we should do, rather than what we can't do or what we shouldn't do.

Sterling: I agree. There is a desperate vacuum. There is no clear "vision thing" in the nineties. It's becoming more and more obvious that without a vision, people perish. It's an unavoidable situation. Something's got to be done. But in the meanwhile, reaction is taking place on a local level through guerrilla activity. The situation's out of control and it's being harassed with almost classic malice tactics. Simply find every single visible activity that the "progressive design groups" are undertaking and just systematically harass them, with everything from lawsuits and restraining orders to boycotts and personal harassment. If you look at the technology of abortion these days, you will find that the mere fact that you may legally be able to perform an abortion does not mean that you will be allowed to live a useful life in this country. You will, in fact, be harassed without mercy by small fringe groups who fanatically pursue you, no matter what the cost.

Viemeister: Getting back to the more positive side, I think that Wendell Berry, the Kentucky poet and philosopher and farmer, has some ideas about working on a local level rather than a universal level. I think that his ideas are probably the most positive ones that relate to how to deal with your own life. I think everybody has to become a designer for themselves rather than waiting for somebody else to design their lives for them.

So here is the next topic, and appropriately it's "Good and Evil, How Much Design is Possible?"

Sterling: I think that artificial simulated computer environments are capable of infinite amounts of design. I think that's going to make them particularly attractive to designers

152

because of that lack of constraints I mentioned earlier. In real life design has always been annoying, stubborn, and doomed to resistance from real-world materials to real-world objects and the horrifying specter of safety factors. You know, the real world can never become a perfectly designed utopia because time, space, and matter are not platonic entities: they are not perfectible. They are innately entropic and chaotic. But cyberspace is platonic. As a matter of fact, it's pure and abstract. So is there a chance that artificial realities will be designed that are so much more attractive than real life that they actually usurp its place? Sure! You bet. Why did Marie Antoinette like to play shepherdess? Let them eat digital cake.

Viemeister: When you started talking about safety, it made me think that one of the things that makes life so exciting is the fact that you can get hurt in it, and I don't understand how you can get hurt in cyberspace.

Sterling: Oh, I think we'll probably discover that there are some subtle, soul-destroying ways that you can get hurt in cyberspace—the same way that you could be hurt by playing, say, too many video games. Repetitive stress syndrome comes immediately to mind. And I've heard of one particular New York designer whose hair is falling out because he spends so much time with the TV strapped to his eyeballs. And some of the cellular uplinks are said to emit low-frequency microwaves that actually cook the aqueous humor in your eyeball.

Viemeister: I'm not talking about that kind of danger.

Sterling: Okay, it can be a harmless Disneyland; that's one of its tragic flaws. You just scrap all the ocean of regulations and go in there and make up any weird stuff you can. I suppose it's possible that you could be hurt in some awful way, like reading bad science fiction, maybe even permanently damaged by reading good science fiction. But I don't see any cen-

sors coming down to my house and telling me, "How dare you create that image inside someone's head?" Maybe in an inquisition they would, but this is not a society that does that sort of thing. Sticks and stones may break my bones, but text will never hurt me.

Viemeister: That's a nice segue into something else that I thought of in relation to how much design is possible. In one of your books you have this brain creature on some mini-planet say to your hero that "intelligence is not the best strategy for survival."

153

Sterling: I'm not sure that intelligence is actually selected out. I think that in a lot of ways intelligence leads us to develop the things that will probably kill us.

Viemeister: In other words, dumb cockroaches will live longer, and they'll be around after a nuclear holocaust.

Sterling: That's right. That's the basic twist. You can only deal with so much design in the environment before you suffer overload. It's true, you know, that most people's VCRs just flash 12:00 P.M. around the clock. It's not that they're too stupid to figure out a VCR; it's just that they don't have enough room in their short-term memory for the elaborate sequence of commands necessary to get them from touching it to actually operating it. You operate so many things in your environment that even when designers make some things more "convenient" for you, it's not worth it if they demand so much of your time. You can get to the point where you can't figure out how to boil water. And if you sit before your computer so fascinated by the intimacy of somebody's program that you're living on Twinkies and take-out Szechuan, well, over a period of decades, that's going to put you in the grave.

Viemeister: That's because there is no longer a dialogue between the real world and human beings. Ezio Manzini of Domus Academy says it's more like a monologue. We think we don't need to listen to anything anymore. Nature is not natural, and so we can do whatever we want to it.

Sterling: The environment human beings have lived in from the year zero has consisted mostly of other human beings. That's the real environment we deal with, that's why communications technology has taken off so drastically. It's gotten to the point now where Japan and the United States have made the fastest part of the economy just selling each other's chips so we can do each other's digital laundry. That's some kind of interface with the real world. If you think the real world is the same as nature, that's just not the case anymore.

154

Tron, 1982. Photofest.

Viemeister: The next topic is "Why Are Designers and Science Fiction Writers Second-Class Citizens?" I don't think we have to answer this question.

Sterling: Really? I think there are excellent reasons why science fiction writers are second-class citizens. You know, most science fiction is disposable pop entertainment that, while relatively harmless, addresses no important issues and simply doesn't matter very much. Another reason is that a lot of science fiction writers are dilettantes. If they weren't, they'd probably either be straight novelists or scientists. Science fiction writers like to play with very big ideas, play with them. If they actually commit themselves to some particular big idea, then they tend to become hopeless, fanatical cranks. This is a phenomena you see again and again. And this destroys what little might remain of their credibility.

Viemeister: You mean if these guys took over we would be in really big trouble?

Sterling: No question about it. Jules Verne as a children's adventure writer is a jewel of the human race. But Jules Verne as a general? President Jules Verne? Terrifying concepts: "Forget about the sewer system! We need more balloons! The balloons! More balloons! They are the future of airflight!" Would never work.

Viemeister: That other designer did get the chance to take over the world. Adolf Hitler designed everything from buildings to insignias. And I think that he's a good example of why somebody-with-a-total-idea-of-what-everybody-should-be is a bad idea.

Sterling: I would agree with that. I think science fiction traditionally, at least until the 1980s, was badly infected with utopian millennialism. And millennialism implies the future is not for real in the same way that the present is real, and utopian design implies that perfect design could banish chaos from our lives. But anybody who has ever poured cream into coffee has witnessed turbulence and agony of incalculable complexity. The present is incalculably complex, and the past is incalculably complex. And humans are rooted in the present.

Jonathan Rosen, *Fast Money*, 1992. Courtesy of the artist.

Viemeister: A friend of mine suggested that designers and science fiction writers live in the present, while everybody else lives in the past. That's why we look so strange to them. Maybe the future is supposed to be strange. If it weren't strange to us, it would be "now."

Sterling: That might be good tag line on an internet poster. You know, the idea that good design is going to change society—all by itself, indirectly, rather than by tackling large problems in large ways—there's something of a cop-out about that. It reminds me of a button that says, "It may look like I'm doing nothing, but on a cellular level I'm really very busy." It may look like we're not tackling the real dangers, but with our dueling ergonomic keyboards, on a social level we're really very busy.

Viemeister: There are lots of different levels to these problems. The specialists know exactly how to do whatever they do, but they don't know how it goes together, where it's going. And that's where the designers and the science fiction writers come in, because we're the only people who take a really general view of what can happen. We look at how all the little bits go together and where it's all heading.

Sterling: I would agree that science fiction writers are interested in mainly theoretical, radical potentials of technology. But real-world technicians and their major backers, who are, I think, considerably more important, are not interested in the alternate possible results of design or the alternate possible results of technological advancement. They're interested in financially optimal results.

Viemeister: Money. Here's a tough subject: "Life and Death: The Ultimate Design."

Sterling: There are matters more important than mere life and death. This segues into a discussion of optimal financial design, a real-world market environment. You know, the human mind and body are not really designed to fit the demands of market economics. But the medical market can rebuild the mind and body. Consider what would happen with an artificially extended human lifespan. You might have the rich living over a century and the poor forced to put up with the so-called natural limits. You'd have a politicization of health policy like you wouldn't believe. The standard science fictional

This Island Earth, 1955. Photofest.

speculation on a development like this is that somebody develops a free immortality pill and everybody gets one. Well, that's not the way it would actually work. I think that after the millennium we're going to learn to radically attack the human body. We're not going to absolutely master it; we'll just have certain keys to get inside it. To hack the body's organic systems the way a computer-intruder can gnaw his way through a really complex mainframe computer system.

Viemeister: You mean if, say, you're sick, you could just pull into the gas station to get fixed?

Sterling: No, it's not that easy. You might have a team of people who are handling your body in the same way that they would run a very complex power plant. You've got monitors all over you, but you have to have enough money to pay, say, half a dozen highly trained medical technicians to watch you at all times.

Viemeister: Then you're in a hospital all the time, is that it?

157

Coma, 1977. Photofest.

Sterling: Well, you've got a cellular monitor on your home data set, or whatever, that delivers data twenty-four hours a day to a hospital processing center.

Viemeister: So instead of blinking 12:00 all the time, it's blinking your heartbeat?

Sterling: That's right. So we're going to end up with this situation where we've got these 120-year-old millionaires living on ginseng, straight vitamin E, and biofeedback. They may very well live on blood products, hormones, that sort of thing. Not that they drink it or anything, just that they would need certain fluids and hormones whose likely source is, in fact, the human body. There is already a black market for transplant organs. And once you learn how to section tissues so that you can refine them in a way that actually enables you to postpone the aging process, then you're going to see the potential for high-tech medical cannibalism.

Viemeister: Well, I was talking to Leland Clark, the inventor of a heart and lung machine, and his project requires artificial blood. He thinks it's going to be a lot easier making fake blood because there's a lot of stuff in blood that we don't really need that's just left over from evolution. Anyway, I was telling him that I think the real advances today are being made in medical science and that we're going to be the last generation to worry about dying and that the next generation is going to be able to live as long as they want. And this doctor said, "The key here is 'as long as they want.'"

Sterling: Or maybe just as long as they can afford. Apparently supporting the large numbers of dying people in America can cost amazing amounts of money. That's one reason why our medical bills and health insurance establishment bankrupt us, because we spend so much money on high-tech maintenance of people who would have died fairly quickly in an earlier nontechnological environment. And I think that's an intolerable situation. Rather than simply pulling the plug on them in sort of an ugly triage fashion, I think it's likely that we're going to come up with some way for them to earn an honest living while in that condition so they can pay their medical bills. Consider, who better for an artificial reality expert than Karen Ann Quinlan? In real life you're just like a twitching lump in an oxygen tent somewhere. In an artificial reality you are a digital sorcerer. "You know Viemeister? Oh yeah, he's what used to be called dead. He can still run that CAD-CAM design firm. He can live as long as he wants."

Viemeister: Yeah, but how can I get out of there? How can I retire? Am I just a brain in some kind of petri dish?

Sterling: Well, I think it doesn't matter whether you get out. You're likely to be in power until you're horribly old.

158

RIGHT: *Brazil*, 1985. Photofest.

Viemeister: What if we live forever?

Sterling: There's the problem. The human body is not something that's easy to maintain. Everything we know about medicine tells us that the human body is capable of absorbing almost infinite amounts of design ingenuity. You're going to find that artificial blood is better than real blood, and I believe that that's possible. Now, taking the real blood out of one person and putting it into another—that was not a very good idea. That's what gave us AIDS. And it also helped the spread of a number of other diseases. It's not very sanitary. It's not something that you see animals do in nature. Artificial blood is good for you. As well as, mark my words, artificial food. Artificial food will be very fashionable after the millennium. Because, unlike real food, it's not trying to kill you.

Viemeister: And artificial food will be designed by us.

Sterling: That's right. And packaged in a way that has to make it look attractive. Folks, put a varnish on barbarism, please.

Consumption and Creativity in the Information Age

JOHN THACKARA

"What's dark and knocks at the door?"
"The Future." [1]

The 1980s made it fashionable to proclaim the end of progress in culture—culture being defined as the sum of the products and images that we consume in our daily lives. This kind of apocalyptic prophecy brings to mind the story of Buridan's Ass: the French scholastic told of a donkey that starved to death while trying to decide which of two equally delicious piles of food to eat. Buridan's Ass is surely the archetypal 1980s consumer—befuddled, confused, and driven to despair by the sheer variety and constant change that made shopping for goods, or for ideas, so stressful.

At one level, things do look bad. It has become common to complain that the 1980s gave us too much change, too much consumption. If this was progress, people now say, then we've had enough of it. Typical of the mood is the Silicon Valley yuppie who complained, "It hardly matters what I buy, I just get a kick out of buying.... It's like that first whiff of cocaine, I just get higher and higher as I buy." [2] Marketing guru James Ogilvy, saying little to dispel the yuppie's paranoia, describes consumerism as "anything you can do to your mind with a product or service... people look at products as if they were mind-altering substances." [3]

This shopping mall gloom pervades thought and cultural criticism in general. We have the discourse of the death of the subject, the death of art, the death of reason, and the particularly fatuous "end of history." Now design, too, finds itself, along with technology, among the more prominent targets of a fast-developing backlash against consumerism. This backlash is wielded by a motley alliance—ranging from radical ecologists who would have us halt industrial production at once to ultra-conservative aestheticians who would abolish modern art even more promptly. But this nascent puritanism nonetheless poses a fair question: do we really need more creativity, or have we had enough?

It is symptomatic of our current disassociation from history that we should imagine this debate to be a novel one. Baudelaire identified a link between fashion and death during the nineteenth century when he observed, "Living matter, you are nothing more than the fixed heart of chaos." And Karl Marx's famous observation that "all that is solid turns into air" [4] concluded his analysis of a perpetual motion consumption system that, although dramatically intensified by industrialization, has roots in the earliest transactions of

economic man. What alters through time is the nature and intensity of our consumption—not the fact that we consume. And this is my first objection to the rather hysterical accusation that design and consumption are in some kind of conspiracy.

Critics of modern design and marketing say we have got sensuality on the brain, that our economic system produces new and quite artificial needs that can never be satisfied. Design, so the argument goes, invests quite ordinary products with a glamor or mystique that only heightens the disappointment we experience when we finally possess them. Thus in America, where adults average six hours of shopping each week, as against forty minutes of playing with their children, 40 percent of shoppers say they have quite a lot of unopened purchases stored at home!

Strictly speaking, however, it is not design, nor even materialism, that drives such behavior. As *Processed World* puts it, "From the technical sophistication of a dress watch, to the durability of ballistics-grade travel luggage, to the purity of the organically grown tomato, people are shopping for qualities that make them feel secure in an unstable world."

In this psycho-social context, technology is the occasion for continuous innovation (and the related pathology of overconsumption), and design is its means; neither, however, is its cause.

The role of technology in our daily traffic with things is more complex than the conspiracy theory of consumption, which imagines design interacting with technology to create superfluous novelty for its own sake. This theory is based on the spurious premise of a rational economic man who would restrict himself to a bare minimum of food and equipment if he were not seduced by the dark forces of commerce. As social anthropologists are now beginning to discover, this view ignores both the social and psychological dimension of consumption. The British critic Peter Lloyd Jones has explained that modern man has "the habit of pleasure... [and] only by understanding the social, as well as the technical dimension of consumption can we understand that the functions people want in their daily lives are not just technical, but psychological ones too."[5] Lloyd Jones goes on to describe the ways in which the seduction of pleasure and our addiction to comfort are as much a part of the aesthetic impulse as is hunger or the need for warmth.

Although some specialists say it is possible actually to measure the so-called aesthetic

Consumer's Rest, armchair, Stiletto Studios, Berlin, 1986.
Cooper-Hewitt, National Museum of Design, Smithsonian Institution.
Purchase Eleanor G. Hewitt fund, 1992-112-1. Photo: Steve Tague.

impulse in consumption—and the literature abounds with such enticing terms as "hedonic indexes" and the "Wundt satisfaction curve"—a yawning gap continues to isolate design practice from the behavioral sciences. Design seems intimidated by the messiness of the territory where the scientific or technological world, with which it is confident, and the study of behavior, with which it is not, overlap. One cannot measure behavior as one might measure a radius or, for that matter, a pixel. Behavior resists attempts to impose rational order and quantitative techniques.[6]

It is in its failure creatively to bridge the worlds of science, behavior, and aesthetics that the crisis of modern design lies—not in consumerism per se. For its part, science is changing, even dramatically, in the direction of interdisciplinary research, but design has

been stranded in a backwater, along with many of the fine arts. It is what Anthony Hill calls an "entropic state... [displaying] neither intensive research nor any movement towards unification. Meanwhile the athletic mind turns to the past, constantly reshuffling a pack which cannot be claimed to be complete."

The failure to translate the raw material of science and technology into desirable products has been described as the innovation gap—a phenomenon whose dire consequences for the economies of Europe and North America provoke constant cries of anguish among technocrats and government mandarins. But despite endless talk of the need to change attitudes, little concrete action has ensued. Even the most sophisticated observers now concede that economic behavior is even more enigmatic than sexuality.

In Japan, where the innovation gap is tiny by comparison with the West—measured in weeks rather than in generations—they take a more rounded, cultural view of the innovation process. Whereas Western managers bang on about leadership and pushing new ideas through, their Japanese counterparts talk about creating fertile environments wherein new products may be born as the progeny of a culture in which innovation and tradition coexist in harmony. Sharp's enlightened design chief, Kyoshi Sakashita, compares the two attitudes to "the sword and the vase... the one being aggressive, the other receptive."

There is much talk of a new era in technology as products become intangible and as incorporeal information systems are distributed around the world. However, the gulf between what is technically possible and what is comprehensible or desirable to consumers has been a recurrent feature of the industrial landscape. Back in 1903, for example, AEG's Paul Westheim observed at the dawn of electricity that "in order to make a lucid, logical, and clearly articulated entity out of an arc lamp, a complete transformation of our aesthetic notions was necessary."[8] In other words, throughout the history of modern science, the creative aspect of the design process has involved a degree of cultural and psychological sensitivity that is given insufficient prominence in the textbooks and curriculums.

Video Still. Photo: John Thackara.

That said, some features of today's scientific and technical landscape do pose qualitatively new challenges for design that will not be met by scavenging around in the archives, where tradition has nothing to offer innovation. According to the French critic Thierry Chaput, the very functions of the information technologies create formlessness, neatly derailing the original modernist prescription that "form follows function." We need, says Chaput, a new aesthetic, an aesthetic that can comprehend the complexity, abstraction, and nonlinearity that distinguish today's technologies from those that preceded them.[9]

By complexity, Chaput means the replacement of mechanical and electrical models of the machines that fill our lives—models with deep roots in our culture—with an aesthetic for the new technologies. These are technologies that are continuously interactive and that, in effect, design themselves and therefore cannot be approached with the same conceptual equipment that would be appropriate for a motor or even a refinery.[10] Abstraction is a quality of information systems that are disarticulated in space, for example, by being located in networks whose nodes may be thousands of miles apart. Furthermore, technology becomes nonlinear when it is fragmented in time; the notion of layered software programs, which are sometimes dormant, sometimes alive, undermines the traditional models of causality that informed previous design regimes.

Electricity, too, was abstract, in the sense that you could not see or touch it, but it was nonetheless possible for design to derive static symbols for what it did from its applications: light, fire, motor. With software, new and dynamic imagery is needed. As was once said of art, design must learn how to "represent the unpresentable."

But just because design in the information era is about perception does not mean it will cease to be about things. On the contrary, there is every sign that as the value of software in the modern economy soars, the role of objects—as interfaces, as controls, or as totems—is receiving greater attention. Although the tradable value of software will exceed the value of hardware by many times in the 1990s, no amount of on-screen gee-wizardry and virtual virtuosity will replace the physical thing as a powerful icon through and in which we will access these global systems.

The French Minitel is an excellent example. French policy for telecommunications recognized that the best way to catapult its populace dramatically into the telecommunications mainstream was to give them the hardware—in this case, an astounding seven million "intelligent terminals"—needed to connect them with the networks. British policy, based on the incremental penetration of information into the home through the commercial (and highly cumbersome) television-based

Judith Goddard, *Television Circle*, 1989. Photo: John Thackara.

Prestel system, has been a great anticlimax by comparison. France is now the world's leader in the establishment of a third-generation technical-information infrastructure. In neither case, however, have designers been able to impart much magic to what are clearly not, given their potential, prosaic objects.

The continuing importance of designed objects is further illustrated by the case of CD-ROM technology. It is now possible to record vast amounts of data on a single silver disk—1,000 books, 10,000 books, 100,000 books, it's only a matter of time—and to access this vast database through laptop readers. To date, this mind-boggling device has been packaged in the most banal format imaginable—a black box with a screen in it that is about as exciting as a central heating controller (and very similar looking too). To the boffins, well aware of what lies inside, such banality is no deterrent, but to engage the interest of the rest of the likely user-population, reared for years on traditional notions of "book," something more imaginative will surely be needed to disseminate the gadget. Unfortunately, such is the impoverishment of the product design community that an inspired answer to this, and to similar challenges, is not an immediate prospect.

Although most objects emerging from the narrow confines of the design business remain banal, technology, and in particular new materials and processes, is now generating many new opportunities. In his important book *The Material of Invention*, Ezio Manzini describes the way that technology has given a "second childhood" to traditional materials and has created opportunities with nontraditional new composites and processes, such as pultrusion, for designers to tackle qualitatively new problems.

Manzini is explicit: he rejects the tendency of the postmodernist 1980s to denigrate the object and to celebrate abstraction. It is a laughable conceit, says Manzini, for modern man to imagine he has grown out of artifacts when he has barely begun to explore the range of possible objects, technical or otherwise, we might create. "For his first million years, man subsisted on just five materials," Manzini explains; "today, a comprehensive technical dictionary contains 4.5 million entries. Who can possibly argue that we have exhausted the potential of such a resource?"[11]

The properties described in Manzini's analysis of transformed traditional materials, or of invented new ones, correspond in many respects to the abstract qualities of the new technologies: lightness, transparency, pliability, transformability, elasticity. In representing the abstract qualities of the new technology, the physical resources are there for the taking—will designers respond? Will they be allowed to respond?

If the prevailing culture in which they work persists, the answer is probably no. I recently attended an internal design briefing for the managers of a major computer company at which great play was made of the need to redesign the company's structures, to make them more open, flexible, and generally "leaky"—the idea being to sensitize their vast bureaucracy to the subtleties of a constantly changing marketplace. I suggested, during this discussion, that the company might look first at its corporate architecture policy which favored two styles: the monolithic, reflecting-mirror type of tower block on the one hand, and on the other, the hidden, camouflaged, and generally mysterious armed-camp

164

RIGHT: Matt Mullican, *Untitled*, 1988. Michael Klein Inc., New York.

style that informed its nonpublic facilities. "Oh, we couldn't change that," several managers said; "our image is based on being the biggest and the most powerful company in the marketplace; that is reflected in our buildings."

Substantive progress in the creative relationship between design and technology is heavily dependent on an organizational culture open to new ideas and supportive of experimentation. Which, in a competitive market, is easier aspired to than achieved. The day-to-day pressure on managers to achieve results is hard to reconcile with an open environment in which expertise is easily transferred, training continuous, and teamwork the norm. Hence the recent importance given to the idea of culture or innovation audits, in which senior managers, with or without the help of outside consultants, interrogate their organization to discover whether the conditions that all agree should, ideally, be met actually are being met.

Scientists and engineers, too, persist in patterns of thought and behavior inimitable to innovation—such as radical separation of reason from intuition and tacit, everyday experience. In the artificial intelligence community, for example, cyberneticians have taken to arguing that creativity rarely represents any large deviation from standard patterns. The cybernetician James Albus says of creativity, "We take a familiar behavioral trajectory, add a tiny variation, and claim we have discovered something new.... [I wonder if] true

creativity ever happens at all... it may be argued that all creative arts and insights merely represent rearrangements of elements in experience."

"Rearrangements of elements in experience"—it is by such language that the so-called knowledge engineers demonstrate that, for all their expertise, they remain incapable of reflective thought. No doubt many human skills can be codified and digitized and taught to machines, but knowledge engineers, brainwashed by their institutional culture of science or big business, are blind to the real understanding of the world that human beings have by virtue of inhabiting bodies and interacting skillfully with the material world.

Designers, for their part, have inherited their own culture, isolated from the economic and technological mainstream. It is one of the fundamental myths and self-delusions of that culture that designers are in some way more enlightened and advanced than much of industry and technology. As in all professions, such as engineering or medicine, outstanding individual architects and designers can change our perceptions and experiences; as a community, however, design has not yet transcended the boundaries of self-interest.

So how are we to combat this isolation? How can design catch up with the fantastically rich, complicated, and fast-changing economic, technological, and knowledge-based context? How can we confront the ambiguities of consumption and creativity in the information age?

No single, all-encompassing definition can describe the multiplicity of roles beckoning design within this hazy place called a "learning society." The French philosopher Jean-François Lyotard makes a distinction here between "learning" (and its subset "science") and "knowledge." Crudely put, learning accumulates facts and data; knowledge puts them to use. I would argue that in relation to the information age, design may be seen as the process that takes data (such as the information systems of global manufacturing or the images swirling around in the media) and does something useful with them. As the functional differences between hard products diminish, this process progressively

166

Study of a Numerically Modeled Severe Storm, 1992. National Center for Supercomputing Applications, University of Illinois at Urbana-Champaign.

involves what the Japanese writer Akira Asada calls symbolic product differentiation—a synthesis of hard and soft that has no precedent in the history of design.

In this future-present scenario, design becomes the integrator of technical and cultural inputs. Designing a milk carton, for example, will entail—as it always has—the imaginative integration of functional, production, communications, and marketing requirements—a functional and symbolic differentiation of one product from another. Tomorrow's designer will act as a team leader, art director, librarian, and product champion. He or she will replace today's brand manager as the pivotal influence on product development. If this sounds more like design management than "design," so be it. In an age when all innovation involves complex processes and multidisciplinary inputs, the evolution of the designer-integrator is symptomatic of a major shift in emphasis in the product environment, a shift that points to a place of convergence for design, knowledge, and culture.

1 Inscription above the entrance to Budapest's Museum of Humor.

2 *Processed World*, Issue 3 (1982), p. 23.

3 Ibid.

4 The quote was later taken as the title of an important book on the meanings of modernism by Marshall Berman, *All That is Solid Melts into Air* (New York: Viking Penguin, 1983).

5 Peter Lloyd Jones, "Things and People," unpublished thesis, Kingston Polytechnic, London.

6 Anthony Hill, "'A Short Space From Time'—Modernism: The Rantings of a Formalist," *Art Monthly*, February 1989, pp. 3–5. Originally presented on December 1, 1988, as part of the William Townsend Memorial Lecture Series.

7 Kyoshi Sakashita, Address to the Regional Design Conference, Fukuyama, Japan, November 1988.

8 Tilman Buddenseig and Henning Rogge, *Industriekultur: Peter Behrens and the AEG* (Cambridge: MIT Press, 1984).

9 *Nouvelles Tendances*, exhibition catalogue, Centre Pompidou, Paris, 1984.

10 John Chris Jones, *Technology Changes* (London and Zurich: Princelet Editions, 1986).

11 Ezio Manzini, *Artefatti* (Milan: Domus Editions, 1991).

The Technological Juggernaut:
Objects and Their Transcendence

JOHN RHEINFRANK

What is a juggernaut? And what, especially, is a technological juggernaut? Something big that crushes us as it moves? Something complicated, etheric, a force that shouldn't be stopped? Is technology truly an object of blind devotion looming over the design horizon? A malevolent force that will take over our lives as people and our aspirations as designers?

Actually, as we look into the future, the prospect of technological transformation is probably best viewed as a multidimensional challenge or dilemma, one that is caught up in the transformation of our culture. And if the technological juggernaut does run rampant through our midst, severing our common, deeply held and cherished connections to the human and natural facets of our lives, then we, as designers, are to blame.

As designers, we have the opportunity to directly shape much more than the form that technology can take and the functionality that it can offer when it enters the social milieu as a product used by people. We also have the opportunity to shape the role that technologies can play as products in that same social milieu. And we have the ability and the responsibility to allow people traditionally categorized as "users" or "nondesigners" to participate in design. Obviously this is a multimodal, and therefore difficult, challenge. It is also one that designers are more than equipped to take on.

Transformation

Design has long been the means through which technologies are (re)invented or transformed into useful tools and cultural artifacts. When transforming products, designers understand (or create) technology; they understand what people do and think; and they develop products that make technology relevant to people's lives in meaningful, useful, and aesthetic ways. There are at least three clear kinds of transformation at work in design: developing, optimizing, and metamizing.

Developing

In its most prevalent form, design is simply development. When developing products, designers first acquire understandings of technology and people, and then create products

168

based on those understandings. Most traditional design falls into the developing class of transformation. The camera is a good example.

In effect, as designers we convince ourselves that we clearly understand the product. We understand as best we can what people think and do with the product. And then we bring products to people that attempt to make the underlying technology relevant to the everyday things they do. Yet when faced with designing a camera, industrial designers continue to make these stupid things called "fool-proof black boxes." And all they do is allow people to continually reinforce the idea that they are fools. These kinds of products don't really help build the world in a different or better way.

169

Optimizing

When optimizing products, designers iteratively refine technologies (or existing products) with the intent of making them as functionally, situationally, and aesthetically appropriate to their contexts of use as possible. The refinement of the basic "black-box" camera over the last twenty-five years typifies the optimizing kind of transformation.

Here we are talking about breakthroughs that generate continuous improvement and result in the continually increasing relevance of objects. For example, at Fitch RichardsonSmith, we did a project for an office enclosure and furniture company with Christopher Alexander, architect and author of the book *Pattern Language*. We were asked to consider what the office place of the future might be like. We spent nearly three-quarters of the project in the field observing office work, and a quarter of the project designing. We developed a new modular office system that allowed the people who worked in it to design it—both during and after it was developed. The breakthroughs and the improvements came from user-participatory design, and the users loved both the process and the resulting product.

Metamizing

When metamizing products, designers design beyond (or through) products (and the technologies on which they are based) in a number of powerful and productive ways. The metamization of the camera has occurred in corporate research contexts and to some extent in the marketplace, but has not yet been fully explored. An approach to metamizing the camera would be to think beyond the design of the camera to the design of the experience that surrounds "using the camera to make memories." Or it might entail the design of the situations the camera could participate in and the circumstances it could help to create, such as a child learning to see in new ways.

For example, we recently finished a project with Apple in which we brought two students and a practicing teacher into the Apple development process. We asked these three "outsiders" to help us invent a way of thinking (or framework for thinking) about educational technology for Apple. We wanted to invent not only a way of thinking but also the means to make that way of thinking take root and begin to grow inside Apple. Working together, we produced a set of objects that were mailed to Apple about every three or four

weeks, along with a set of descriptive posters. Both the objects and the posters were representative of ideas and ways of thinking about and using the ideas. We finished the project with a report that described the framework and with a presentation on the part of the two students and their teacher. This work, which was about modes of thought and education and processes rather than computers, will have an important influence on what Apple does.

The Potential of Metamizing

The transformational activities of developing and optimizing products and technologies are fairly well understood and have been practiced within the design community for a long time. Metamizing products is a transformational activity which is uncommon, not widely practiced, and full of potential.

In the course of our work at FRS, we have identified at least three kinds of metamizing, or "going beyond." They are concerned with moving from product to purpose, from product to essence, and from product to context.

Product to Purpose (Through the Product to What It Is Used For)

For an example of moving from product to purpose, consider moving from designing a camera to designing a range of "picture-making experiences." Or consider moving from designing document-processing software (papers, files, folders) to designing computer support for the activity of handling insurance claims. In situations like these, the goal would be to design physical and cognitive support for activities—in as human and natural a way as possible and in a wide variety of contexts. The result of moving from designing the product to designing the product's purpose is an "intentional" product.

Product to Essence (Through the Product to Its Fundamental Nature)

For an example of moving from product to essence, it is first necessary to understand what we mean by essence. When we use the term, we are referring to the fundamental nature of a thing and to the exposure of that fundamental nature through the qualities of the thing itself. Consciously designing the essence of a product provides the people who use it with the opportunity to experience it in something close to its pure form—or, in other words, with the opportunity to experience epiphany.

Epiphany: a usually sudden manifestation or perception of the essential nature or meaning of something—an intuitive grasp of reality through something (as an event) usually simple and striking.

The results of designing the essence are often products that are, or that become, archetypical. In the case of the camera, designing the essence would be to design the

171

LEFT: Ken Kaplan and Ted Krueger, *Pigheads* (from *Renegade Cities*), 1989.
Photo: K/K Research and Development, New York.

preservation of experience through visualization (visual memory) and the enhancement of the human desire to capture, manipulate, and share experiences for their own and others' enjoyment. In other words, design would be concerned with the idea and act of visual storytelling. Or to cite Jan Dibbets, instead of inserting computers into classrooms, computer support would be designed to maximize essential human capacities of constructing, transforming, and acting on knowledge—in ways that allow people to enrich themselves and their world.

Product to Context (Through the Product to the Effect of the Product on the World)

For an example of moving from the product to context, what we must do is anticipate—and then design—the effect of the existence of the product on the world. This is a very simple and powerful concept. With respect to cameras, we can think about designing how people's family lives will change as a result of their ability to develop and maintain a kind of visual family memory over time. We can also think about how enabling people to see in new ways will allow them to generate knowledge about the nature of "seeing." We can think about the effect of interactions among cameras, designers, and users in the world. Other examples include moving from designing vehicles based on new kinds of electric motors to designing the effects of electric motors on the world, or moving a client from designing products and services to creating a market, constructing a business, and continually crafting an organization. The outcome is a product that is situated in its context and extremely relevant to the people who use it.

Audrey Flack, *Farb Family Portrait*, 1969–1970.
Rose Art Museum, Brandeis University, Waltham, Mass. The Riverside Collection.

Correspondence

Metamized (or transcendent) products correspond to other products, and to the world, in different ways from other products.

Metamized products, whether they are transcendent because of purpose, essence, or effect, are deeply connected to other (developed and optimized) products. There is a kind of sympathetic vibration between the two groups, a resonance that exists because the roots of transcendent products draw from a rich history embedded in developed and optimized products. Transcendent products have historicity; they are connected to the past. Developed and optimized products have potential; they are continually straining toward the future.

There is another kind of connection that links all three classes of transformation—developed, optimized, and transcendent—with the world. It is about how products correspond with the world. We use the term reverberation (ripple and return) to refer to it. The effect of reverberation on transcendent products is to ensure that they have something to do with shaping their surroundings and that they in turn can be shaped by their surroundings. The effect of reverberation on developed and optimized products is to ensure that they are as appropriate to their contexts as possible and that their appropriateness is continually evolving.

Conclusion

Products and their transcendency can provide designers with resources for taming the technological juggernaut and directing its momentum to our advantage. By thinking about the kinds of situations or experiences that products will participate in and create, we can ensure that technology makes meaningful contributions to people's lives. Beyond that, we are finding that in making products transcendent they embody complex social processes and social understandings. Once we have the option of designing situations, of designing the activities of people and groups of people, we also have the option of changing what individuals and groups of people do. In a sense, products and services have the potential to be seen as abstractions of better ways for people to work and play—and to maximize their own potential.

Rethinking the Border in Design:
An Exploration of Central and Peripheral Relations in Practice

JOHN SEELY BROWN AND PAUL DUGUID

A crucial component in the introduction of one of most successful human-computer interfaces we know was a large cardboard box. It was the clever packaging that really began the "Tour of the Macintosh" for most new users. Taking them along a skillfully designed pathway, the packaging opened up a structured physical and conceptual exploration. Objects were oriented to be manipulated, boxes nested within boxes, and icons cleverly directed the user toward a computational world of objects, nested relations, and icons. Gradually, informatively, and without disturbing the user's attention, the route led almost seamlessly from the everyday world of cardboard boxes to the highly circumscribed world of the personal computer. Only then did a disk take users "inside" the inmost box. Well before reaching this point, newcomers had developed important intuitive insights into the conceptual structure of the artifact. To understand (and to emulate) the success of such a well-designed object, it is essential to look not just *at* but also, as John Thackara puts it, *beyond* the object.

No artifact is self-sufficient. The spot-lit, pristine artifact commanding the center of attention among the usual array of potted plants at a trade show reveals very little about whether, or how, or why it will or will not be used. But the artifact in the workplace, plastered with stick-ums or Scotch tape, modified or marginalized by practice, and embedded in social activities, can tell a rich, well-situated story. Consequently, in contemplating usability, designers cannot just consider isolated (and isolating) notions of functionality. Instead, they have to relate these to the socially and physically embedded practices.

Designers are not simply part of a delivery service from producers to passive users. They do not, as it can too easily be assumed, package the pronouncements of producers for consumers like temple priests interpreting the oracle to the people. Rather, like the god Janus, designers have to face two ways. Facing in one direction, they have to prompt new patterns of practice in response to emerging technology. But equally, facing in the other direction, they have to prompt changes in response to evolving, renegotiated, and reappropriated patterns of practice.

Actually, Janus not only looked in two spatial directions; he also looked both into the past and the future. Thus he would make a particularly apt god of design. For design is fundamentally a process of supporting the negotiation whereby past social practice is transformed to meet current and future conditions.

Center and the Periphery

In practice, people pick out what immediately concerns them from what they take for granted; they note change in relation to the unchanged; and they define artifacts, events, and interactions with respect to certain features while excluding others. In so doing, they make important, if implicit, connections and distinctions between what they regard as *central* and what as *peripheral*.

Such center-periphery relationships are not rigid. If focus, attention, perspective, or practice changes, then what is taken as central and what as peripheral will probably change too. But within consistent practices, some aspects of a situation will be habitually taken as central and others as peripheral. What is relegated to the periphery, though it might evade attention, does not automatically become irrelevant. Rather, its presence in the periphery makes it available as a resource for users—a resource, moreover, that while it may support practice will, in remaining peripheral, neither disturb nor interrupt it. And resources for users are resources for designers.

Lucas Samaras, *Chicken Wire Box No. 21*, 1972. Saatchi Collection, London.

For example, part of what makes a building "well designed" is the way its designers marshal center-periphery relations. A building stands distinct from, yet related to, its environment. It is the periphery of a building as much as the canonical building itself that helps visitors find both the right building and the right entrance. This center-periphery relation is not absolute: though a building may appear unquestionably central to its own users, it is nevertheless undoubtedly peripheral to users of the building next door. Indeed, a single building may in fact offer several centers within itself. For many, the primary focus may be the "main entrance"; for some, however, it is the employees' or the freight entrance.

Such center-periphery relations offer several important assets to design and use. First, they provide a crucial *interpretative resource*, helping people develop a greater understanding of their social and physical environment. Second, particular peripheral features used with skill can be invaluably *center-orienting*—directing people to what is important or new. And third, in doing this, center-periphery relations are remarkably *efficient*. By establishing relations to the periphery, a designer ensures that an artifact does not have to bear the impossible burden of defining itself from scratch. Artifacts inevitably rely a great deal on their periphery to establish what they are. Notions of "context independent," "self-sufficient," or "self-explanatory" designs testify not to independence from the periphery but only to the invisibility of the latter's contribution.

Genres—Interrelations of Center and Periphery

Peripheral features are interpretive resources because they help to identify *types*. They help distinguish, for example, office buildings from apartment buildings, factories from prisons, domestic cars from taxis, or consumer kitchen appliances from industrial equipment. And the distinction of type plays a crucial role in successful design.

In essence, people *read* an artifact against, or in the context of, its type and thereby develop an understanding of it. Keeping close to this metaphor, the linguist Geoffrey Nunberg describes the types they exemplify in these readings as genres, the literary term for a type.[1] Genres make a significant contribution to communication, limiting ambiguity, constraining interpretation, engaging expectations, invoking prior understanding, and making elaborate reexplication unnecessary. When a reader recognizes a book as an English detective novel, for instance, certain expectations—a subtle crime, sophisticated suspects, a cerebral investigator, an intricate motive, and a certain acceptable level of unreality—are raised; others—a brutal crime, seedy criminals, a rough "gumshoe," and a tone of "dirty realism"—are set aside. Once the genre is established, writer and reader communicate within usefully drawn boundaries.

These genres are not esoteric phenomena. When, for instance, office workers decide whether to communicate through a personal phone conversation, an e-mail note, or an office memo, they are making broad generic distinctions, for each of these distinct technologies supports certain genres, but not others. Each offers certain distinct communica-

tive possibilities and raises in the recipient certain expectations. People subconsciously assess the range of these possibilities as they choose between the phone, the "send," or the "print" keys. They recognize, too, the significance of requests to shift from one to another—to repeat a communication in "an e-mail note," to "put it on a memo," to "call me on the day," or whatever. Reproducing the same words with different peripheries, it is implicitly understood, can fundamentally change the central import.

The underlying generic conventions, though well established and remarkably widespread, are not predetermined. They evolve locally and continually in practice. Change is prompted from many different directions. The office memo, for example, arose as businesses became larger and more widespread. Personal communication became impractical or impossible, and letters became too cumbersome and inefficient.[2] The memo's appropriate uses were themselves narrowed and sharpened by the introduction of the telephone. It was increasingly reserved for more "official" and formal internal communication. Then the appearance of e-mail revealed an intervening niche for the evolution of new genres. Consequently, e-mail has simultaneously continued to redefine the limits and expectations of the memo and the phone call.

As a result of this local and continual evolution, these genres are never universal. They are limited to particular organizations or institutions. For newcomers to an organization, even when they are familiar with the underlying technology, it usually takes a little time to find out the appropriate genre for particular communications. Old-timers can usually recognize organizational newcomers by their generic transgressions—by, for example, the inappropriate distribution of their messages, such as requests for a good neighborhood bar that get broadcast to a thousand readers, including the president of the university or the chairman of the multinational corporation.

The Periphery in Practice

The genre, then, is a context for interpretation, socially constructed out of center-periphery interrelations. In this section we offer some illustrations of the use of genre and the role of the periphery grouped under three rough headings: "Engaging Interpretation," "Maintaining Indexicality," and "Transmitting Authority." We make no claims, however, to being either systematic or exhaustive. It will quickly be evident that most of these examples focus on text-based communication. There are a couple of reasons for this. First and most obviously, since our notions of genre come from the world of texts and writing, examples come most readily from the same domain. But second and more significantly, text provides a test case for the importance of our argument. More than almost anything else, text appears to be context independent—to mean the same thing whether read in your bath or your neighborhood bar, in Bali or Baja California.

177

In fact, reading does involve constructing a coherent relation between text and context. Recently a University of California faculty member was taken off a plane in Phoenix, Arizona, by FBI agents. A fellow passenger had seen this rather mild-looking professor holding a hijack note. Only later was it discovered that the note had begun life in a game played by a child who had previously held the professor's seat. In the hands of an adult, not a child, and in the cabin of an airplane, without the intervening context of a game, the text took on a menacing significance. The root Latin word, *texere*, means "to weave" and the *con*text provides an array of peripheral elements that, woven together with the text, make a document. Therefore the immediate periphery of artifacts and documents is not a merely trivial, decorative surface. Rather, it is an essential, socially shared, historically evolved part of the practices in which it is involved, as we hope will become more apparent in our three groups of examples.

Engaging Interpretation: The Portable Context. Peripheral clues may extend almost indefinitely beyond the artifact itself. For example, before encountering a book, a reader often passes along an informative route that might include a store or a library, a particular section of the store or library, other books upon the same shelf. With that in mind, publishers try to produce designs for general books that are incompatible with the normally somber tone of the academic shelves—hoping thereby to produce an incoherent weaving if the book ends up on the wrong shelf.

In trying to constrain interpretation in this way, publishers are really trying to provide their books with a sort of portable context. The process of publication is one in which the text is in several senses bound for a larger audience. Efficient but local genre markers (such as handwriting) are replaced by more public, more broadly accepted, and more conventional ones that peripherally accompany the text on its travels, allowing authors to engage readers who share the publisher's conventions. In the end, a lurid cover, narrow margins, and tightly set type play an important part in preventing the phrase "This is a hijack" from offering any threat. In short, contrary to cliché, you can tell some important things about a book from its cover.

Product design can also be usefully thought of as a process of publication. Like typescripts in a publishing house, artifacts can circulate within a lab without much formal design. From knowing which colleagues are working on it and the general social context in which it is encountered, people in the lab can usually deduce what type or genre of device they are looking at. Locally, artifacts usually don't need a portable context because they aren't going anywhere. Unfortunately, this sort of "self-evidence" contributes significantly to assumptions that design is unnecessary or intrusive. In fact, as many a failed prototype can show, product design is vital. As the product moves out of the lab and into the public consumer market, it too needs a publicly recognizable and consistent periphery shared by producers and consumers.

So product design is the process of providing a shared, portable context and invoking acknowledged conventions to make the device understandable in the conditions in which

it is likely to end up. Just as a book cover engages a particular audience, the design of a product plays an important role in engaging a particular market segment. There is no universal language of product design. Product designers, like authors and book designers, have to have a sense of the community they are targeting and the conventions of that community.

Maintaining Indexicality: Getting the Point Across. Products, then, rather like letters, are addressed. But not everyone is addressed by the implicit "you." Addressing particular audiences or markets appropriately presents a challenge in the context of our argument. The challenge involves indexicals—words such as *you, I, now, here, there, next, last, tomorrow*, and *below*.

Indexicals are efficient in face-to-face conversation. However, they become problematic in communications that, like phone calls, bridge space or, like mail, bridge both time and space. In these circumstances, participants lack a single, shared periphery. Consequently, recipients don't automatically know what periphery a speaker is indexing. Anyone who has participated in a conference telephone call knows how tricky it can be to use "I" or "you." International callers can stumble over "tomorrow." Cellular callers get confused over "here." And people listening to answering-machine messages know that "now" or even "today," adequately precise for the speaker, can be infuriatingly imprecise for a listener who doesn't know when a message such as "call me within two hours" was left.

It is helpful to recognize what makes a curious but common phrase such as "I'm not here now" sensible. Clearly, the words themselves do not clinch the matter. The same words would baffle if the caller thought that he or she was listening to a live voice and not an answering machine. It is the recorded quality of the voice on the message machine that helps make the sense clear. Given the background clicks and whirrs and tape hiss, utterances that might otherwise seem absurd become intelligible. The message works through a contribution from what would usually be thought of as thoroughly peripheral and therefore inconsequential. In fact, the periphery helps to identify the genre of the communication and that identification helps to make it efficient. Now that the quality of the recorded message is once again on a par with that of the live voice, there is no useful distinction in

179

This Year Reach Farther for Sales, c. 1930. *Fortune.*

the periphery. The phrase "Hi, this is my voice mail" is starting to appear. The periphery no longer contains the information it once held.

Transmitting Authority: Force at a Distance. Communication has been said to involve answering "Who said what to whom." And our comments on indexicality are very much to do with using the periphery to identify the "who" and the "whom." It quickly becomes apparent, however, that more subtle questions also need to be answered, including importantly "under what conditions?" "with what authority?" "through what mediating forms?" or "within what social and historical context?" People need to know not just who pronounces them man and wife, domestic partners, or members of the bar association, but whether that person has the authority to do so and has done it correctly. Similarly with artifacts, users need to be able to construct the producer's notion of appropriate use (an important, if contentious, matter in product liability cases) and authority for prescribing it.

Artifacts in general and documents in particular attempt both to reflect the authority of their producers and to preserve it across space and time. Documents are not merely approximations of face-to-face conversation; they also provide records, accumulate a history or provenance, and preserve authority. This important ability of documents to act at a distance from where and when they were composed has been described as a document's "force." The periphery plays a significant role in what might thus be called enforcement.

To recognize the force, the recipient of a document has to "read" well beyond the text itself, discovering in the process a sense of its authors, their authority, and their intentions. When a ticket that says "Admit One" is issued at an entry kiosk, the broader periphery makes authentication relatively unproblematic. But when the ticket is bought at a remove, it needs to have the authorial force available in its portable context scrutinized—as those who buy from scalpers usually know.

In the resolution of force, many different resources can come into play—certain documents, for instance, require seals; others require specific types of ink or paper; some require a corroborative, documented history of their own. One of the most important contributions to enforcement is what we call inertia. If we go back for a moment to the question of how to recognize the genre of a book, one important feature is its heft or sheer bulk. Producing a book is expensive and time-consuming. A reader confronted with a large, heavy dictionary or reference book is inclined to defer to its

180

authority simply because it is reasonable to assume that only an organization with considerable resources could have produced it and that it would be economically unwise for organizations to go to such lengths without making an effort to get the content right. The validation of that argument is in some ways simply embodied in the heft of the thing.

Changes in technology can, however, significantly change the inertia, and thereby threaten the resourcefulness, of a document or an entire genre. Shifting between media, for example, can strip away some of a document's authority. The same dictionary that could physically stop a truck as easily as it could an argument may now appear on-line. In this dematerialized form, it is very hard to sense its authority.

Consistency, Communities, and Demassification

The underpinnings of communication—indicators of *genre*, elements of *inertia* and *authority*—rely significantly on constancy. The six o'clock slam of a car door signaling beneath the threshold of attention that the neighbor is home; the skeletal rattle of a keyboard subliminally indicating that a colleague is at work in the next office; the packed mailbox reminding you subconsciously that a friend is on vacation; or even, as Sherlock Holmes pointed out, the disturbing but unappreciated significance of the dog that *didn't* bark, all illustrate the way people continually and inventively assign informative significance to the recurring, peripheral features of their environment. In this section we address the uses of consistency, its role in generic understanding, its relation to the communities who enlist consistent features as community resources, and the challenge posed by inescapable change.[3]

Consistency. The sociologist of science Bruno Latour aptly describes documents as "immutable mobiles."[4] Their mobility allows them to communicate easily across space and in a variety of circumstances. And their immutability allows them to appear at the end of their travels unchanged. Yet in the age of the "electronic document," Latour's definition seems unduly limited. Many of these new "documents" are powerful exactly because they are mutable. Databases gain much of their resourcefulness by having broken the fixed bounds of the books or filing systems in which their information was formerly stored, making the rigid and unwieldy demands of alphabetical ordering simply unnecessary Dictionaries, auto manuals, library catalogues, and sales inventories have also been usefully liberated. In other technologies too, immutability has given way to mutability. Digital copiers now allow users to reformat text. Adding versatility by adding mutability has unquestionable benefits. But in the context of ongoing human activities that have come to rely on constancy, it can also create problems—problems that are neatly encapsulated in oxymoronic terms such as "on-line paper" or "original copy." These problems and their socially complex implications can be explored in terms of genres and their relation to the technologies that underpin them.

It is easy to overlook this crucial distinction between the genre and the technology.

Groups of optimistic futurologists and gloomy conservative bibliophiles are united in the belief that "new technology" will sweep away the book as it is known today.[5] One group believes that this is a good thing and the other that it is deplorable. Both fail to see that "the book" as a technology comprises several genres, only some of which are likely to find better homes elsewhere. Not all genres involve searches, random access, easy mutability, or hypertext solutions. The immutable, consecutive order and spatial juxtaposition of text in books is crucially central to some genres. Consequently, though some genres may abandon book technology altogether, others will continue to be supported by it for a long time to come. As we pointed out earlier in the context of e-mail, innovations in electronic document capabilities are probably better understood as allowing genres currently held together by a single idea—the book—to develop along multiple trajectories on multiple technologies. These trajectories are then understood in relation to the communities and practices for whom the genres are relevant.

Artifacts and Communities. Cultural theorists[6] point to the way artifacts are completely reappropriated, reinterpreted, and invested with new signification by countercultural groups. Their work shows that it can be profoundly misleading to assume that the use of an artifact indicates shared beliefs: the police and the Hells Angels chase one another on Harley-Davidsons; soldiers and pacifists confront each other, each wearing military fatigues. Deep concern for river gorges means one thing to a conservationist and another to a hydroelectric engineer. Producers and designers cannot assume that because people use an artifact they are therefore using it in the predicted way.

Instead, artifacts need to be thought of in terms of the communities that use them and in terms of both their *internal* properties, which allow them to be part of shared practices within a community, and of their *boundary* properties,[7] which allow them to mediate (and occasionally mask) relations between communities. Not only are artifacts used differently by different communities, they also function slightly differently when circulating within a community than they do when circulating between communities. Thus while the removal of a particular feature might be desirable within one community, that removal may cause problems in relations between that community and others. The noise of a car might be a nuisance to people within the car; silent cars, however, might make relations between drivers and pedestrians life-threatening.

Consider, as a less life-threatening example, the scholarly journal. The expense of the publication process, the immutability of the text, and the long delays between issues have all encouraged a shift to on-line journal publishing. The "on-line paper" can now be electronically distributed when it alone is ready and not when an entire issue has been prepared. As on-line articles can be circulated one by one, readers can receive articles by an author who interests them without being obliged to take half-a-dozen by others who don't. Within a field, the on-line journal is understandably preferred by many—particularly newer members who feel that their ideas are kept out by the inherent conservatism of conventional systems of peer review. *Internally*, the shift across technologies seems highly

182

efficient and entirely beneficial. The on-line journal tends to leave much of the filtering to the reader who knows the field.

Between communities, however, across disciplinary boundaries, the journal functions rather differently. Here it has to establish rather than just confirm status. Lacking access to the insiders' social networks, outsiders rely heavily on the cross-boundary inertia of print publication to provide a sense of what is valued, and what is not, in a community they are not particularly close to. The on-line journal has discarded the inertia inherent in the material form of the conventional journal. And this inertia is an important *boundary* property. In discarding what might seem superfluous to insiders, the on-line publication risks limiting circulation to insiders only.

The Paradox of Demassification. Moving beyond particular examples, we find it useful to address the effects of the removal of apparently peripheral features, such as the paper and covers of a journal, through the concept of "demassification." Demassification has two distinguishable, but ultimately interwoven, meanings, one focused more on physical properties and the other more on social. The two are causally related, but their interaction seems to produce an awkward paradox.

Demassification refers primarily to the removal of physical mass—a progressive trend as technology has moved from being predominantly mechanical, through electromechanical, to digital-informational. Huge mainframes that tied people together have been reduced to laptop computers; memory storage capability that once crowded floors of office buildings can now be carried in a shirt pocket. As a consequence, people no longer need to communicate through individual machines or within single buildings in order to work together.

Social demassification, the second sort of demassification, is in part made possible by physical demassification. The loss of physical mass has made it more viable for design and manufacturing to cater not to broad masses of people but to small groups and even individuals. Economies of scale, which guaranteed commonality of artifacts, are increasingly less significant. Artifacts can be tailored to the practice of a particular subset of a community, right down to the individual. Here lies the paradox. The more demassified objects are tailored to individual users, the more the

183

separation of those users becomes problematic in terms of maintaining shared practice. It's hard to have a shared practice if you don't share the same objects; it's almost impossible if you also don't share the same space. Paradoxically, by allowing mobility, physical demassification underwrites processes of social demassification. The centrifugal influence of physical demassification, allowing people to work apart, is in conflict with the centripetal needs that rise when separated people are unable to coordinate. It is essential to realize that in this complex state of affairs technology holds the potential to engender and maintain a sense of connectedness in communities that are more widely distributed than ever before, but only if the technology is suitably designed.

The prospect of the electronic, individually constructed "newspaper" illustrates some of the different and conflicting possible trajectories of demassification. Despite all its proclaimed advantages, the demassified "paperless paper" has failed to get successfully out of the lab. Why this is so can partly be explained in terms of genre.[8] The concept of the on-line paper reduces the relation of news to paper as one of content (deemed central and essential) to form (in this light, inessential and peripheral). It effectively strips away the periphery. In so doing, it simultaneously attempts to make individual what is essentially a communal artifact.

But paper plays an important role in determining, for writers and readers, both what news is and what is news. The physical limits of paper engender a process of selection—only certain items make it in and those that do are deemed "newsworthy." The physical immutability and circulation of paper across a society (ensuring that the "same" news is available to everyone at roughly the same time) turns those items into "social facts" common to a broad readership, not particular to individuals.[9]

The spatial properties of paper, furthermore, grade and relate the news. The significance of particular items is conveyed not merely by their presence in the paper but by their position and juxtaposition on the paper. Given that there is only one front page and a limited area "above the fold," paper implicitly relates stories in a hierarchy of social significance, and a great deal of information about news items is conveyed in this way. The savings and loan scandal, for instance, became major "news" when it moved from the business section to the news pages.

This is not to argue that there is no use for on-line sources of news items. Nevertheless, to step from there to the conclusion that the "news" should be transferred from paper to databases that are then sorted by individual interest is simply to confuse genres and their social roles. What on-line do-it-yourself services offer is not a simple replacement. Rather they, like e-mail, provide a means for different genres to follow different trajectories— one of which helps to circulate information, the other of which confers the status of "news" on that information.

Mr. Blandings Builds His Dream House, c. 1955. Photofest.

The example of the professional journal suggests that artifacts whose design is tailored solely to particular communities' needs pose a challenge to coordination between communities. With the example of the newspaper we are extending that argument to suggest that artifacts whose design is tailored to individuals pose an equally serious challenge to the formation, maintenance, and evolution of a community. With the former, what we have called boundary properties were ignored; with the latter, internal requirements are overlooked. As the physical becomes less constant and more contingent, it seems that social coordination both *between* and *within* communities will need more direct attention.

Changing Practice

In drawing attention to the importance of physical constancy in the periphery, we may have given the impression that social practice is resistant to change and that our search for design that honors practice is fundamentally conservative. So it is important to stress that the constancy of objects does not preclude changes in practice. Rather, practice, almost by definition, involves engagement with change—even when artifacts remain relatively stable.

Rather than resisting change, practice is constantly involved in it. The "maintenance" of practice is, then, paradoxically a process of continual change. It is the successful management of change and the relative constancy of artifacts, not the constancy of practice itself, that makes change invisible. Along with the book and its genres, the histories of the telephone, the radio, or the television and the genres they support also present classic examples of artifacts involved in this sort of negotiated evolution.[10] Practices around these artifacts evolved and continue to evolve as consumers respond to producers and, equally, producers respond to consumers, and all respond to changes in their social world. (At any one point, however, they will tend to seem remarkably stable, which is why designers need a good historical perspective.)

That this sort of negotiation is not a process over which one side can exert a determining control poses a fundamental problem for design that doesn't enter negotiations but attempts to exert control from outside. Communities are less threatened by change

185

than by attempts to control or circumvent negotiations. Design needs to be thought of as a process of engaging, not resisting or controlling negotiation.

Changing Design

The importance of communities of practice and the way they negotiate change have several implications for design for the future. Designers need to cultivate an awareness of communities, getting close enough to be able to understand community practice and evolution in a thoroughly situated way. In particular, the designs they produce should be usefully underconstrained, helping, not inhibiting, evolution of community practice. Designers also need to be in a position to watch new communities emerge and even to help seed them where that is possible. For much industrial design, this points to a thorough reconceptualizing and repositioning of the design community and its work.

Participation and Observation. A designer's understanding of practice decreases almost exponentially with distance. In the void—which human factors labs cannot bridge—prejudices and preconceptions substitute for more hard-won knowledge and understanding. Good designers, however, seem able to locate their work at the level at which practice evolves and to get close enough to the community to be able to understand its negotiations.

The definition of community in this context may well not accord with other descriptions

186

ABOVE: Anne Shaw, *Collating Paper,* c. 1950, published in Mike Mandel, *Making Good Time* (Santa Cruz, Cal.: Mike Mandel, 1989). Anne Shaw Organisation, Cheshire, England, and George Barr, Stow College, Glasgow, Scotland.

RIGHT: Lance Wyman, *Reading the Washington Metro Map.* Photo: Lance Wyman, Ltd.

of communities—of neighborhoods, teams, work groups, market segments, and the like.[11] The community of practice is by no means necessarily harmonious. Nor is it necessarily a face-to-face or contiguous grouping. The community of practice, as we understand it, denotes the level of the social world at which a particular practice is common and coordinated, at which generic understandings are created and shared, and negotiation is conducted. Thus it is the locus at which it is possible to explore the social and physical context in which artifacts are used, to understand the roles objects play internally and across boundaries. This, then, is the level in the social formation at which designers can most profitably work.

While we suggest that good design has to operate with reference to this level, rather than across the no-man's land that conventionally separates producers and consumers, we are not advocating complete immersion—that designers should simply become members of the communities of practice they wish to work with. The problems of the immersion only mirror those of separation. Both design approaches have critical limitations. Design from across no-man's land enshrines imaginary practice. Design in the trenches avoids this problem: it makes a critical effort to discover the realities of actual practice. But—particularly where it is poorly conducted—having found the crucial elements, it immediately threatens to cast them in concrete.

Honoring the Emergent. In addition to integrating new artifacts into ongoing community practices, designers have to learn to spot new communities as they form—to honor the emergent and support its development and evolution.[12] They also have to consider whether it is possible to seed communities and community practice. For example, in creating a social milieu for otherwise isolated users, user groups have had an enormous effect on the successful introduction of personal computers. And independent user groups are the sort of sites in which designers can usefully undertake participant observation.

When it comes to the introduction of new devices, designers can undoubtedly take inspiration from the rapidity and success with which, given the chance, autonomous support groups can form. Indeed, in certain circumstances it may even be practicable to seed such communities. The new Washington, D.C., subway system provides an example of something very like this. When the system opened, its managers faced a problem of introducing thousands of people quickly to its automated ticketing machines. In existing

187

systems, newcomers are usually able to watch old-timers going about their business and follow in their footsteps. And old-timers have an interest in raising the skill level of newcomers—otherwise they have to stand and wait while the newcomer fumbles and fumes. Unfortunately, in a completely new system, there are no old-timers, no established practices, no context for design. But with the D.C. system, the pump was cleverly primed. When it opened, a cadre of people who knew how to work the machines went repeatedly through the system where they could act like well-established old-timers. This gave newcomers practices to watch and follow. Where designers cannot spot the potential for a new community to emerge autonomously around a new artifact, then, it may be possible for them to seed one.

Conclusion

It is our contention that the focus of design in the future will be the constantly adaptable social periphery—the locus of practice in which highly efficient genres of communication and use are negotiated and developed. Perhaps the most important point to emphasize in conclusion is that this resource is social, not individual. It is the social periphery that undermines notions prevalent in interface design such as "abstract," "context independent," "internally coherent," "self-sufficient," or "self-explanatory." These cannot be either universal or individual, but only communal. If, as we suggested at the outset, it is the physical periphery that helps lead the new user instructively to the Macintosh, it is the social periphery, in the end, that surrounds that particular experience, bringing the user to the box and affirming that the learning process involved is socially shared and valued.

188

Lifetime Station Identifier for Lifetime Cable Television Network, 1992.
Tibor Kalman, creative director; Emily Oberman, art director and editor;
Andy Jacobson, producer; Laurie Anderson, music and voice-over.
Photo: M&Co., New York.

1 See Geoffrey Nunberg, "The Places of Books," paper presented at the conference on the "Très Grande Bibliothèque and the Future of the Library," Berkeley, Cal., 1992. To be published in *Representation*.

2 See JoAnne Yates, *Control Through Communication: The Rise of System in American Management* (Baltimore: Johns Hopkins University Press, 1989).

3 For this important use of "community," or more fully, "community of practice," see Jean Lave and Etienne Wenger, *Situated Learning: Legitimate Peripheral Participation* (New York: Cambridge University Press, 1991).

4 See Bruno Latour, "Visualization and Cognition: Thinking with Eyes and Hands," *Knowledge and Society* 6 (1986), pp. 1–40.

5 See Paul Duguid, "Computer Prose," *TLS* 4590 (March 22, 1991), p. 13, and Nunberg, op. cit.

6 See, for example, Paul Willis, *Profane Cultures* (London: Hutchinson, 1978), and Dick Hebdige, *Subculture: The Meaning of Style* (London: Routledge and Kegan Paul, 1977).

7 See Leigh Starr, "The Structure of Ill-Structured Solutions: Boundary Objects and Heterogeneous Distributed Problem Solving," paper presented at the "Eighth AAAI Conference on Distributed Intelligence," Lake Arrowhead, California, 1988.

8 See, for example, The MediaLab's lab-based experiments or Knight-Ridder's commercial failure with "Viewtron."

9 See Benedict Anderson, *Imagined Communities*, 2d ed. (London: Verso, 1991).

10 See, for example, Raymond Williams, *Television: Technology and Cultural Form* (New York: Schocken Books, 1975).

11 See John Seely Brown and Paul Duguid, "Enacting Design for the Workplace," in *Design for Implementation*, ed. Paul Adler and Terry Winograd (Oxford: Oxford University Press, 1992).

12 See John Seely Brown and Paul Duguid, "Organizational Learning and Communities of Practice: Toward a Unified View of Working, Learning, and Innovation," *Organizational Science* 2 (1991), pp. 40–57.

Ross McBride and Mary Moegenburg, "The Post-Happy Conditions,"
Telescope, cover, September 1992.
Workshop for Architecture and Urbanism, Tokyo.

Communication: New Translations

Yogi Berra to Phil "the Scooter" Rizzuto, having discovered they've taken a wrong turn on the way to the ball park: "Don't worry. We may be lost, but we're making great time."

— Apocryphal

As the remaining years of the decade slip away, we are beginning to adjust to the idea that, like the errant baseball players, we are lost. Lost in the twilight zone of the postmodern, all the while we haplessly speed through the windows of our ubiquitous screens.

As any traveler knows, the extent to which this state of limbo induces a liberating sense of pleasure or the paralysis of unease is directly related to our fluency with other languages. Today, as those languages multiply, literally and figuratively, graphic designers find their customary role as translators challenged from both within and without the borders of practice.

One wonders what Freud would have made of the obsessively verbal culture that has emerged at the end of his century—a culture in which the text is both subject and object of endless self-conscious speculation. Or of the subculture of incessantly chattering computers, forming faceless (at least for the time being) relationships between kindred hackers, like latter-day Cyranos. We accept the illusion of being "all connected" in a global culture, yet we are oddly disconnected, living in a prolonged phase of delusion. Constantly talking, we are a culture on the couch searching for ways to cope without the linear script of modernism.

Already claiming the high ground of

moral righteousness in its earliest appearance, the word *modern* was first used in the late fifth century to distinguish Christianity from the Roman and pagan past.[1] Just as one set of gods was replaced by a singular God in response to an altered cosmology, modernism in the twentieth century offered a singular vision in reaction to the cataclysm of two world wars and an acceleration of technological invention. However, since World War II, its ideology of presentness has been debased into a strategy to allay the effects of the exponential increase in knowledge at our disposal at the close of the century. Ultimately, it was the end of another war, the Cold War, that drew the final curtain on the hegemony of the univocal modern.

Shortly before the notions of East and West became blurred, an architect from what was then East Berlin created an unusual scrapbook. Each page contained a pair of postcards. What those postcards showed was how the city's railway stations, monuments, market halls, churches, and boulevards looked as they were in 1988 and how they had looked before 1945. It is a remarkable document of memory by an architect almost too young to have had any of his own.

All that appeared to be careful reconstructions were far cries from the former grandeur of their original architecture. War had mutilated not only buildings but the contiguous spaces of parks, thoroughfares, and squares. Now we are watching what peace will graft onto the complexion of Berlin and other cities and states that have emerged from the minimalism of communist-socialism into the mannerism of quasi-capitalism.

In Germany and Russia and elsewhere, an entire generation is finding most of its familiar landmarks displaced and replaced, from traffic signals to store signs, to street names and subway stops. As the visual landscape is redrawn, be it through erasure (the disappearance of Communist Party propaganda posters) or insertion (the appearance of McDonalds and Estée Lauder near Red Square), our very understanding of history is called into question.

It was thought that this century's project of modernity was completely dismissive of memory, of time. But this is, perhaps, a misreading worth reexamining as old power structures become extinct and embryonic political species vie for survival, as one millennium outpaces another. Jürgen Habermas addresses the assumption that modernism vitiated the past, observing that the "time consciousness articulated in [the] avant garde is not simply ahistorical; it is directed against what might be called a false normative history... it opposes... a neutralized history which is locked up in the museum of historicism."[2]

192

Designers in post-Communist states are acutely conscious of their role in the reimaging that is part of acculturation to the global market. And growing ranks within the profession at large are reacting against "neutralized histories" (including a neutralized, narrow history of modernism) that seek to diminish difference. Consequently, there is a strong interest in the vernacular among graphic designers that is reminiscent of Robert Venturi and Denise Scott Brown's seminal forays into the landscape of signs and marquees some twenty years ago. This time around, however, there is not just one vernacular of "low" culture, of the "other." There is a more even-handed awareness of the multivocality in the street media of our cities and towns. And beyond that, an awareness of the cross-fertilization "of (literally) different languages... across different social contexts."[3]

Speaking to us from the other end of the century, Walter Lippmann pointed out, "What each man does is based not on direct and certain knowledge, but on pictures made by himself or given to him.... The way in which the world is imagined determines at any particular moment what men will do."[4] Today the ways and means by which the world is being shaped by designers are multiplying in proportion to their expanding perception of that world. With communications networks linking heretofore remote regions of the globe, there are undeniable cultural forces mitigating against any one vehicle or style of imaging.

Ironically, the fracturing of modernist ethos has been accompanied by the possibility of endless memory through computers. While they have "jacked up the pace of global change, intensifying the rush of passing time, they nonetheless offer the paradox of total retention."[5] However, it is doubtful that this capacity for infinite recall will assuage the feeling that vital memories and habits of practice are disappearing. It is more likely to exacerbate our fears that those memories won't belong to us anymore, that we are part of a dehumanized master data bank designed to control and condition our public and private lives.

Perhaps even more distressing is the prospect that the data bank will think and act. As mathematician Roger Penrose writes in *The Emperor's New Mind:*

> We have long been accustomed to machinery which easily out-performs us in physical ways.... We are even more delighted to have machines that can enable us physically to do things we have never been able to do before: they can lift us into the sky and deposit us at the other side of an ocean in a matter of hours. These achievements do not worry our pride. But to

be able to think—that has been a very human perogative. If machines can one day excel us in that one important quality in which we have believed ourselves to be superior, shall we not then have surrendered that unique superiority to our creations?[6]

The idea of thinking machines has been with us for hundreds of years, but for the first time in history we are faced with the possibility that within a generation we may coexist. The corollary scenario being the ensuing power struggle for creative dominance that Penrose raises: Who will run the asylum? Perhaps it is this larger oedipal fear that underlies the current conflicts in design.

What we need to do most urgently, in fact, is to *find* asylum and accept the discomfort of that place of asylum. As much as designers are conditioned to plan, to problem solve, to control, they must also have the humility to respond and the inner vision to articulate those responses. Neither of which is possible without confidence, without faith, without a sense of responsibility to the human community.

In the end, Yogi Berra's dismissal of worry in the state of being lost may not be so inane. For the present—the only present allowed us as yet—it is essential that we recognize and accept this place of asylum for what it is—part holding pen, part portal to the landscape of the next millennium.

— S.Y.

1 Jürgen Habermas, "Modernity—An Incomplete Project," trans. Seyla Ben-Habib, in *The Anti-Aesthetic,* ed. Hal Foster (Seattle: Bay Press, 1983), p. 3.

2 Ibid., p. 5.

3 Sojin Kim and Somi Kim, "Type Cast: meaning, culture, and identity in the alphabet omelet (?which came first?)," in *Lift and Separate: graphic design and the vernacular quote unquote*, ed. Barbara Glauber (New York: The Herb Lubalin Study Center of Design and Typography, The Cooper Union for the Advancement for Science and Art), p. 31.

4 Walter Lippmann, "The World Outside and the Pictures in Our Heads," *Public Opinion*, 1922.

5 Erik Davis, "A Computer, A Universe, Mapping an Online Cosmology," *The Village Voice Literary Supplement*, March 9, 1993, p. 11.

6 Roger Penrose, *The Emperor's New Mind: Concerning Computers, Minds, and the Laws of Physics* (New York: Oxford University Press, 1989), p. 3.

Graphic Design: Lost and Found

LORRAINE WILD

Recently I read a very spooky novel by Martin Amis entitled *London Fields*. The narrative takes place against a backdrop of nuclear winter, which affects the characters' daily lives in awful ways—but it is just background, a hideous variation of normal bad weather. In the foreground, the characters go on with their drama, seemingly unaffected by that which is beyond their power to change; eventually you realize that, in the context of this novel, their entire world view has been poisoned in light of the industrial accident or political miscalculation or whatever sloppy circumstance led to the ecological nightmare that Amis describes.

When I finished reading *London Fields*, the week they pulled the hammer and sickle from the roof of the Kremlin, I found myself hoping that what still strikes us as profoundly horrific and meaningful might strike the next generation as simply kitsch. But then I reconsidered Amis's scenario, where everybody doesn't die but everything is just different, as being a bit like where we are today in graphic design (and a lot of other fields, I suspect), where nobody's dead, but everything is just different. And it is this pervasive unsettlement, intrinsic to our postmodern present of perpetual coexistence, synthesis, schizophrenia, and change, that forms the new and disturbing context for our work as designers.

So what were you doing the day the newspapers featured that picture of the flag coming down all over what was the Soviet Union? I was on the phone going over type changes with an editor on the other side of the continent, for a book that was being printed on the other side of the globe, wondering, "Have I done this project justice? In the future, will someone ever be able to look at this work and see all the effort and desire that went into it?" Who can possibly answer these questions, as enmeshed as we are in the speed of communication, the technology, the information overload, the conflicting ethics and values of our present condition? To what degree is each one of us a futurist? To what degree is each one of us hopelessly mired in the day-to-day as we lurch toward the threshold that may be someone else's millennium, but not mine.

Loss of Consensus

Intuitively, we know that our personal equations of idealism and pragmatism shift from day to day; what becomes most crucial are the values that we bring to our work and the

context in which we create it. But those values are precisely what is most contested in contemporary graphic design, and if anything characterizes graphic design practice and the discourse that surrounds it now (and probably through the 1990s), it is the widespread notion that there has been a loss of consensus as to what constitutes "good" design. How interesting that the shifting construct and context of our activity as graphic designers are often described in terms of loss. What has definitely been lost is our ability to lean on the principles of modernism to regain that consensus. This presents a big problem for designers, since the ideals and myths of modernism, especially those having to do with universality, objectivity, timelessness, "problem solving," and social values, are the wobbly base upon which the professional identity of the graphic design community has rested until this time. Consequently, discussions about contemporary graphic design practice are marked by a sense of confusion and rancor. And this dissatisfaction expresses itself in all sorts of ways.

Gerard Hadders, of Hard Werken in Rotterdam, recently put it this way: "I got in a crisis in the late '80s about the whys and why-nots, and really started to hate design that centers on itself.... I guess this design crisis is a common phenomenon by now, or at least

in Europe it is, as I see everything reassessing itself to new demands from the industry and a growing awareness that style stinks (or at least smells)."[1]

Michael Rock, a designer who teaches at Yale, described his reaction to a recent graphic design competition: "It was a roomful of fascinating objects admirably crafted, extensively decorated, and absolutely indecipherable. There was nothing to say, not because the products did not warrant discussion, but because the language with which we frame design has not developed sufficiently to take on new problems... has there been a breakdown between thought and the action of design? Has theory stopped feeding designers new ideas?"[2]

Writing in *Metropolis*, critic Karrie Jacobs also sensed the same rupture: "Design mediates between what clients want (or think they want) and what audiences get (or think they get). If there's one thing that's interesting to me about design process right now, it's how little the intentions of the designer have to do with how something is perceived by its audience, how little the 'problem solving' has to do with problems or solutions."[3]

On the other hand, there are those who question the meaning of graphic design that does not respect the forms alleged to emanate from the ideals and myths of modernism. These discussions often break down over generational lines, with an old guard (those who believe in the modernist credo, even if they do not actually practice it) often demanding an allegiance to modernist values and forms, while a new generation is having a hard time identifying any values that are stable. The frequent reference to a unified, successful, modernist past and its subsequent decay and dissolution is important because that discussion may well end up delineating how the new guard—those who are not near the end of their careers, but who perhaps are just beginning—will ever be able to think through this confusing present to find the future of our work.

In the world of graphic design there is still abundant sentiment that there is nothing inherently wrong with how contemporary design is practiced that a little economic upturn wouldn't cure, and that if only our clients would cooperate, designers could return to the same kinds of "problem solving" we have been engaged in since 1950. The trouble with that attitude is that the entire backdrop against which we solve our problems has shifted radically, and either a lot of designers haven't noticed the change, or they have but they harbor fantasies of being able to fend it off.

Symptoms of the Postmodern

Universality has collapsed into multiculturalism, focus groups, and zip code clusters; objectivity has collapsed into subjectivity at the same time as the author and the subject, or both, have been declared dead; and the techno-scientific march of progress has been canceled because of doubt. The linear is harder to detect; the simultaneous is becoming habitual. All of these conditions are symptoms of what is called the postmodern. But this term has not been very appealing to designers—the "post" part implying exhaustion, decline.

LEFT: Edward Fella, *Finger on Exactly Identifying That Meddlesome Art Touch in the Design Pie,* 1986. Courtesy of the designer.

Postmodernity acknowledges the existence of many modernisms—a range of strate-
gies, from the liberating to the constraining. Some modernists like Kurt Schwitters or
John Heartfield were extremely temporal and challenged the politics of the status quo;
others, such as Mies van der Rohe, practiced an aesthetic absolutism that ignored the
temporal. Some modernists such as Theo van Doesburg and El Lissitsky did both.

The influence of modernism on American graphic designers may have originated in
the work of the futurists or the constructivists or the designers of the Bauhaus, but the
social utopianism and the revolution of that earlier modernism had metamorphosed into
something quite different by the time it began to guide the practices of designers here in
the years just before and after World War II. So now we have a lot of sloppy thinking,
fake history, and romance attributing some sort of ethical accomplishment to modernism
surfacing in reaction to the uncomfortable unknowns of postmodernism. Some fields of
design activity seem to be coming to grips with the fact that the social ideals of modernism
weren't realized, but graphic design? "Design is communication." "Design is problem
solving." One hears these clichés repeated endlessly, the mantra of the graphic designers
stuck in the denial and anger phases of mourning for a time when the values we lived and
defined ourselves by made sense with the larger world.

Dysfunctional Modernism

In the 1991 spring issue of the *AIGA Journal*, under the heading "Long Live Modernism,"
Massimo Vignelli states unequivocally: "As seen in a broad historical perspective, mod-
ernism's ascetic, spartan look still has a towering position of strength and dignity.
Modernism's inherent notion of timeless values as opposed to transient values still great-
ly appeals to my intellectual being."[4]

Which modernism are we talking about? Marinetti? Mies? Something about "timeless-
ness" suggests that it's Mies. In that same journal, Vignelli and the other authors—Dan
Friedman, Bill Bonnell, and Kathy McCoy—identify functionalism and the conviction
that design would act as a positive social and cultural force as the most salient character-
istics of modernism. But the minute you look at the products of that late Miesian or Swiss
or International Style modernism, in all the design fields, you are confronted with all the
contradictions of those aspirations in the actual performance of its projects.

McCoy, Friedman, and Bonnell are all just young enough to have been much more
affected by the onset of doubt in modernism initiated by postmodernism. That is why
those three writers are careful to distance themselves from the formal credo of mod-
ernism. But still they persist in identifying function and social value as particular mod-
ernist values worth keeping. Kathy McCoy identifies functionalism as an ethic inherited
from modernism—alive, even if its forms are not.[5] Dan Friedman identifies as mod-
ernists, "those of us who merely believe that we should use all existing means to improve,
change, and refresh our condition in the world."[6] Bill Bonnell admits that the stylistic
stewing of modernism might have rendered it unrevivable.[7]

198

Despite its pervasive attachment to modernist mythology, functionalism can be seen to be imbedded in the definition of design itself: a series of actions taken to produce a desired effect implies that, well, the result of the plans will be... what was planned. It may be time to detach that notion of function from the failed ideology of modernism in order that function might regain its simplicity and clarity as a design value.

Another reason that we witness this yearning for modernism (even if it is deeply misunderstood or misinterpreted by those doing the yearning) is because Late or International Style modernism provided a defined visual style along with an ethos; in fact, you could dispense with the ethos altogether and still lay claim to righteousness through style. This aesthetic security is now missed by many of those who functioned well within it, and the attempt to revive the modernist conviction in form comes at a time when several other aspects of design practice that affect form have been destabilized.

"Those Damned Machines"

First, and perhaps foremost, the complete reworking of the production of print wrought by digital technology has thrown graphic design's identity into question. The computer has affected all design practices, with CAD programs in common use in architecture, industrial design, etc. But whereas the development of these programs has cut out lower-level production positions in architecture and industrial design, at worst, it hardly threatens the very definition of those design fields the way it threatens graphic design. The professional identity of graphic design developed when the conceptual processes of layout and form were separated from the setting of type and print production, but now the new technology reunites those activities, and what should be convenient or even liberating turns out to be surprisingly traumatic.

In a "debate" published in *Print* magazine[8] between Massimo Vignelli, the self-professed minimalist/modernist, and Ed Benguiat, a pragmatic pluralist, the two designers confounded the editors by ignoring their own absolutely conflicting design philosophies in favor of ranting about their fears of the loss of control and quality in design through the production of work by people that they don't recognize using those damned machines. Ed Benguiat decries the work of "those who don't know"; according to Vignelli, "they" now

199

Frank Heine, *Stop This,* 1992. Courtesy of the designer.

have "a tool that gives them license to kill." He goes on to compare typography that deviates from his standard of a restricted palette of fonts and point sizes to cultural and ecological pollution. Vignelli describes *Emigre*, the journal that has documented much contemporary typographic experimentation, as a "national calamity... an aberration of cultures."[9]

Speaking for himself and Benguiat, he proclaims that in the face of this horrible decline, the correctly conservative position is to "maintain a level of quality that hasn't changed from the Roman times to the Renaissance to the 18th century to you name it."[10] The history of technology, of functional and aesthetic responses of producers of print and their audiences, *of memory itself*, that might provide guidance for those trying to live and work in the present are here sacrificed to a completely romanticized and moribund vision of the timeless authority of the designer. Unfamiliar forms of work produced in response to major changes in technology are classified as "ugly" because of their formal strangeness. Unfamiliar forms are often interpreted as evidence of aesthetic malfeasance, the obliteration of standards and practices of craft.

It should be noted again that no condition is universal, and some members of "the old guard" (I'm thinking here of Matthew Carter or Gerard Ungers) who are well versed in typography and its history recognize our present as a condition of great creativity similar to others brought on by technological revolution. In the midst of this perceived decline, new developments in digital typography and technology have brought about an explosion

of font design, and the energy coming from small font publishers and distributors has enlivened graphic design. Those who are not terrified by the new typographic technologies are using them in all sorts of ways, as an opportunity to reinvent type aesthetics in response to the technology itself.

This is not to say that all of the products of this type explosion are valid, and they're not timeless by any stretch of the imagination. But the refusal by many of our modernist "old guard" to see this as a historical moment is ironic in light of the fact that the technology of digitization has brought us closer to one of the great old early modernist techno-dreams, the "electro-library" of El Lissitsky, the extension of the technological reverie taken to its logical conclusion.

Technology has challenged many of the precepts of graphic design education, and educators must struggle to rethink curricula because of it. It has changed the way younger designers enter the field, the way projects are managed and offices are run, and, ultimately, it is heading right for the way design is consumed. The relationship of designer to client, already tenuous, could be on the verge of obliteration since the production-related reasons for any client to hire a graphic design consultant are decreasing steadily. Obviously job security is driving graphic designers crazy.

Complicity and Contradiction

During the 1980s we had to endure such inanities as Michael Peters declaring that big offices were the only structures that could offer legitimate design services; small offices were primitive and doomed to fail.[11] At the same time, design education suffered a barrage of criticism for not devoting itself completely enough to the preparation of entry-level employees to feed the big offices. Criticism of the commercial abuse of design is always a problem: if it comes from Stuart Ewen, it's rejected because he's an academic; if it comes from Neville Brody, it doesn't count because he's English; if it comes from Tibor Kalman, it's invalid because he's somehow tainted by his own commercial practice; if it comes from Dan Friedman, well, "doesn't he design furniture now?"; if it comes from someone like me, it's written off because my practice is not commercial enough.

Nothing is more problematic than a critique of business. Yet here is Larry Keeley, the voice of design management, writing about corporate design changing forever: "Corporate identity doesn't matter much now and will matter less as time goes on... we have entered a new era where individuals are important and institutions aren't." He goes on to say that it will be a test of the integrity of big design offices because their profitability has been based on selling large identity programs: "What's right for the consultants is harmful to the clients."[12] What a far cry from the modernist dream embodied by Paul Rand meeting man to man with Tom Watson at IBM, then going home to heroically produce one of the most effective and "timeless" corporate identities of the century, single-handedly, and *for free!*

To accept that design is complicit is to reject the myth of the designer as disinterested

201

genius. We must keep looking for the values behind these preconceived notions of good design. This does not mean that we must reject what history we have or consider projects held up on the basis of formal innovation unworthy of our attention. It means becoming honest about the forms and the circumstances of their production and actual function in the world.

New Criteria

The inability to describe a set of universal formal guidelines for "good" graphic design should not be seen as a handicap (even if it often feels like one). This condition offers us a "window of opportunity" in which we can maybe begin to address some of those other issues that so many educators and practitioners pay lip service to yet are still so easy to ignore as long as we can be satiated by the more immediate gratifications of form. This is *not* to denigrate form. If the audience has changed and the production has changed, and the messages might change, wouldn't common sense suggest that the notion of form might evolve too?

There is no doubt that aesthetics are a tough call. As the educator Jacques Girard has stated about critiquing work nowadays, "Someone who refers to a design as beautiful, ugly, good, or bad is not talking as much about the object as about himself."[13] Appropriateness cannot be held up as a value in and of itself without looking closely at the situations to which we pledge our obedience. In an interview in *Emigre* ("the national disgrace"), Laurie Haycock described the major differences that would distinguish new design from the old as "the kinds of subjects that you start seeing design being wrapped around, and the technology which allows anyone to do it."[14]

A modest case for such a difference in practice could be made around an oversized postcard I received from the phone company announcing the new area code for the west side of Los Angeles. It's got five languages on it; I'm interested in how they picked those five, given that Los Angeles supposedly contains significant populations of 130-some language groups. The typography of this thing annoyed my professionally refined sensibilities. It looked clumsy and even scary to some of my neighbors. The designer who could figure out how to make this multilingual announcement interesting, informative, maybe even beautiful, would also be engaging in a very political act in my city, where rapid immigration is sometimes seen as fortuitous enrichment but more often felt as an alien threat. I don't know the solution to the Pacific Bell announcement, but these are the kinds of problems we should be looking out for, problems that will test our commitment to social amelioration and our capacity to give form to the new, more complex definitions of functionalism. And I suspect Univers won't do the trick.

For a few years now some designers have been using the metaphors of language to describe the workings of design. Actually this is not new, as some members of the old guard are always quick to point out. Yes, they taught semiotics at Ulm. But their understanding of semiotics was still affected by late modernist design theory, which inclined them to look for universal signs; the interpretation of semiotic theory is significantly different now. Another language theory that may lend to the development of new paradigms for graphic design is the use of rhetorical concepts as a framework for design analysis. Again, this is not a new idea in design studies, but timing is everything. In the past, academic problems in graphic design studies that used rhetoric as an analytical tool were often sabotaged by straight "objective" modernist typography that mitigated against the very expression the rhetorical concepts were supposed to highlight. You didn't know what you were looking at. The revival of interest in rhetoric now comes at a time when we may be freer to put those guidelines to a much broader test.

Reception theory, another quintessential postmodern construct, is obviously behind the revisions of notions of function, use, and meaning. The picture of graphic designers starting to think about meaning as a result of situations of use is a challenging one, perhaps because graphic designers have not had to live with marketing the way industrial designers have, and to many designers market testing and legibility testing are pernicious activities that only reinforce the obvious. So how do you try to understand use or performance in graphic design? I doubt that it will ever be quantifiable in any way, and I'm sure that the understanding can only be particular and contextual. The pressure on the young designer is not to become a star, a master or mistress of the universal, but to become a participant in the communication process, a co-conspirator, a co-author, maybe even an author/designer. This is why the development of the personal voice or agenda has emerged as an important new aspect in the training of young designers now, to equip them in this expanded, much more accountable role that will be demanded of them if they are to retain any validity at all in the new context.

Bitterness as Professional Liability

But what about the old folks—the old guard—or those of us who straddle the two guards? We are the ones who in the last fifteen years complained that graphic design had an inadequate body of theory and history to guide its own development, but ironically, as more theoretical and historically informed ways of thinking about graphic design have evolved, as our heroic modernist past has been demystified, we're distressed, we're unhappy, we're in pain! What should we do?

In her influential book, *The Drama of the Gifted Child*, psychoanalyst Alice Miller posits that children who are consistently forced to subjugate their desires to the demands and wills of their parents will experience a kind of stunting of their own personalities, leading to depression (based on never really being able to feel securely loved) or what Miller calls "grandiosity," the tendency to repeat behavior that gains approval (in lieu of

203

love) over and over again, no matter how emotionally unfulfilling. The grandiose are literally trapped in their own success, and miserable for it.

When I encountered Miller's thesis, I thought that I had stumbled upon a pretty good psychoanalytic paradigm to explain the inability of graphic designers, particularly American ones, to withstand the vicissitudes of history and theory as they are mirroring themselves in our collective unconsciousness. Our old guard fought battles for us dedicated to the ideology of modernism; the audience, in the role of parents, didn't buy the story (for their own neurotic reasons), but they rewarded many of the designers by using them up, ignoring their ideals, paying them very well—but never granting those designers quite the same level of status and glorification reserved for even the most mediocre of artists. Thus, in our old guard, we frequently encounter bitterness despite lifetimes of success, a lack of generosity toward new work or new designers, defensiveness, a desire for control, and, worst of all, the attempt to dictate the intellectually pathetic idea of a singular history into myth so that it can never be challenged or broadened.

Consider the recent spectacle of several of the most highly regarded names in graphic design—Milton Glaser, Ivan Chermayeff, and others—excoriating the Walker Art Center for daring to assemble an exhibition titled "Graphic Design in America: A Visual Language History" (not *the* history), which failed to pay suitable homage to their accomplishments (or so they thought).[15]

When graphic designers complain that their parents don't understand what they do, it used to sound like an innocent little joke, repeated to reinforce group identity; now it takes a sinister tone, like a symptom of disease, grounds for professional counseling. Remember, admitting that there *is* a problem is the first step to the road to recovery...

Portions of this essay were printed in *I.D.* magazine under the title "On Overcoming Modernism," September/October 1992.

1 Unpublished letter to the author, 1991.

2 Michael Rock, *I.D.*, January/February 1992.

3 Karrie Jacobs, "Safety in Numbers: 1400 Designers Go to Chicago," *Metropolis*, December 1991, p. 74.

4 Massimo Vignelli, "Long Live Modernism," *AIGA Journal* 9:2 (Spring 1991), p. 1.

5 *AIGA Journal* 9:2.

6 Ibid.

7 Ibid.

8 "Massimo Vignelli vs. Ed Benguiat (Sort Of)," *Print* 45:5, p. 91.

9 Ibid.

10 Ibid.

11 Colin Forbes and Michael Peters, "Design and Business," *Graphis* 46:265 (January/February 1990), pp. 10–13.

12 Larry Keeley, "The Mission is the Message," *AIGA Journal* 8:1 (1990), p. 2.

13 Jacques R. Girard, "Design Education in Crisis: The Transition from Skills to Knowledge," *Design Issues* 7:1 (Fall 1990), p. 26.

14 Laurie Haycock, quoted in "3... Days at Cranbrook" by Rudy Vander Lans, *Emigre* 19 (1991).

15 "The Critics' Response to Graphic Design in America," *AIGA Journal* 8:1 (1990), pp. 12–13.

204

RIGHT: Vladimir Chaika, *Kasbek* cigarette box graphic, c. 1990. Photo: Constantin Boym.

Russia Now: Survival of Design or Design for Survival?

CONSTANTIN BOYM

The rapidly changing political and cultural situation in Russia makes it necessary to mark the date of this writing: October 1991.

In 1986, a year after his appointment as the Communist Party Leader of the Soviet Union, Mikhail Gorbachev initiated a three-part program of economic revival: *perestroika* (restructuring) was to be accompanied by *glasnost* (public openness) and political democratization. The first years of Gorbachev's reforms promised the forthcoming of a golden age of Soviet design. Generated at the top, the reform was originally intended to preserve the Soviet regime intact yet make it self-sufficient, more productive, and perhaps more human. Again, as it was twenty years earlier, industrial design was perceived as a necessary yet underutilized economic tool.

In the 1960s the government attempted to introduce design into the state-run economic system. The decision was dictated by economic calculations rather than by any kind of cultural philanthropism. Industrial design was seen as a means of improving the quality and appearance of Soviet merchandise, necessary for regulating the distribution of goods, and beneficial for foreign trade with Eastern-bloc countries.

As an outcome of a special Communist Party resolution, the All-Union Research Institute of Technical Esthetics (VNIITE) was established in Moscow in 1962. Soon the institute had branches in large cities and at major industrial sites. However, the main design institution became a scholarly organization in which theorists, historians, and scientists undertook research that had little connection with the country's economic reality. Instead of working directly with industries on improving products for the market, they created comprehensive design guidelines and programs, most of which were shelved in the bureaucratic routine of state ministries. Meanwhile, factories and plants followed their familiar strategy: foreign samples were routinely purchased at trade shows, dismantled, and copied with gross simplifications. Shortages and irregular distribution helped to sell these unappealing products to the mass consumer.

In the spirit of reform, during his visit

205

to a giant automobile plant in Toliatti in 1986, Mikhail Gorbachev twice spoke out, demanding good design from the car makers as well as from the rest of Soviet industry. The use of the word *design* in its English transliteration (instead of the term familiar to the Russian ear, *artistic engineering*) was so unusual that some newspapers even omitted it from their reports. However, far from being a slip of the tongue, Gorbachev's call effectually indicated a new party directive for the promotion and support of industrial design.

In April 1987 a constituent congress of the Society of Soviet Designers took place at VNIITE in Moscow. A strange meeting it was, as no one knew who had qualified to be a member and who had had the right to accept or reject the candidates. Eventually every-

body present was admitted, with the ubiquitous VNIITE director, Yuri Soloviev, elected as president. In addition to industrial designers, the society included interior designers, graphic designers, and even fashion stylists. As the first private enterprises, or cooperatives, were being legalized, the designers were encouraged to open private studios and to work on a contract basis with the factories. The words of the deputy prime minister were widely quoted: "There is a need for design everywhere, and our industry is ready to shower designers with commissions. Now it's up to you!"

Needless to say, events took a different course. An unplanned side effect of Gorbachev's reforms manifested itself in political and national instability, which spread in the different regions of the country—and ultimately resulted in the splitting of the country into independent republics. This last blow to the centralized bureaucratic system has thrown the economy into a deep crisis, the most visible characteristics of which have become inflation and perennial shortages. Lack of the most elementary goods and supplies in particular has nullified any serious design effort. In direct contrast to a capitalist economy, where a competitive market constantly dictates the introduction of new and superior products, the empty stores in Russia cry out for *any* merchandise, no matter new or old, well made or shoddy. There was hope that private enterprise might bring fresh blood into the economy by providing a necessary competition. Alas, a profiteering mentality and flea-market aesthetics dominate most of the cooperatives, making them an unlikely candidate for the application of designers' talents. A private Moscow restaurant, Atrium, lovingly designed and constructed by Paper Architecture protagonists Brodsky, Utkin, and Monakhov in 1988, has since remained almost a singular exception.

Some designers have been eager to join the new class of entrepreneurs, forming various ventures with cooperatives, factories, and export firms. Perhaps this is the last

206

Alexandr Brodsky, Ilya Utkin, and Eugeny Monakhov, *Atrium Restaurant*, Moscow, 1988.

Photo: Igor Palmin.

chapter of the now familiar exodus from the design profession that started back in the 1970s. Instead of creative liberation, however, this transformation threatens to culminate in a mercantile, profit-oriented position. Architect Maxim Poleschuk formed a joint venture with the participation of the Samara aviation plant and a glass factory. They set themselves the interesting task of producing conference and coffee tables fashioned from thick aviation glass. The first samples, reminiscent of low-end commercial Italian production, indicate the direction of their product line. "Yes, it is Italian-looking design, but we need it here," said Poleschuk in defense of his position. Yet even he acknowledges the ambiguity of being designer-cum-businessman in the condition of an indiscriminate Soviet market.

By 1990 government planning and control over the industrial sector had virtually come to an end, even though the state formally retained its ownership. In October that year, leading Soviet design theorists and practitioners published an open letter in their professional magazine in which they delineated a threatening situation in the design field. "If previously design was introduced in the economy by means of pushes and nags, resolutions and directives, now there is a complete vacuum. Voluntarily, nobody wants to spend resources on design research. 'Who cares about aesthetics!'—this is the motto of today's industrialist." The writers of the letter addressed the government leaders and the private industrialists, desperately trying to prove the usefulness of their profession. "The unclaimed talent of a designer, his or her unwanted knowledge, is more than somebody's private misfortune. It is a strategic mistake with serious economic and cultural consequences," wrote the authors. The survival of the design profession has come up as a recurrent theme in private conversations in Moscow in the wake of 1991.

The predicament of design relates to the wider process of "cultural commodification" that has already affected Russian theater, cinematography, and literature. Market considerations, often vulgar and shortsighted, are being applied to all kinds of artistic endeavors to judge their viability. "Every aspect... is subjugated to economic redefinition, so that the censor, external and internal, figures in the new landscape of the marketplace, aware of what will sell and censorious of what will not," wrote Nancy Condee and Vladimir Padunov in "Makulakul'tura," their study of Russian cultural politics, published in *October* (No. 57, 1991). As the well-known nonconformist writer Andrei Bitov has put it bitterly, "it is forbidden" has already been replaced by "why bother."

Those who are unable or unwilling to emigrate, who reject the all-too-familiar professional compromises, and who are ready to analyze the design situation critically often find themselves in a strange creative impasse. Mark Konik, one of the leaders of the Senezh

207

Bandakov, *Monument,* 1990. Photo: Constantin Boym.

studio during the seventies, in 1989 declined to participate in his studio show, providing the following commentary: "For twenty-five years I have been working on design transformation of the urban environment. *Now I refuse to design.* The basis of our environment is worthless in all senses: urbanistically, architecturally, ecologically, socially, culturally. To propose any artistic improvements is simply immoral. One has to start from the beginning, from the basis." There is a sad irony here, since for decades projects of the Senezh studio served precisely as an ethical counterpart to the official architectural mentality. As the officialdom withers away, progressive design accepts a new challenge, a different morality. Instead of supplying an alternative rhetoric, such design wants to take an active part in the actual transformation of reality, however impossible this task might appear in the 1990s.

A similar situation in graphic design has forced talented young graphic designers to abandon the conventional methodology of their discipline, confining their work to throw-away materials and helping only a selective group of client friends. Russian design critic Sergey Serov emphasizes an ethical dimension of this refutation: if conventional design is immoral, one has to look for different methods, for a new style. Permutations of this emerging trend have been variously described as the "poetry of refusal," the "aesthetics of poverty," or simply "the blackness." The motto of Alexander Ermolaev's studio, TAF, "design for survival," captures the sentiment of this creative direction. The followers of "poor design" use cheap, readily available materials. They appeal to low technology, employing foolproof compositional methods that cannot be ruined even with inferior Soviet workmanship. Crooked margins, uncoordinated type, one- and two-color printing often serve both as an expression and as the only technical possibility for a project. It is these rough works, rather than the sleek posters with politically correct messages, that can lay claim to representing the graphic design of *perestroika*.

The work of one such young graphic designer, Vladimir Chaika, offers a case study that illustrates the general cultural predicament. A sad symbol of new Russian design emerges as one follows the fate of his career.

Chaika was born in 1955; he spent the first twelve years of his life in the steppes of Kazakhstan, where his father served as an officer at a military base. He then studied at Stroganoff Art School in Moscow, specializing in graphic design. An uncommon talent and a naive, open, wholesome personality soon made him a favorite with school professors. He was still a student when the doors to the leading figures of the professional graphic design elite had opened for him. After graduation with honors in 1982, Chaika immediately got a job at the prestigious studio Promgraphica at the State Art Foundation. There he participated in the development of the large-scale, hyper-inflated graphic programs so

208

ABOVE: Irina Tarkhanova, *Rakurs Typeface,* 1989. Photo: Constantin Boym.

RIGHT: Vladimir Chaika, *Self-Portrait with Shaved Head,* C. 1987. Photo: Constantin Boym.

URS★2

representative of the late Brezhnev period. Typically enough, none of these projects were realized, yet they brought the young designer professional recognition, awards, a clearly promising future. He was close to becoming an executive art director of the entire studio.

At that time *glasnost* had already opened up a curtain over the country's history, and many previously forbidden literary and historical texts became accessible to the public. Absorbing books, like Solzhenitsyn's epic *The Gulag Archipelago*, had a profound influence on Vladimir Chaika. Once a Communist, a loyal and "politically correct" citizen, he left his position at Promgraphica, canceled many previous assignments and contracts, and, in an unprecedented gesture for 1987, abandoned his Communist Party membership. "I got sick and tired of lying," recalls Chaika. "Tired of superficial projects that nobody really needed, that burst like soap bubbles at the first touch with the reality of our life and our typographic industry." He then shaved his head, as a sign of mourning or as a farewell to a trendy designer stereotype.

During a year-long period of crisis, Vladimir formulated his new direction. In a stationery store he bought some black ink, small sheets of plain paper, a children's glue brush—these were his "technological base," appropriate for the country, and helped him to form a new design language. In fact, he calls it an "anti-language," a rough and defiant utilization of the most primitive and throwaway materials and types. A virtuoso of calligraphy, Chaika chose to scribble with a blue brush in order to imitate the undesigned casualness of amateur expression. And he became particularly conscientious in his choice of

clients. "I was going to do only the projects for which there was a real need. Only those where I could help somebody," he recalls. According to the critic Sergey Serov, the evolution of Chaika's graphics is both instrumental and symptomatic for the design of *perestroika*. There a clearly defined ethical position generates the new aesthetics, the "poetry of refusal," a painful search for alternative methods of expression.

With all their undesigned roughness,

209

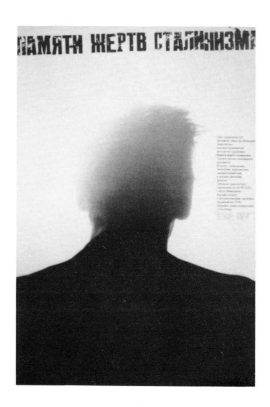

TOP: Vladimir Chaika, *Society of Victims of Stalinist Repressions Poster,* 1990.
Photo: Constantin Boym.

BOTTOM: Vladimir Chaika, *Piva Net (Beer Is Sold Out),* cover design, *Reklama* magazine, 1990.
Photo: Constantin Boym.

the new projects of Vladimir Chaika stood out thanks to their strong conceptual ideas, visual and metaphorical keys, which immediately captured one's attention. A 1988 exhibition, "Designer-Artist" was organized in Moscow jointly by VNIITE, the state design agency, and by the Union of Soviet Artists. For the show Chaika created a four-part poster that captured the tenuous relationship between the two disciplines. The first sheet depicts a French curve, a symbol and tool of designers, artistic yet practical. In the subsequent sheets the tool is progressively shattered, with its pieces forming an abstract composition. As parts of the poster were posted around the city, the order of reading could vary from centrifugal to centripetal. One could interpret them as a design product that disintegrates into a work of art or, conversely, as an abstract piece shaping into a figurative functional object.

Even in his alternative projects for selective clients, Chaika met with indifference and misunderstanding. The most memorable and frustrating experience was his award-winning competition for the Society of Victims of Stalinist Repressions established in 1989. First Chaika participated in a competition for the society's graphic identity program and won the top prize with an expressive, very rough entry that effactually subverted the very idea of corporate identity. Later in 1990 he took part in a contest for a monument for the victims. This competition, open to any citizen of the USSR, drew several thousand entries. Chaika proposed a graphic project, an anonymous backside portrait with half-erased head. He envisioned a very long wall, somewhere in Siberia, with more than 30 million such heads, one for each victim, executed in ceramic bas relief. The startling rationalist precision of the project brought Vladimir another first prize—yet, needless to say, both proposals were immediately shelved. The ethical dimension of Chaika's design—his desire to help people—has been more difficult to achieve than winning competitions.

One of Chaika's more fortunate design relationships was established with *Reklama* magazine. After Vasily Tsygankov took over as an art director in 1983, the publication became an important showcase of Soviet graphic design. Beginning in 1984, Chaika designed more than twenty memorable covers, including an amusing series of "magazine faces" inventively relating to the cover stories of the issues. His farewell cover of 1990 coincided with his departure for America. In the trademark style of the Coca-Cola logo, the copy reads, "*Piva Net*" (Beer Is Sold Out), a sign familiar to every Russian who has stood in long beer queues—a sad symbol of material and spiritual deficiency.

Chaika came to the U.S. for six months at the invitation of New York designers Massimo and Lella Vignelli. Yet the consumer paradise of the West left him surprised, confused, and ultimately alienated. He could not reconcile the amounts of creative and monetary resources that end up in junk mail and the desperate struggle of young graphic artists to publish their work. While appreciating the strength and precision of American graphic design, he instinctively sensed the lack of spiritual content. The idealism of his aspirations did not strike a chord with the professional pragmatism of the New York design scene, just as his wholehearted openness felt awkward amid the polite smiles of indifference.

Back in Moscow, as Vladimir puts behind his memorable American experience, he has no clear direction. In the small studio apartment where he lives with his wife and young son, he works at a kitchen table, making ambiguous, grotesque, unsettling compositions and objects. These untitled works are his personal reflections, glimpses into the anxieties of his self search and, maybe, hopes for his return to the graphic design profession. With a charming smile he quotes Solzhenitsyn: "Don't trust, don't beg, don't fear! This was the man's motto in a gulag camp. Appropriate for all of us here, isn't it?"

In July 1991, a few weeks before the coup, Serge Schmemann reported from Moscow: "All across the Soviet land, there is a bewildering sense of a wounded monolith surviving through sheer inertia, beyond the laws of economics, politics or common sense.... There is a widespread sense that something has to give, that something fundamental has to change." Many events have taken place since then, yet this expectation of change is still there; perhaps it has become more acute. Unimportant as it may seem, one hopes that the long-suffering design profession will not be left behind. From a seed planted now in a liberated land, on the cusp of the next millennium, we could witness a truly golden age of the New Russian Design.

Portions of this text appear in the book *New Russian Design* by Constantin Boym (New York: Rizzoli International Publications, 1992).

212

ABOVE: Vladimir Chaika, *Untitled*, 1991. Photo: Constantin Boym.

RIGHT: *Brandenburg Gate*, West Berlin pre-unification.
Photo: Erik Spiekermann, MetaDesign Plus, Berlin.

West Eats East, or the Biggest Takeover Bid in German History

ERIK SPIEKERMANN

It is a familiar experience for anybody traveling in Europe to enter a new country without noticing a demarcation line, let alone a formal check point. But you still immediately notice that you have entered another culture. The language on the road signs and on the billboards is, of course, the first and most obvious indication, but there are many more differences: signs for roads and freeways can be green, blue, white, or yellow. Furthermore, the typefaces used on these signs are different, often indigenous to the particular country. Road markings are also different, as are the shapes, positions, and colors of streetlights, warning signs, telephone booths. Public utilities have distinct identities; advertising uses different imagery. The signs above the shops and restaurants tell you immediately where you are. (We'll have unified pictograms, I'm afraid, very soon, but at the moment traveling around Europe is still nicely punctuated by these visual border crossings.)

Apart from things looking different from country to country, there are also great

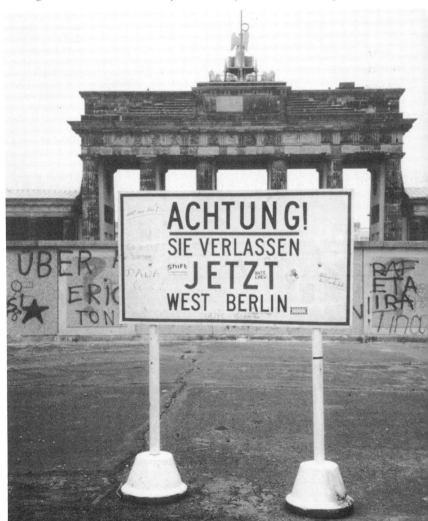

variations within one country. Every society creates its own visual culture. The graphics on trucks and buildings in southern France have their own inimitable style and look nothing like their counterparts in Paris. It's pretty obvious just from looking at certain artifacts where you are. In the main, however, distinct graphic styles have developed over centuries in countries with different languages, which obviously have helped to keep things distinct from other cultures. The literary culture of a country is obviously a true expression of its identity.

But what of two countries that have been separated only by different political and economic systems? Separated for all of forty years, with an impenetrable border in place for just short of thirty years, while the people continued to speak the same language and were able to watch each other's TV programs?

This was the situation in Germany, where the Soviet sector became the German Democratic Republic (GDR), while the three western sectors joined to form the Federal Republic of Germany in the same year, 1949. The wall was erected in 1961, allowing not much else apart from electronic messages to cross. For almost thirty years—one generation—East Germans weren't able to choose where they wanted to go. Travel was restricted to the "brother" countries of the Eastern bloc, and only a few privileged people were allowed to see the West apart from on their TV screens, and even that constituted an illegal activity.

214

ABOVE: *East German Traffic Light Signal Figure.*
Photo: Erik Spiekermann, MetaDesign Plus, Berlin.

RIGHT: *West German Traffic Light Signal Figure.*
Photo: Erik Spiekermann, MetaDesign Plus, Berlin.

Isolated as they were, East German designers made a virtue of necessity and developed a distinct style of their own. That style was partly dictated by the limited availability of materials and technology, partly by strict guidelines concerning fees and prices, partly by censorship and rigid central planning, and partly by the desire to make their society look as successful as the propaganda claimed it to be. Lastly, East German design was affected by an inferiority complex toward the West, which looked more attractive despite the fact that East German propaganda professed it to be on the decline while the only existing "working class paradise" (as the GDR referred to their own country) was going from strength to strength.

The former GDR was made up mainly of what used to be Prussia—the agricultural north—and Saxony, the industrial south of eastern Germany. The people in these states have always been known as hard-working, law-abiding, not exactly fun-loving Protestants. Just the right mix for an authoritarian government that rigged votes at elections and imposed strict rules on every aspect of public and even private life, enforcing those rules with the help of a secret police that, in the end, employed almost one in every hundred citizens. For almost forty years people put up with the system, until it became too evident that it was not only corrupt but also bankrupt.

In a society that called itself progressive, graphic design was meant to contribute to the progressive culture. This gave designers some freedom to formally express themselves on posters and book covers, as long as the subject was an approved one, while the almost total absence of advertising and other competitive commercial communications made the

development of a distinct East German style in those areas virtually impossible.

Packaging is one of those areas of design where in market-oriented societies a lot of money is spent trying to appeal to a particular audience. The ubiquitous presence of packaging in every household, on TV, in newspaper advertisements, on billboards, and on supermarket shelves is a strong influence on a country's visual culture. As there was hardly anything to buy in the first place and there was certainly no competition, packaging design in East Germany was restricted to information regarding the properties of a product's contents. In the light of discussions designers are having today about restricting superfluous packaging to cut down waste, this might not have been such a bad thing. Be that as it may, the state-controlled economy

certainly created a very distinct East German style. Now that that style is only a memory, some of us are already feeling a sense a nostalgia for those austere, simple designs.

Trying to establish a national identity was a major goal of the East German government, suffering, as it was, from lack of proper recognition in the world. Becoming one of the world's top sporting nations was one way toward that goal, although today we know that these successes were largely achieved not only by subjecting athletes to rigorous training programs and rewarding them with privileges when they succeeded, but also by running an extensive operation to supply them with all manner of "performance enhancers."

TOP: *East German Canned Goods.* Photo: Erik Spiekermann, MetaDesign Plus, Berlin.

BOTTOM: *East German Printed Ephemera.* Photo: Erik Spiekermann, MetaDesign Plus, Berlin.

There were, however, some traditions in East Germany that the Communist administration was proud to follow. Before the Second World War, Leipzig had been the center of the German printing and publishing industry. The Leipzig book fair was the biggest of its kind, and everybody who was anybody in book design, typography, or printing technology had studied at the academy there. This tradition was continued by the new regime after the war, but the academy never adapted to our time. Modern technologies like photosetting and digital reproduction were hardly used in the GDR, making even the most recent years' books look like 1920s revivals. Almost everything was set in hot metal and printed letterpress, and artists could still afford to spend a week doing a wood engraving for a cover illustration. A book would take as much as five years in production. Once the text was available, a paper contingent had to be approved and ordered, which in itself might well take a few years. Typesetting also had to wait its turn until the state-owned printers got around to it. This leisurely production cycle allowed designers to indulge in detailed work on every page, something that has long been considered a luxury in the West, where designers may do the cover but where the actual pages of a book are done by typesetters to strict commercial standards—which usually means that they're done cheaply and quickly but not carefully.

The desire to look different from West Germany led to at least three design commissions that are worth looking into. The first one was the introduction of a new standard alphabet for road signs. Like everything else in Germany, road signs had always been regulated by DIN standards: the industrial norms that were introduced in the 1920s and by now covered all aspects of industrial and commercial activities. The prewar DIN typeface that had been used on road signs across the country was finally considered out of date in the West and was replaced by a slightly updated version in the seventies. Since the East Germans weren't part of the regulating body anymore, they had the chance to establish

217

Marx-Engels-Platz, East Berlin. Photo: Erik Spiekermann, MetaDesign Plus, Berlin.

their own standard. Instead of going for the constructed engineering look that their colleagues chose in the West, some brave designer recommended the use of Gill Bold, a typeface that was something of an institutional typeface on the British Isles until it was officially replaced there by the Transport alphabet in the late 1960s. It doesn't look German at all, which is not a bad thing, but it has certainly given the East German road signs a distinctive look. It will be interesting to see whether the replacement of this alphabet by the Western version will be noticed by anybody at all, although it will certainly change the look of most intersections and highways.

The other projects concerned the design of two typefaces, one specially done for the typesetting of telephone books, the other for East Germany's second television channel. (There were only two altogether). The main purpose for the telephone directory project—called Minima—was to save space and thus precious paper. The resulting typeface certainly saves space, but whether it is successful as a type design in its own right is very much a matter of opinion. Now that the telephone system has been taken over by West Germany's Telecom, which delegates the production of its directories to private publishers, Minima has already become obsolete.

The typeface for television is still being used by the new fourth channel, which was formed from the leftovers of East German state-owned TV and which now provides news and entertainment aimed at the five new states. Considering that it is an alphabet designed to appear on the TV screen, it looks very much like a classical book face in the Leipzig tradition, and it was, indeed, designed by one of East Germany's leading traditional graphic designers.

Walking down a street in East Berlin today, one can still see a difference from the streets in West Berlin, only a block away. The architecture is the same turn-of-the-century apartment blocks, but the street signs and, of course, the street furniture look different. Even though the cigarette manufacturers, insurance companies, gas companies, and particularly the automobile producers have been very quick and successful in attaching their logos and corporate slogans to every building, there are still plenty of graphics around to remind us of the fact that for forty years this was a different society with a distinct visual vocabulary.

What happens if you take away this identity? Once all those reminders will have

East German Storefront. Photo: Erik Spiekermann, MetaDesign Plus, Berlin.

been wiped out, it might be more difficult for people living in former East Germany to remember what it was like in the old days. Already there are voices expressing a longing for those days, when things weren't all that great, but predictable. Now that the shelves in the supermarkets are full of all those glossy, promising packages, some people miss the old simplicity. But that particular style is gone, as is the society that produced it.

219

Gill Bold Typeface, East German road signs. Photo: Erik Spiekermann, MetaDesign Plus, Berlin.

Critical Way Finding

ELLEN LUPTON AND J. ABBOTT MILLER

The pyramids of Egypt are mythic monuments to the origin of Western culture, from its architecture to its alphabet. These oversized tombstones have always fascinated the West; they are testaments that a human society could actually design something that could last for five millennia. At the edge of another millennium, a glass pyramid marks the entrance of a more modern form of tomb: an art museum in contemporary Paris. The grand concourse of the Louvre looks, sounds, smells, and feels like an airport or a hotel lobby or a department store. What reminds one that it's an art museum is the *Mona Lisa*—or rather backlit transparencies of the *Mona Lisa*—visible from across the broad hall in which visitors congregate.

What links the Louvre to other public spaces—aside from its stadium-capacity entry-way—is its use of pictorial symbols addressed to an international public. Such icons participate in a broader phenomenon in the cultural landscape: the emergence of a hieroglyphics of communication, which overlays the contemporary experience of cities, buildings, products, and media with a code of repeatable, reduced icons, compacted chunks of information that collapse a verbal message into a visual mark. The expanding domain of this hieroglyphic speech poses subtle problems for designers in the next millennium: how can we create cross-cultural communication without flattening difference beneath the homogenizing force of a single dialect?

Perhaps these dubious achievements are what makes graphic design the black sheep of the design family. Graphic design lacks the spatial drama or *presence* of architecture and product design. Architectural criticism often contrasts the plenitude of architectural form with the one-dimensionality of "sign," "communication," "illustration," "anecdote," and "information"—the very modes of expression that graphic design traffics in.[1]

Like an overeager, pimply-faced younger sibling, graphic design is what architecture never wants to be: namely, packaging, ornament, frame, and sign. Architecture says, "Experience, Space, Tactility, Drama, Eternity"... while graphic design says, "Can I help you? Do I look okay? Buy me, read me, eat me, drink me!"

Yet graphic design is a frame that makes spaces, places, and objects legible. Graphic design continually mediates contact with the environment. Signs, arrows, instructions, "you are here" maps, advertisements, and other kinds of information set up the conditions in which experience takes place. And this process of wayfinding—the term used by environmental graphic designers—is increasingly more visual than verbal. The semantic and visual reduction of international symbols—their concise generality—gives them their paradoxical status. They are simultaneously open and closed, vague and specific, ostensibly neutral and yet loaded with connotations and stylistic mannerisms.

Environmental signage is simultaneously there and not there—not really a "part of" the architecture, yet indispensable to its functions, its lived use. The signs that lead visitors to the *Mona Lisa* are like the frame around the painting: they direct attention to the object and yet are considered extrinsic to it. Graphic design—signage in particular—is largely a framing activity. Graphic design occupies the space *between* a product, building, or text and its user. Graphic design is the margins of a book, the buttons of a boom box, the friendliness of a computer interface, or the label wrapping a tin can.

In common usage, the term *graphic* describes a high-contrast image: black against white, white against black. The silhouette is the dominant strategy behind the language of international pictures, suggesting an objective shadow of material reality, a schematic index of fact. The ideal of an international picture language has been part of modernist design since the 1920s, and reached the intensity of an obsession during the 1960s and 1970s. Sign systems, such as the Department of Transportation's 1974 symbol set,

designed under the guidance of the American Institute of Graphic Arts, aspire to the semiotic consistency of a typeface.[2] The quest for uniform symbols for public information parallels the rise of coherent corporate identity programs and the emergence of an international consumer hieroglyphics.[3]

Such civic and commercial marks signal the challenges of cross-cultural communication in the next millennium. For as the globe is rendered increasingly accessible by communication technologies and forces of economic consolidation, it is at the same time segmented by diverse national, racial, and ethnic identities. Differences must be maintained to counter the domination of what Herbert Marcuse has called "one-dimensional man," whose culture has been robbed of ambivalence and negativity in favor of a mass media capable of assimilating, and thus neutralizing, any form of cultural difference or dissent.[4]

International communication carries the dangers of homogeneity and hegemony alongside the hopeful promise of an integrated global village lined with universally legible street signs and uniformly available products. Designers working at the edge of the millennium are faced with the conflicting imperatives to both expand and contract these formal languages: to reach a diverse public without succumbing to the dangers of assimilation. The one-world, one-language ideal of heroic modernism is an untenable solution for design in the next century.

TOP: Eastern European logos.

BOTTOM LEFT: Egyptian hieroglyphic eye.

BOTTOM RIGHT: *CBS "Eye" Logo.*
The CBS "Eye" logo is a registered trademark of CBS Inc. Used with permission.

The simultaneous expansion and contraction of markets for products and media has encouraged the compression of messages into more compacted units. Visual, verbal, and aural texts—transmitted through print, television, film, radio, computers, products, and exhibitions—are increasingly reduced to a code of repeatable icons, or what we call a hieroglyphics of communication. These hieroglyphics punctuate daily life with a pattern of generalized, repeatable signs or marks that signal ownership or information.

Historically, hieroglyphs occupy the space *between* pictures and writing; it is the passage connecting the concrete depiction of objects with the abstract, mechanical coding of the alphabet. The hieroglyph marks the clash between the soft, continuous, flowing substance of visual experience and the hard, polarized, digitized articulations of writing. The power of the phonetic alphabet, in contrast with the older forms of the ideogram, lay in its ability to ignore the "ideas" or "meaning" of a language and to represent only its material side—its sounds—disconnected from the objects and ideas that a language refers to. The alphabet, unlike the hieroglyphic, is blind; it is a neutral grid, an automated device capable of converting any word into a graphic mark, regardless of its referent.[5]

The alphabet claims to represent only the *outside* of a given language—its exterior envelope—rather than its interior content.[6] The hieroglyphic script is the checkpoint *between* the mechanical abstraction of the alphabet and the vivid particularity of the image. In hieroglyphics, the specificity of pictures embeds itself in the schematic abstraction of the typographic sign. Through repetition and conventionalization, the picture enters the realm of writing. The soft becomes hard, the fluid becomes fixed, the concrete becomes abstract. In between these two extremes stands the hieroglyph, a rebus that is both silent and spoken, a full-bodied depiction of an idea and a standardized abstraction.

Modern communication has returned to the transitional medium of hieroglyph writing. The logotype, the corporate symbol, and the international pictogram combine the generality of the typographic mark with the specificity of pictures. In corporate identity the image becomes the "personality" behind a mass-produced product, a sign of uniqueness stamped into an intrinsically multiple object. The fictional character Betty Crocker, for example, is regularly updated by her image managers, who have enabled her features

223

The Modernization of Betty Crocker, 1936–1980. General Mills.

to slowly evolve over the decades while keeping her identity—her status as a proprietary symbol—intact. She is at once naturalistic and schematic, changing and fixed, a rendered portrait and a conventionalized mark.

How does the return of the hieroglyph affect everyday life? Writers from diverse ideological positions have described ways in which the media that supposedly "record" events have come to play a central role in shaping those events—sometimes initiating the event in the first place. From Daniel Boorstin's "pseudo-event" to Jean Baudrillard's "simulacrum" to Stuart Ewen's "all consuming images," critics of culture have noted that representation has come to *inhabit* reality, not content to document it after the fact.[7] This by-now familiar critique has attacked network television, mass-market publishing, advertising, and Hollywood film for substituting an endless stream of superficial images for the lost fullness of experience.

This diaphanous veil of commercial imagery is punctuated with a pattern of hieroglyphics, signs that are neither strictly image nor text but occupy a middle ground between them. Such signs, whether generated in the name of private commerce or public information, are attempts to anchor or regulate the ongoing barrage of pictures and products. Like digital rocks in an analog stream, hieroglyphics guide the flow of communication by directing the interpretation of events, the consumption of goods, or the navigation of public spaces.

Baudrillard has critiqued the function of signs in contemporary media, arguing that they have organized reality into a reductive pattern of oppositions. Baudrillard describes how the symbolic plenitude of a concept is emptied when it becomes *instrumental*, when it is strictly coordinated against its semantic opposite. Baudrillard's example is the sun, which for nonindustrialized cultures is a concept approached with considerable ambivalence: it is a source of destruction as well as growth. To this he contrasts the vacation sun of the tourist economy, which is "a completely positive sun... source of happiness and euphoria, and as such... is significantly opposed to non-sun (rain, cold, bad weather)." The vacation sun results from a semiological reduction: the ambivalence of the sun is lost

LEFT: *Parody Pictograms,* published in *Print,* 1974, Henry Beard, David Kaestle, and Michael Gross, creators of *National Lampoon.*

RIGHT: DOT female/male pictogram.

when opposed to the idea of non-sun. This yes/no, on/off operation of the sign is what Baudrillard describes as "semiological organization": the process through which signs are given a cultural value.[8]

A comparable pattern of semiological difference governs the cultural boundaries of sexual identity, a phenomenon inadvertently expressed in the official U.S. Department of Transportation travel symbols. The difference between male and female bathrooms is signified by the addition of a cultural mark to the generic human form: the finlike extrusions representing the woman's dress. Rather than express the difference between male and female lavatories with an anatomical representation, as in the more sexually explicit signs proposed by *National Lampoon* in the mid-1970s, the DOT design committee stayed with the already conventional device of the finlike party dress.

The semiotic pattern male/female disappears in other signs in the DOT system, however, in which the male figure represents humanity in general, just as the word *man* becomes a generic title in many verbal contexts. The supposedly neutral pattern of linguistic oppositions breaks down in this particular sign, which happens to depict a service relationship between an employee and a consumer. The DOT sign system thus unwittingly brings home the fact that sexual relationships are determined not solely by biological fact but also by culture, customs, images, and structures of power.

The symbols used in commerce, information graphics, and environmental signage draw upon and reinforce dominant cultural ideas. With the rise of television journalism in the 1960s, pictograms became an important element of news graphics as symbolic logotypes for issues or events. In the television industry, such symbols are called

225

Drinking fountain for men. Escalator for men. Waiting room for men.
Trash can for men. Departure point for men. Female selling ticket to male figure.

"over-the-shoulders," referring to their ubiquitous location in the void behind a talking head. Over-the-shoulders draw upon a stock vocabulary of flags, maps, hearts, doves, and olive branches. Over-the-shoulders became visually more complex with the introduction of the Paint Box system in the 1980s; conceptually, however, they are virtually unchanged.

The idea of pictorial logos for news stories crossed over into print media in the late 1970s, when Nigel Holmes and Walter Bernard revamped *Time* to make it more competitive with television. Such logos continue to provide news events with a corporate identity. The 1970s also witnessed the renaissance of pictorial information graphics, or what Edward Tufte has called "chartoons," in which numbers are projected into entertainingly figurative scenarios.[9] A pictographic chart from *Time* showing an Arab "over a barrel" belies the supposed objectivity of journalistic statistics by resorting to caricature. The ethnic stereotype is itself a kind of hieroglyphic form, consisting of a set of conventionalized, exaggerated features.

The hieroglyph has also found its way into the verbal features of broadcast news. The ascendancy of the "sound byte" as the basic unit of News Speech reflects the media's increasing reliance on condensed chunks of information in favor of extended, linear discourse. The term *sound byte*

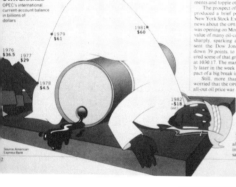

couples the immateriality of speech with the materiality of a product—a bite-sized portion, a compacted blip of information.

The replacement of linear discourse with visual and verbal hieroglyphs in the news media is exemplified by the newspaper *USA Today*, which favors illustrations over text and serves up its articles in TV-sized portions. *USA Today*'s "snapshot series" presents pictorial statistics on mass habits, supporting the publication's desire to be everybody's hometown paper by celebrating the uniformity of taste and canonizing the myth of a national consensus on such issues as how eggs should be prepared.[10] *USA Today* came of age in the 1980s, a decade that was also fascinated with bringing comic books to life. In films such as *Roger Rabbitt*, live-action cinema was merged with the flat, caricatured aesthetic of the cartoon, laying an opaque hieroglyphics over the depth of the filmic image.

The modernist ideal of the sharp, crisp graphic symbol is giving way to a logic that favors the folding of signs *into* experience. This softening of the edges between signs and reality reflects the ongoing conquest of the real by the abstract, the will to impose a legible pattern or symbol over the amorphous mass of experience. The grafting of hieroglyphic signs onto the fullness of experience—to bring the sign *to* life and *into* life—is seen in numerous advertising campaigns. Absolut projects its product silhouette into various settings with its endlessly transformed bottle, while other ads merge the corporate hieroglyph with naturalistic settings and live-action drama. Either we see living objects becoming signs, or we see corporate symbols acting as life-size elements in the landscape.

Architecture also increasingly participates in the phenomenon of the hieroglyph. Numerous office towers have come to function like graphic logos for a corporation, their silhouettes serving as massive commercial signs across the script of urban skylines, such as San Francisco's Transamerica pyramid or New York's Citicorp building.

The expansion of global advertising strategies has been another agent in the internationalization of the public landscape. Initiated in the mid-eighties by British firms such as Saatchi and Saatchi, global advertising relies on images and messages that function across diverse markets. An early example is a series of Coca-Cola ads called the Mean Joe Greene Series, which features American, Brazilian, Argentinean, and Thai sports stars, each giving a youngster a football jersey in gratitude for a Coke. Such "universal" narratives of heroism and identification are considered general and durable enough to cross cultural contexts. Global strategies increasingly preoccupy advertisers, who wish to control their worldwide identity centrally rather than entrust their marketing to local firms.

TOP LEFT: Nigel Holmes, *Over Their Own Barrel*, 1983.
Nigel Holmes, *Time*.

BOTTOM LEFT: Ben Blank, *"Over-the-Shoulder" Graphic*,
newscaster Harry Reasoner, mid-1960s. Photo: Ellen Lupton.

RIGHT: Chiat/Day/Mojo, *Rome Rooftops*, 1992.
Used with permission. American Express Travel Related Services Co., Inc.

The success of this centralization depends upon the pairing of sufficiently general messages with equally generic imagery. The production of a single ad to run across different national markets has created a demand for a new "everyperson"—or "everyconsumer"—a full-bodied, full-color corollary to the international man of airport signage. It has created a need for what a marketing director at Coca-Cola described as a "global teenager."

There is global media now, like MTV. And there is a global teenager. The same kid you see at the Ginza in Tokyo is in Piccadilly Square in London, in Pushkin Square, at Notre Dame.[11]

Of course, Coca-Cola and MTV have a vested interest in the concept of a universal teenager, although Tokyo, London, and Moscow hardly fulfill the definition of "globalness." Yet the projection of a globally consistent consumer—through advertising, marketing, and packaging—increasingly will inform the public representation of cultural identity.

For example, the international marketing of Frosted Flakes uses a young man whose racial, ethnic, and national identity are uncertain. His generic good looks allow him to function as a logotypical consumer in American, Latin American, and European contexts. Tony the Tiger presents another approach within global advertising: the cartoon mascot/spokesperson who escapes questions of cultural identity entirely. The cartoon/mascot is a speaking, acting logo—a proprietary beast of burden who is trademark and spokesperson rolled into one.

The economic and bureaucratic advantage of global campaigns is that advertisers can approach divergent audiences as a unified market, as in the United Colors of Benetton campaign. In contrast to Frosted Flakes, Benetton has constructed a global market not by blurring cultural difference but by *incorporating* cultural difference as its theme or trademark. While Frosted Flakes attempts to override racial and cultural specificity, the Benetton campaign makes a fashion statement about cultural difference.

The possibility of a "world culture" in the next millennium brings with it the same anxieties that attended the postwar uniformity of American culture. The loss of individuality and the sense of placelessness in American suburbia can be extrapolated to a worldwide context. Mass media, internationalized markets, and tourism suggest a future "world culture" of stunning sameness.

Internationalization, especially as expressed in the U.S. Department of Transportation symbols, has been viewed as a democratizing force that facilitates intercultural communication and contributes to an *ecology* of information through an economy of signs. What many instances of internationalization show, however, is a hegemonic relationship between the officially sanctioned "language of internationalism" and the specific cultural contexts they inhabit. The sign for "women's toilet" in a Saudi Arabian university has been modified by the addition of the silhouette of a veil, since the long dress depicted could just as easily signify the traditional robes worn by Muslim men. The use of

RIGHT: Graphic from Otto Neurath's *Modern Man in the Making*, 1939.

pictorial symbols is, in itself, problematic for Muslim religious codes, which discourage representations of the body.

Consider also the poorly conceived sign that has been used on San Diego freeways to alert drivers to Mexican immigrants who run across the freeway trying to avoid the customs checkpoints. The image of the family in that sign was interpreted by Spanish-speaking people as a directive to "cross here." Thus the very audience most in danger was misled by a sign directed at drivers rather than pedestrians.

Modern hieroglyphs crystallize through simplification and repetition: by offering schematic icons for film genres, news events, or corporate messages, the hieroglyph visually categorizes experience into tidy packages, often reducing it to a flattened cliché. One of the chief functions of graphic design is to generate such tidy icons. But are designers only in the business of purveying dominant ideologies and pandering to the reduced attention spans of contemporary audiences? Could the code of repetitive symbols and schemes that provides the bulk of our visual diet be used for something more than passive instruction or the caricature of complex ideas into univocal statements? If graphic design provides an interface between people and products, could it not also provide an interface between people and culture? We call this utopian project for design in the next millennium "critical wayfinding," or the construction of interfaces that serve not to package corporate messages but rather to provide alternate routes of access to media and information.

For example, one of the chief inventors of international pictograms was Otto Neurath, a Viennese philosopher and social scientist who pioneered the use of pictorial symbols in the 1920s and 1930s as a means of public, cross-cultural education. Although his pictograms are remembered now as the ubiquitous signage found in train stations, airports, and art museums, in his own lifetime he used them to display social statistics in a visually accessible way.

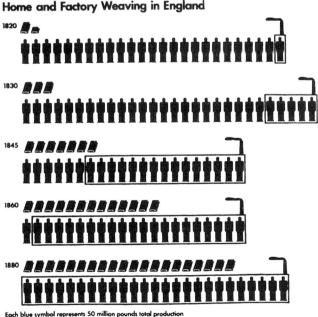

Home and Factory Weaving in England

Each blue symbol represents 50 million pounds total production
Each black man symbol represents 10,000 home weavers
Each red man symbol represents 10,000 factory weavers

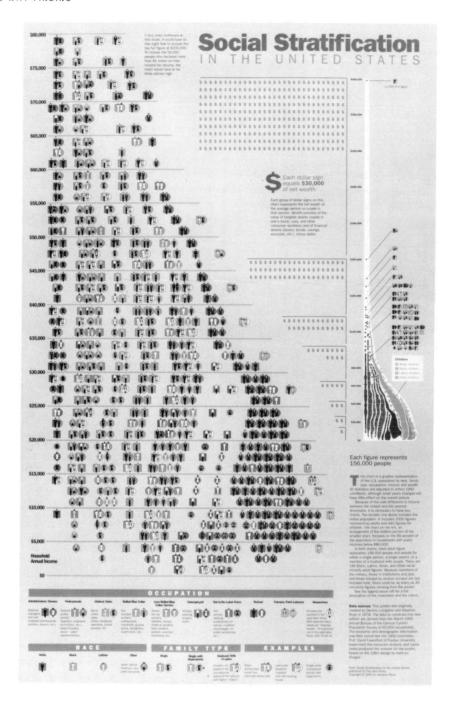

Social Stratification Chart, originally created by Dennis Livingston and Stephan Rose.
This version by Laura Lewis based on the 1983 design by Kathryn Shagas,
published by The New Press, 1992.

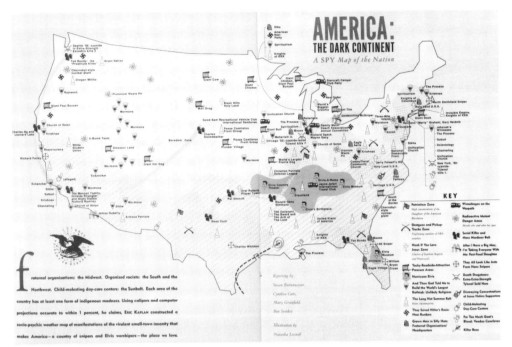

Designers working in the critical spirit of Otto Neurath today include Dennis Livingston, a Baltimore-based activist designer who uses pictorial symbols to track distribution of wealth across the categories of race, sex, profession, and family organization. His chart of "Social Stratification" allows readers to see vertical paths running upward through the economic heap, expressing the fact that for many people social identity is formed more by profession (e.g., office work vs. factory work) than by income.

A billboard-sized poster created by Michael Lebron, a New York-based artist and designer, uses the language of advertising and information design to compare the amount of money spent preventing terrorist attacks on international airplane travel to the amount of money spent preventing the death of poor children across the globe. A 1988 billboard designed by Sheila de Bretteville and the Brooklyn 7 entitled "Can-U-Read-Me?" uses a combination of pictures, letters, and symbols to encourage people to learn to read. By showing nonreaders how much they already know just by living in a literate culture, this hieroglyphic billboard helps to demystify literacy and thus make it more accessible.

In a more comic vein, the designers of Spy magazine in the 1980s created a mode of information graphics that derails the intellectual paternalism of mainstream news media and explores instead the messy subconscious of the information age. The tongue-in-cheek yet meticulously archival style of Spy's news graphics, invented by Stephen Doyle and Alex Isley in the mid-eighties, is an example of design that works within yet against the dominant codes of the media.

These examples, taken from both the context of activist design and the commercial media, indicate some paths that designers could pursue at the edge of the millennium.

231

America: The Dark Continent, created for Spy, June 1988,
Alexander Isley, art director, and Natasha Lessnik, illustrator. Alexander Isely, Spy.

Graphic design, as the interface between people and products, information, and environments, has the potential to interpret, revise, and critique the world as well as to simplify and condense it. The notion that design should be transparent, and that we are simply legibility and problem solvers, offers a recessive and reactive role for design that is ultimately disempowering.

1 Kenneth Frampton questions the legitimacy of "communication" as an architectural value in his essay "Critical Regionalism: Six Points for an Architecture of Resistance," in *Anti-Aesthetic: Essays on Post-Modern Culture,* ed. Hal Foster (Port Townsend, Wash.: Bay Press, 1983), pp. 16–30.

2 On the history and theory of international pictograms, see Ellen Lupton, "Reading Isotype," in *Design Discourse: History, Theory, Criticism,* ed. Victor Margolin (Chicago: University of Chicago Press, 1989).

3 On corporate identity, see Maud Lavin, "Design in the Service of Commerce," in *Graphic Design in America: A Visual Language History,* ed. Mildred Friedman (Minneapolis and New York: Walker Art Center and Harry N. Abrams, 1989), pp. 126–143.

4 Herbert Marcuse, *One-Dimensional Man* (Boston: Beacon Press, 1964).

5 I. J. Gelb, *A Study of Writing* (Chicago: University of Chicago Press, 1952).

6 Jacques Derrida, *Of Grammatology* (Baltimore: Johns Hopkins University Press, 1974), pp. 30–44.

7 Daniel J. Boorstin, *The Image: A Guide to Psuedo-Events in America* (New York: Atheneum, 1971); Jean Baudrillard, *Simulations* (New York: Semiotext(e), 1983); Stuart Ewen, *All Consuming Images: The Politics of Style in Contemporary Culture* (New York: Basic Books, 1988).

8 Jean Baudrillard, "Fetishism and Ideology: The Semiological Reduction," in *For a Critique of the Political Economy of the Sign* (St. Louis: Telos Press, 1981), pp. 88–101.

9 Edward Tufte, *Envisioning Information* (Cheshire, Conn.: Graphics Press, 1990).

10 J. Abbott Miller, "USA Today: Learning from Las Vegas," *Print* 44:6 (December 1991), pp. 90–97.

11 Peter S. Sealey, Senior Vice President and Director of Global Marketing for Coca-Cola, quoted in *The New York Times* (November 18, 1991).

232

RIGHT: Lee Friedlander, *Washington, D.C.,* 1962. Copyright Lee Friedlander.
Photo courtesy of Laurence Miller Gallery, New York.

VR The World

MICHAEL SORKIN

O n Christmas Eve 1990, Walter Hudson died. At the time of his death he weighed 1,125 pounds, slightly down from the 1,200-1,400 pounds (he kept breaking scales, the exact figure is unknown) that established his Guinness certified record as the world's fattest man. Indeed, Hudson had grown so large, a section of the wall of his house had to be torn down and a forklift brought in to remove his body. His enormous coffin was towed *behind* a hearse to the cemetery where he was buried in a double plot.

Walter Hudson is, for me, the paradigmatic millennial man, ideal subject for the post-electronic age. His quintessence, however, lies not in his bulk but in his immobility: except for a tragically brief period of slimming, Hudson was unable to leave his house. Indeed, for years he was unable even to leave his bed. He was sustained by surrounding himself with an *existenzminimum* of contemporary personhood: flanking his specially constructed bed were refrigerator and toilet, computer and television set.

His bulk, however, is not entirely irrelevant to his exemplary condition. To be sure, it was the medium of his immobility. But it was also the reason for his celebrity, for his visibility. Hudson is so superb an emblem for our current condition because he's so transitional, simultaneously evoking both old and new strategies of visuality. On the one hand, his baroque corpulence—his achievement, the nominal reason for his celebrity—speaks of historic routines of spatiality. Hudson's distinction was, after all, to occupy more space at a given moment than anyone in history.

But if his initiating condition was to apotheosize an antique, volumetric condition of space, a rhapsodization of excess, his celebrity came via a new, televisual condition of spatiality. We knew Walter Hudson via his endless presence on the evening news as he battled his bulk, ran his business (couture for big gals), and strove to survive. He was a citizen of that virtual world of images that is coming to so

dominate consciousness with its infinite, recombinant, mendacious mobility. Hudson's heft always argued for his previrtuality, but his mobility was entirely virtual. When Hudson entered a million living rooms at seven o'clock around the globe, he entered via TV because that was precisely the only way he could get in.

I sincerely believe that we are among the last generations that will enjoy or suffer (depending on your point of view) nonvirtual subjectivity. More, I believe that this divide between an artificial, electronically or chemically conjured reality and that which is more directly apprehended by the senses is the dominant issue that we confront as designers. The postmillennial struggle will surely be about space and autonomy, about the politics of limit to mind and—more relevantly—body. If the virtual reality jockeys are able to conjure sensations of physicality that are either indistinguishable from or better than the quotidian version, it may be time to move along, to chill out, to fire up the CAD and design the fleshy ergonomic toggles to switch the Holo to VR mode.

The site for all of this—at least in the near term—is likely to be the seam between virtuality and physicality. A vast discourse of the prosthetics of translation is already arising, yielding a class of objects that bridge between the aspatial, nondimensional world of virtual space and the body-bound world of antique reality. These will range from stereoptic laser scanning glasses able to beam virtual images straight onto the retina, to a myriad of stimulating implants, to a million shrinking appliances bringing numberless images into our shrinking homes. Already children learn to hold the TV remote before a fork.

A totemic current example of this site is the cash machine, a primitive translation

234

Julia Scher, *Security by Julia II, Dark Rooms,* 1989.
Artists Space. Photo: Peter McClennan.

device bridging material and ethereal realms. The existence of these machines is predicated, obviously, on the need for cash, on our condition of not-quite-readiness to relinquish the reliability and palpability of paper notes to a more completely abstracted, electronic relationship to money. Here is also architecture degree, let us say, .001. In its minimal way, the cash machine links this transaction with the electronic beyond to a tiny ordering of actual space.

At one level the cash machine is simply a piece of automation, another displacement of a formerly human interaction by a machine. It colonizes a piece of human territory—the teller-customer transaction—for the mechanical, eliminating a small, if sometimes annoying, ritual from the texture of civil society. However, perhaps more important than the ritual it removes is the one that replaces it.

In ancient Egypt gateways to the afterlife were included in funerary architecture, depicted as narrow stone slits. The cash machine is also such a portal, a point of entry into the virtual, electronic, global city. Activated by the insertion of a plastic "identity" card into a slim orifice, the citizen attempts to "log on" to the system. This is a moment of great tension, the pause as the invisible police test you, examine your account, decide whether or not to let you have what you want. It's the primal test of citizenship in the new world order; the only requirements are a balance and a number.

In many cities certain nonelectronic realities intrude on this transaction. For security's sake (increasingly architecture and design's most absolute rationale), cash machines are often located in glazed antechambers to bank branches—places, in theory, of adequate public visibility to deter robberies on the spot. To be admitted, one sticks one's card in an external slot, the computer runs a check, and an automatic door buzzes you in. To penetrate this first circle of security, low-level qualifications are adequate; one merely needs a card, not a balance. In practice, though, no card is necessary to get in. At most banks in New York City, homeless people are stationed at these doors, opening and closing them in circumvention of the security system, cups in hand, self-designated door persons.

The scene is in many ways a perfect rendering of the degeneration of the physical space of public activity in the millennial, postelectronic city. Efficiently, it deploys a compact apparatus of privilege, ranging from the untouchable at the door, demeaning himself or herself in the hopes of some trickle-down from those admitted to the inner circle, to the brahmins secure in their secret code numbers and reliable balances, Reaganism made flesh. What they share, though, is not simply the meanly designed physical environment of the little cash piazza; all participate in a culture in which surveillance substitutes for public space.

It is a deep irony of this essentially paranoid condition that the most enfranchised members of this electronic public are those willing to submit to the most draconian forms of observation. To fully participate in the electronic city is to have virtually all of one's activities recorded, correlated, and made available to an enormous invisible government of shadowy credit agencies, back-office computer banks, and endless media connections.

To exist in the public realm in the electronic system means to be wired in. The ultimate consequence is that the body, the person, no longer simply exists *in* public space but actually becomes it.

As with the cash machine's bridging position along the seam between physical object and immaterial network, the intermediate character of the present is reflected, again ironically, in the vast increase in mobility that the global citizenship is currently experiencing. For the moment we are obsessed with an old, Newtonian vision of mobility. Status among multinational mental proletarians such as ourselves is calculated in frequent flier miles. But the global corridor is also a direct physical analogue to the space of virtuality, a vast territory of diminished expectations. It is increasingly everywhere the same. And it is also a condition of intense surveillability. The endless credit card transactions, security checks, car reservations, seat assignments, and special meals speak of a condition in which one's position is constantly fixed. Over a billion people pass through this system annually.

In the end, though, literal mobility matters almost not at all. In a world of exponential population growth, we are constantly receiving (mixed) signals to take up less space. Keep your cigarette smoke out of my eyes, become an anorexic, sit still, and check out what's on channel 902 tonight. Here's the message: I believe we are all at risk of becoming so many Walter Hudsons, well-wired lumps of protoplasm, free to enjoy our virtual pleasures, mind-moving and disembodied, unable to get out of bed. Designers must decide how complicit they wish to be with this.

On the other hand, though, there are lots of mornings when not getting out of bed seems like a pretty appealing alternative to me.

Walter Hudson had no choice.

Portions of this essay were printed in *I.D.* magazine under the title "The Electronic City," May/June 1992.

Nam June Paik, *TV Buddha Installation at the Whitney Museum of American Art,* 1983. Holly Solomon Gallery, New York. Photo: Eric Kroll.

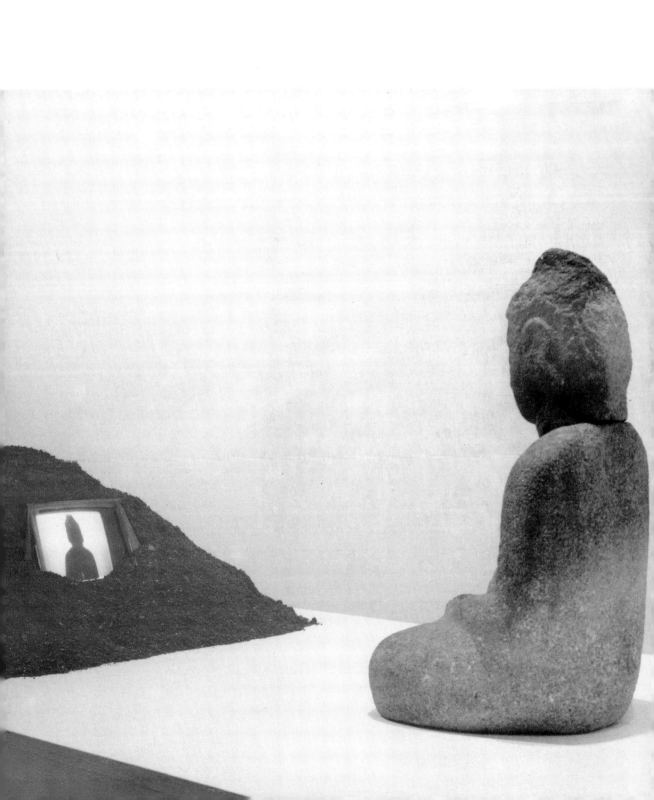

Afterword: Sonnets to Orpheus, #24

This delight, always fresh, in the loosening of soil!
The earliest risk-takers—almost no one helped them.
But cities rose up by blissful gulfs all the same,
pitchers filled, all the same, with water, with oil.

Gods—first we sketch them in daring designs
that surly Fate tears up for us again.
But they are immortals. Look, we can
hear those out who will hear us at the end.

We're thousand-year generations: mothers and fathers,
filled more and more with the child of the future
so that someday, climbing over, it can convulse us.

We're the endlessly risked ones; what time-spans are ours!
And only tight-lipped Death knows what we really are
and what he always gets from the way he lends us.

Rainer Maria Rilke [1]

1 Rainer Maria Rilke, *Sonnets to Orpheus, Second Part #24*,
trans. David Young (Middletown, Conn.: Wesleyan University Press, 1987).

LEFT: John Hejduk, *"Asylum" from Bovisa: A Work by John Hejduk*, c. 1982.
Collection Centre Canadien d'Architecture/Canadian Centre for Architecture, Montréal.
Copyright John Hejduk.

Selected Readings

Aldersey-Williams, Hugh. *World Design: Nationalism and Globalism in Design*.
New York: Rizzoli International Publications, 1992.

Amis, Martin. *London Fields*. New York: Random House, 1991.

Attali, Jacques. *Millennium: Winners and Losers in the Coming World Order*.
New York: Random House, 1991.

Balfour Alan. *Berlin: Politics of Order 1737–1989*. New York: Rizzoli International
Publications, 1990.

Barkun, Michael. *Crucible of the Millennium: The Burned-over District of New York in the 1840's*.
Syracuse, NY: Syracuse University Press, 1986.

———. *Disaster and the Millennium*. New Haven, CT: Yale University Press, 1974.

Benedikt, Michael, ed. *Cyperspace: First Steps*. Cambridge: MIT Press, 1993.

Blanchot, Maurice. *Death Sentence*. New York: Penguin, 1978.

———. *The Unavowable Community*. Barrytown, NY: Station Hill Press, 1988.

Bloom, Harold. *Ruin the Sacred Truths*. Cambridge: Harvard University Press, 1989.

Branzi, Andrea. *Domestic Animals*. Cambridge: MIT Press, 1987.

———. *The Hot House*. Cambridge: MIT Press, 1984.

———. *Learning from Milan: Design and the Second Modernity*. Cambridge: MIT Press, 1988.

———. *Luoghi*. New York: Rizzoli International Publications, 1992.

Calvino, Italo. *Invisible Cities*. New York: Harcourt Brace Jovanovich, 1974.

———. *Six Memos for the Next Millennium*. Cambridge: Harvard University Press, 1990.

Cohn, Norman. *The Pursuit of the Millennium*. Oxford: Oxford University Press, 1970.

Davis, Michael. *City of Quartz*. New York: Verso, 1991.

Dormer, Peter. *The Meanings of Modern Design: Toward the Twenty-First Century.*
London: Thames and Hudson, 1990.

Eco, Umberto. *Travels in Hyperreality.* New York: Harcourt Brace Jovanovich, 1983.

Entrikin, J. Nicholas. *The Betweenness of Place: Towards a Modern Geography.*
Baltimore: Johns Hopkins University Press, 1991.

Friedman, Mildred, ed. *Tokyo: Form and Spirit.* New York: Harry N. Abrams, 1986.

——, and Joseph Giovannini, eds. *Graphic Design in America: A Visual Language History.*
New York: Harry N. Abrams, 1989.

Garreau, Joel. *Edge City: Life on the New Frontier.* New York: Doubleday, 1991.

Gibson, William. *Count Zero.* New York: Arbor House, 1986.

——. *Mona Lisa Overdrive.* New York: Bantam Books, 1989.

——. *Neuromancer.* New York: Ace Books, 1984.

Halley, Peter. *Collected Essays 1981–87.* Zurich: Bruno Bischofberger, 1988.

Hayden, Delores. *Seven American Utopias: The Architecture of Communitarian Socialism
1790–1975.* Cambridge: MIT Press, 1976.

Heilbroner, Robert. *An Inquiry into the Human Prospect.* New York: W.W. Norton, 1974.

Hejduk, John. *Mask of Medusa.* New York: Rizzoli International Publications, 1985.

——. *The Victims.* London: Architectural Association, 1986.

Hiss, Tony. *The Experience of Place.* New York: Alfred A. Knopf, 1990.

Kennedy, Paul. *Preparing for the 21st Century.* New York: Random House, 1992.

Lasch, Christopher. *The True and Only Heaven: Progress and Its Critics.* New York:
W.W. Norton, 1991.

Lupton, Ellen, and J. Abbott Miller. *The Bathroom, the Kitchen, and the Aesthetics of Waste: A
Process of Elimination.* New York: Princeton Architectural Press, 1992.

Margolin, Victor, ed. *Design Discourse.* Chicago: University of Chicago Press, 1989.

McClung, William. *The Architecture of Paradise: Survival of Eden and Jerusalem.*
Berkeley: University of California Press, 1983.

McCoy, Michael, and Katherine McCoy. *Cranbrook Design: The New Discourse.*
New York: Rizzoli International Publications, 1990.

Miller, Alice. *The Drama of the Gifted Child.* New York: Farrar, Straus, and Giroux, 1981.

242

Moltmann, Jürgen. *Theology of Hope*. New York: Harper and Row, 1976.

Mumford, Lewis. *The City in History*. New York: Harcourt Brace Jovanovich, 1968.

Norman, Donald A. *The Design of Everyday Things*. New York: Doubleday/Currency, 1988.

Orville, Miles. *The Real Thing: Imitation and Authenticity in American Culture, 1880–1940*. Chapel Hill: University of North Carolina Press, 1989.

Postman, Neil. *Technopoly: The Surrender of Culture to Technology*. New York: Alfred A. Knopf, 1992.

Reich, Robert B. *The Work of Nations: Preparing Ourselves for 21st Century Capitalism*. New York: Alfred A. Knopf, 1991.

Ronell, Avital. *The Telephone Book: Technology, Schizophrenia, Electric Speech*. Lincoln: University of Nebraska Press, 1989.

Rossi, Aldo. *The Architecture of the City*. Cambridge: MIT Press, 1982.

Rowe, Colin, and Fred Koetter. *Collage City*. Cambridge: MIT Press, 1978.

Schwartz, Hillel. *Century's End: A Cultural History of Fin de Siècle from the 990's through the 1990's*. New York: Doubleday, 1990.

Sennett, Richard. *The Conscience of the Eye*. New York: Alfred A. Knopf, 1990.

Sorkin, Michael. *The Exquisite Corpse*. New York: Verso, 1991.

——, ed. *Variations on a Theme Park: The New American City and the End of Public Space*. New York: Hill and Wang, 1992.

Sterling, Bruce. *Mirrorshades*. New York: Ace Books, 1986.

——, and William Gibson. *The Difference Engine*. New York: Bantam Books, 1991.

Tafuri, Manfredo. *Architecture and Utopia: Design and Capitulated Development*. Cambridge: MIT Press, 1976.

Thackara, John, ed. *Design after Modernism, Beyond the Object*. London: Thames and Hudson, 1988.

Tigerman, Stanley. *Architecture of Exile*. New York: Rizzoli International Publications, 1991.

Toulmin, Stephen. *Cosmopolis*. New York: Free Press, 1990.

Treib, Marc. "Reading The City: Maps, Signs, Space in Japan," *Idea*, Japan, 1979.

Vidler, Anthony. *The Architectural Uncanny: Essays in the Modern Unhomely*. Cambridge: MIT Press, 1992.

Wallis, Brian, ed. *Art After Modernism: Rethinking Representation*. Boston: D.R. Godine/
New Museum of Contemporary Art, 1984.

Walter, Eugene Victor. *Placeways: A Theory of the Human Environment*.
Chapel Hill: University of North Carolina Press, 1991.

Watkin, D. *Morality and Architecture*. Oxford: Clarendon Press, 1977.

Watzlawick, Paul, ed. *The Invented Reality, How Do We Know What We Believe We Know?:
Contributions to Constructivism*. New York: W.W. Norton, 1984.

Weber, Timothy. *Living in the Shadow of the Second Coming: American Pre-millennialism
(1875–1982)*. Chicago: Academic Books, 1983.

Werkmeister, O. K. *Citadel Culture*. Chicago: University of Chicago Press, 1989.

Wilson, Elizabeth. *The Sphinx in the City: Urban Life and the Control of Disorder and Women*.
Los Angeles: University of California Press, 1991.

Contributors

Hugh Aldersey-Williams Author and design journalist. Aldersey-Williams lives and works in London. His most recent book, *World Design: Nationalism and Globalism in Design* (1992), explores designers' increasing interest in the resurgence of national cultural identities in the midst of the globalization of commercial design. Aldersey-Williams has also written *New American Design* (1988) and contributed an essay to Michael and Katherine McCoy's *Cranbrook Design: The New Discourse* (1990). Aldersey-Williams is the European Editor for *International Design* and Contributing Editor for Blueprint. His articles have appeared in *Architectural Record*, *Business Week*, *Graphis*, and *High Technology*. He is currently at work on a book describing the recent surprise discovery of a molecular form of carbon known as buckminsterfullerene or "bucky ball."

Alan Balfour Director, Architectural Association, London, and former Smith Professor and Dean of the School of Architecture, Rice University. Previously associated with Arthur D. Little, Inc., of Cambridge, Massachusetts, where his work ranged from issues of national urban policy to studies on the social and economic impact of new technologies. Taught at Massachusetts Institute of Technology and was editor of the *Architectural Education Study* (1981). Directed the graduate and undergraduate programs in architecture at the Georgia Institute of Technology. Major publications include *Portsmouth* (1970), *Rockefeller Center: Architecture as Theater* (1978), and *Berlin: Politics of Order 1737–1989* (1990). Currently sits on the boards of the Rice Design Alliance and the architectural periodical *Cite*.

Michael Barkun Professor of Political Science, Maxwell School of Citizenship and Public Affairs, Syracuse University. Author of *Crucible of the Millennium: The Burned-over District of New York in the 1840's* (1980), *Disaster and the Millennium* (1986), and *Law Without Sanctions* (1968), among others. He is the Editor of *Communal Societies*, the Journal of the Communal Studies Association (1986 to present), and a frequent contributor to a wide range of scholarly journals such as *American Studies; Terrorism and Political Violence; Religion, Alternative Futures: The Journal of Utopian Studies; The Journal of Sex Research;* and *Mass Emergencies*. Professor Barkun is a member of the Board of Directors of the Communal Studies Association; his honors include a Senior Fellowship with the National Endowment for the Humanities (1974–75) and a Faculty Fellow in Political Science, Ford Foundation (1970–71).

Peg Elizabeth Birmingham Professor of Philosophy, DePaul University. Formerly Edward J. Mortola Scholar, Department of Philosophy, Pace University. Birmingham has also taught at Marist College, Point Park College, and Duquesne University. Recipient of a 1988–89 National Endowment for the Humanities grant to study "Ethos: Ethics and the Question of Place." Has published articles in *Graduate Faculty Journal of Philosophy*, New School for Social Research; *Research and Phenomenology*; and *Phenomenology and Social Sciences*.

Rosemarie Haag Bletter Architectural historian. Professor in the Department of Art and Professor and Coordinator Interdisciplinary Program in Modern German Studies at City University of New York, Graduate Center. Formerly affiliated with Rutgers University; the Institute of Fine Arts, New York University; Barnard College; Columbia University; and Yale University. Her books include *Skyscraper Style—Art Deco New York* (co-authored with Cervin Robinson, 1975), *El Arquitecto Joseph Vilaseca i Casanovas—Suas Obras v Dibuios* (1977), and *Venturi Rauch and Scott Brown: A Generation of Architecture* text, Krannert Art Museum (1984). She curated the exhibition "Skyscraper Style" at the Brooklyn Museum (1975) and guest curated the 1930–45 section of "High Styles—Twentieth Century American Design" for the Whitney Museum of American Art (1985–86). With Martin Filler, Professor Bletter consulted on three films by Blackwood Productions: *Beyond Utopia* (1983), *The Architecture of Arata Isosaki* (1985), and *James Stirling* (1987). She is a former Director of the Society of Architectural Historians, a frequent juror, a prolific writer, and an active lecturer in the field of architectural history.

Constantin Boym Principal of the multidisciplinary Boym Design Studio in New York. Boym was born in Moscow and received his training at the Moscow Architectural Institute and Domus Academy in Milan. He has designed furniture and products for Acerbis, Brickel, Details, Formica Corporation, and other corporations, and his objects are included in the permanent collections of Cooper-Hewitt, National Museum of Design in New York and Musée des Arts Décoratifs in Montréal. Currently Boym also serves as coordinator for the Product Design Department at Parsons School of Design. He is the author of *New Russian Design* (1992).

Andrea Branzi Architect and designer, Vice President and founder of Domus Academy, Milan, Italy. Until 1974, a member of Archizoom Associati. Since 1972, besides architectural planning, Branzi has been concerned with the theoretical problems of Nuovo Design. General coordinator of the International Section of Design at the XV Triennale of Milan, he participated with personal exhibitions at XIV, XVI, and XVII Triennale; he took part in the Venice Biennale in 1976, 1978, and 1980. His work has been exhibited in museums throughout the world, most recently at the Musée des Arts Décoratifs in Montréal. Among numerous other design awards, he was a recipient of the Compasso d'Oro in 1979 and 1987. A prolific writer, Branzi edited the book *Il Design Italiano Degli Anni '50*, which was based on the exhibition of the same name. An anthology of his theoretical writings was published in 1980 entitled *Moderno, Post-moderno, Millenario*. His more recent books include *The Hot House* (1984), *Domestic Animals* (1987), *Learning from Milan: Design and the Second Modernity* (1988), and *Luoghi* (1992). As a journalist he collaborates with the leading Italian and foreign magazines. A highly influential teacher, he

has lectured in Italy, France, Holland, England, the U.S., Canada, Japan, Argentina, and Brazil as a visiting professor at major universities. Recent design projects include a meta-project for Mitsubishi for a large settlement in the Bay of Tokyo, a pavilion for the Greenery Expo Osaka '90, the planning of the Cemetery of Carpi in Modena, and the formation and direction of a planning group for the municipality of Arezzo.

John Seely Brown Corporate Vice President and Chief Scientist of Xerox Corporation and Director of its Palo Alto Research Center. Dr. Brown's research interests include artificial intelligence, cognitive science, and organizational learning and work activity. He has published more than fifty articles in professional journals, co-authored two books, and lectured worldwide on topics ranging from artificial intelligence to organizational design. He is co-founder of the Institute for Research on Learning, a nonprofit institute dedicated to studies of lifelong learning. He has served on numerous editorial boards of professional journals, scientific advisory boards, and boards of directors, and has often been called to give congressional testimony. Dr. Brown is a Fellow of the American Association for Artificial Intelligence and member of the National Academy of Education.

Peter Cook Principal, Cook and Hawley, London. Founder of Archigram; in practice with Christine Hawley since 1977. Author of several visionary projects such as "Plug-in City," "Instant City," and "Arcadia," among others. Prizes include 1988 AIA Los Angeles Prize and Graham Foundation Award. Built projects include housing in Berlin, folly in Osaka, and exhibition structures. Guest professor at UCLA, Southern California Institute of Architecture, and Oslo; member of the faculty of the Architectural Association, London, for twenty-four years. Currently Bartlett Professor of Architecture and Head of Architecture at the Bartlett School, University College, London; Professor of Architecture at the Hbk Frankfurt.

Paul Duguid Independent writer and researcher. Duguid currently holds consultant research positions at the University of California, Berkeley, and at the Xerox Palo Alto Research Center.

Christine Hawley Principal, Cook and Hawley, London. In practice with Peter Cook since 1977. Has worked previously on hospitals, underwater structures, and housing research. Prizes in several German and Japanese competitions. Built projects include housing in Berlin, folly in Osaka, and exhibition structures. Guest Professor at Perth (Australia), Oslo, Nebraska, and Southern California Institute of Architecture. Taught for ten years at the Architectural Association, London, until appointed to her present post: Head of the School of Architecture, Polytechnic of East London (being the first female head in the United Kingdom).

John Hejduk Architect and educator living and working in New York City. Since 1975, Dean of The Irwin S. Chanin School of Architecture, The Cooper Union School for the Advancement of Science and Art, where he has taught since 1964. Fellow of the American Institute of Architects and the Royal Society of Arts. His work has been exhibited in New York, London, Amsterdam, Paris, Tokyo, Athens, Milan, Oslo, and Berlin. Hejduk received a Brunner Grant from the New York Chapter AIA (1980); a Design Arts Fellowship from the NEA (1983); the

Arnold W. Brunner Memorial Prize from the American Academy and Institute of Arts and Letters (1986); the Association of Collegiate Schools of Architecture/AIA Topaz Medallion for Excellence in Architecture Education and the New York Chapter/AIA Medal of Honor for Distinction in the Profession (1988); the Creative Arts Award Medal in Architecture from Brandeis University (1989); and an Honor Award from the AIA (1990). He is the author of five books: *Mask of Medusa* (1985), *Victims* (1986), *Bovisa* (1987), *Collapse of Time* (1987), and *Vladivostok* (1989). Structures from his projects have been built at the Gropius Bau (Berlin), the Architectural Association (London), the University of the Arts (Philadelphia), the Oslo School of Architecture (Norway), the Georgia Institute of Technology (Atlanta), and Prague Castle (Czech Republic). Buildings from Hejduk's award-winning projects have been constructed in Berlin under the auspices of the Internationale Bauausstellung Berlin. His work was exhibited at Cooper-Hewitt, National Museum of Design, Smithsonian Institution in "A Memorial to Jan Palach" (1993).

Karrie Jacobs Journalist and critic known for editing and developing unconventional and unusual magazines and for writing design criticism that goes beyond aesthetic issues to address the broader cultural and social implications of graphics, products, and architecture. Associated with *Metropolis*, the New York-based architecture and design magazine, since 1987; her criticism has also appeared in *I.D.*, the British publications *Eye* and *Blueprint*, the Swedish journal *MAMA*, as well as *Mirabella*, *The New York Times*, and *Interview*. Until 1993 Jacobs was Executive Editor of *Colors*, an international magazine about cultural diversity published by Benetton, which she helped found. Co-author with Steven Heller of *Angry Graphics: Protest Posters in the Reagan/Bush Era* (1992). A frequent lecturer at design conferences, including the Stanford Design Conference (1989), the American Institute of Graphic Arts national conference (1989), and the annual "Modernism and Eclecticism" symposium sponsored by the School of Visual Arts (1990, 1992).

John Kaliski Principal Architect for the Community Redevelopment Agency (CRA) of the City of Los Angeles. Oversees the Redevelopment Agency's efforts in urban design, architectural review, and historic preservation, and the planning and design aspects of the agency's Citywide Housing Program. Before joining CRA, he was senior designer at Skidmore Owings and Merrill in Los Angeles and Houston, where he also taught urban design theory, history, and studio at the University of Houston College of Architecture. Kaliski's writings on architecture and cities have appeared in journals and magazines, including *Cite*, *Los Angeles Architect*, *Texas Architect*, and *Harper's*. He currently teaches courses on myth and literature in Los Angeles and theory of urban design at the Southern California Institute of Architecture.

Tibor Kalman Principal, M&Co., a multidisciplinary design firm with clients ranging from Knoll International to Talking Heads to Chiat/Day. Kalman was born in Hungary in 1949 and emigrated to the U.S. in 1956. After studying journalism and working as Creative Director for Barnes & Noble, he established M&Co. in 1979. His design work is included in the permanent design collection of the Museum of Modern Art. He was the producer of *(Nothing but) Flowers* for

Talking Heads, which was accepted by the New York Film Festival and received an MTV Breakthrough Award in 1988. As of 1990, Creative Director for *Interview* magazine. Directed his first television commercial for Wieden and Kennedy. He is the Editor-in-Chief of *Colors*, a magazine published by Benetton.

Ellen Lupton Curator of Contemporary Design at Cooper-Hewitt, National Museum of Design, Smithsonian Institution, since May 1992; formerly Curator, The Herb Lubalin Study Center of Design and Typography, The Cooper Union for the Advancement of Science and Art. Curator of numerous exhibitions, including "The Bauhaus and Design Theory, from Preschool to Post Modernism" (1991) and "The Bathroom, the Kitchen, and the Aesthetics of Waste: A Process of Elimination" (1992). She has written on design for *Eye*, *I.D.*, *Design Issues*, and other publications. Lupton is also a partner in *Design writing research*, a design studio co-founded with J. Abbott Miller in 1985. She is also on the Board of Directors of the AIGA and chaired the 1993 "100 Show" for the American Center for Design.

Michael McCoy Co-chairman of the Design Department at Cranbrook Academy of Art. McCoy is partner with Dale Fahnstrom in the firm Fahnstrom/McCoy and partner with his wife, Katherine, in the design studio of McCoy & McCoy. His theories and projects regarding the symbolic meaning of forms in interiors, furniture, and technological products have been featured in *Blueprint*, *Axis* magazine, *Domus*, and numerous other publications, including the book he co-edited with Katherine McCoy, *Cranbrook Design: The New Discourse* (1990). He has lectured on design at conferences worldwide, including the National IDSA Conference, the Aspen Design Conference, and the World Design Conferences in Helsinki and Amsterdam.

Michael McDonough Principal, Michael McDonough Architect, founded in 1984. McDonough has won numerous awards, including the Architectural League Young Architects Award, the *I.D.* Annual Designer's Choice Award, the Design Explorations 2001 Award, and the American Institute of Architects Design Award. His work has been exhibited at the Cooper-Hewitt National Museum of Design, the Berlin Museum, Holly Solomon Gallery, White Columns Gallery, Gallery 91, the Grey Art Gallery, and Art et Industrie, among others. He is a member of the American Institute of Architects and is Board Certified by the National Council of Architectural Registration Boards.

J. Abbott Miller Design historian, writer, designer. Co-founder with Ellen Lupton of *Design writing research*, a graphic design and design studio whose clients have included the MIT List Center for the Visual Arts, Princeton School of Architecture, Jersey City Museum, *Dance Ink Magazine*, and Geoffrey Beene. He has co-curated, with Ellen Lupton, the exhibitions "The Bauhaus and Design Theory, from Preschool to Post Modernism" (1991) and "The Bathroom, the Kitchen, and the Aesthetics of Waste: A Process of Elimination" (1992). His publications include "American Graphic Design, 1829–1989," in *Graphic Design in America: A Visual Language History* (1989), and "Line Art: Andy Warhol and the Commercial Art World of the 1950s," in *"Success is a job in New York...": the early art and business of Andy Warhol* (1989), as well as numerous articles on typography and graphic design.

Alan Plattus Associate Dean of the School of Architecture at Yale University. Previously an Assistant Professor of Architecture at Princeton University. Plattus has contributed to numerous design journals, including *Architecture*, *Progressive Architecture*, *Design Book Review*, and *The New York Times Book Review*. Has consulted on a number of architectural projects, most recently the design and planning for Flushing Meadows–Corona Park, which won a Progressive Architecture Urban Design Citation.

John Rheinfrank Executive Vice President, Fitch RichardsonSmith. Rheinfrank directs programs that involve design research, strategy and planning, and human interface design. He has conducted workshops, tutorials, and presentations on product semantics, the nature of design languages, and the integration of design and corporate strategy. In the past he has had research associations with the Aspen Institute for Humanistic Studies, the International Institute for Applied Systems Analysis (Vienna), the United Nations Institute for Training and Research (New York), the Alfred Thyssen Foundation (Germany), the Club of Rome, and the Franklin Institute. Rheinfrank is an affiliate research scientist with the Institute for Research on Learning in Palo Alto, California.

Michael Sorkin Architect, critic, and writer on architecture. Currently Visiting Professor at the Cooper Union for the Advancement of Science and Art, Adjunct Professor at Columbia University, Visiting Professor at Southern California Institute of Architecture, and Visiting Critic at Harvard University. Sorkin has held numerous other academic appointments across the nation. He maintains a private design practice in New York City with a wide variety of urban, architectural, interiors, furniture, theatrical, and conceptual design projects, including numerous competitions. His design work has been shown in the U.S. and European galleries and museums and has been published in various catalogues. Author of numerous articles on architecture, urbanism, design, television, and other subjects. From 1978 to 1989, architecture critic for *The Village Voice*. In addition to two humorous books, he has written *The Architecture of Hardy Holzman Pfeiffer* (1981), *The Exquisite Corpse* (1991), and *Variations on a Theme Park* (1992). Both his writing and design have earned him numerous awards, from the Graham Foundation, the NEA, NEH, the New York AIA, and Columbia University, among other institutions.

Erik Spiekermann Typographic designer and type designer. Financed his studies in art history at Berlin's Free University by running a printing press and setting metal type in the basement of his house. After seven years as a freelance designer in London, he returned to Berlin in 1979, where—together with two partners—he founded MetaDesign Plus, currently employing more than thirty people, making it one of the few larger design studios in Germany. In July 1992, MetaDesign Plus opened an office in San Francisco, operating as MetaWest and employing seven designers. Spiekermann has written numerous articles and four books about type and typography, which have appeared both in Europe and in the U.S. His work and that of his studio have won awards in many national and international competitions and have been featured in magazines, annuals, and catalogues in Japan, U.S., England, Holland, and Germany. He is a Visiting Professor at the Academy of Arts in Bremen.

Bruce Sterling Author and journalist best known for his science fiction work. His four science fiction novels, *Involution Ocean* (1977), *The Artificial Kid* (1980), *Schismatrix* (1985), and *Islands in the Net* (1988), have firmly established him as a leading modern science fiction writer. Sterling writes a critical column for *Science Fiction Eye*. Sterling is also a key figure in the cyberpunk movement; his articles appear in *Mondo 2000*, a vanguard magazine that is home to computer junkies, liberal individualists, and cyberpunk writers. Sterling also edited and prefaced *Mirror-Shades*, an anthology viewed as the definitive doctrine of cyberpunk. His most recent work is *The Hacker Crackdown: Law and Disorder on the Electronic Frontier* (1992), a nonfiction work about computer crime and civil liberties.

Eduardo Terrazas Principal, eduardo Terrazas associates, with offices in Mexico City and Tepoztlan, Mexico. Resident Architect for the Mexican Pavilion in the World's Fair in New York while teaching at Columbia University, 1963–64. General Coordinator of the Olympic identity program "Mexico 1968," responsible for the graphic design program, publications, and urban design. Artistic director of the 1969 exhibition "Mexican Image." Served as Director of Technical Assistance representing the Mexican government to the government of Tanzania for the design and construction of its capital city, Dodoman. Projects in Mexico include the System of Urban Furnishings, Signs, Symbols and Gardens in Mexico City, and Cintermex in Monterey, the largest industrial exhibition center in Mexico.

John Thackara Director of the Netherlands Design Institute since May 1993, a new research center based in Amsterdam. Originally a design critic, Thackara was editor of *Design* magazine for five years. He was also Managing Director of Design Analysis International, a management consultancy, with offices in London and Tokyo, which helped business, education, and the arts work together. Thackara's clients included the Royal College of Art, for which he was Director of Research, The Architectural Association, The European Commission, and business clients in ten countries. His books include *Design after Modernism* (as editor, 1988), *New British Design* (as co-editor, 1991), and *Cultural Strategy for Business* (forthcoming).

Marc Treib Professor of Architecture at the University of California, Berkeley. Has held two Fulbright Fellowships to Finland and an Advanced Design Fellowship at the American Academy in Rome. Frequent contributor to architecture and design journals, including *Journal of the Society of Architectural Historians*, *Progressive Architecture*, *A+U*, *Arkkitehti*, *Landscape Architecture*, and *Pacific Horticulture*. Serves as Contributing Editor for *Print* magazine, as a Senior Fellow for the Program in Landscape Architecture Studies at Dumbarton Oaks, and on the editorial boards of *Design Book Review*, *Places*, and *Design Issues*. Books include *A Guide to the Gardens of Kyoto* (1980) and *The Sanctuaries of Spanish New Mexico* (1993), both as co-author, and *Modern Landscape Architecture [Re]Evaluated* (1993) as editor.

Tucker Viemeister Vice President and Co-founder of the industrial design consultancy Smart Design. At-Large Director of the Industrial Designers Society of America (formerly chair of the New York Chapter), a member of the American Institute of Graphic Arts, and a Trustee of Pratt Institute's Rowena Reed Fund. Viemeister has taught at Pratt, California Institute of Arts,

University of Cincinnati, Parsons, and at Les Ateliers—Ecole Nationale Supérieure de Creation Industrielle. His work has been selected for the Presidential Design Achievement Award, ten times for the Annual *I.D.* Design Review, and two IDEA awards. His designs are in the permanent collection of Cooper-Hewitt, National Museum of Design and the Grand Rapids Art Museum.

Lorraine Wild Faculty and former Director, Program in Graphic Design, California Institute of the Arts. Currently a partner in Reverb design studio, Wild has maintained a private graphic design practice since 1978. Her clients have included the Architectural Association, London; George Braziller, Inc.; Cooper-Hewitt, National Museum of Design; The Getty Center for the History of the Art and the Humanities; The Institute for Architecture and Urban Studies; Oxford University Press; and Rizzoli International Publications, Inc. Her design work has been widely recognized, in particular the publications *Mask of the Medusa* (1986), *Victims* (1986), *Blueprints for Modern Living: History and Legacy of the Case Study Houses* (1989), and *Violated Perfection: The Fragmentation of the Modern* (1990). An active lecturer and juror, Wild is also a frequent writer on graphic and industrial design. Her articles have appeared in *Emigre #17*, *Print*, *AIGA Journal of Graphic Design*, and *I.D.* among others. She also contributed essays to the books *Graphic Design in America: A Visual Language History* (1989) and *Cranbrook Design: The New Discourse* (1990).

Susan Yelavich Head of Education Cooper-Hewitt, National Museum of Design, Smithsonian Institution. A staff member of the Museum since 1977, Yelavich has organized scholarly lectures and symposia on subjects ranging from architecture to product design to communications history. In 1992 she produced the international symposium "The Edge of the Millennium." That same year she served as a juror for *I.D.* magazine's annual design awards. In 1993 she was project director for the Cooper-Hewitt exhibition "A Memorial to Jan Palach," a collaborative project of architect John Hejduk and poet David Shapiro. As Head of Education she also manages the Museum's programs for school children and public programs on contemporary and historic design. Yelavich is a graduate of Brown University and Cranbrook Academy of Art. She is also a practicing artist.

Index

Page numbers in *italics* refer to illustrations.